✓ **W9-BUT-812**

ART DECO PAINTING

759.06
LUC

~$45.00 97-3689

Lucie-Smith, Edward

WITHDRAWN

DEC 26 '97	DATE DUE	
JAN -2 '98		
MAY 22 '98		
JUL 2 4 '98		
FEB 26 '99		
APR 2 '99		
AUG 6 '99		

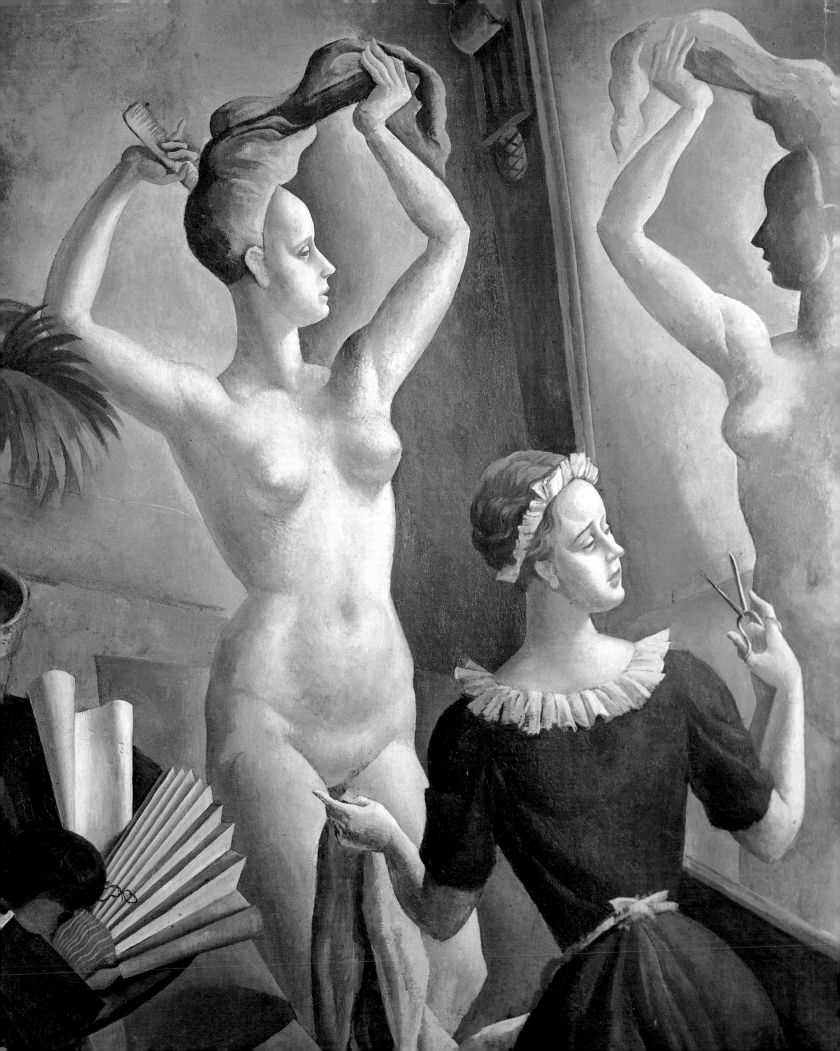

ART DECO PAINTING EDWARD LUCIE-SMITH

Phaidon Press Limited
Regent's Wharf
All Saints Street
London N1 9PA

First published 1990
First paperback edition 1996

© 1990 Phaidon Press Limited
Text © 1990 Edward Lucie-Smith

ISBN 0 7148 3576 5

A CIP catalogue record for this book
is available from the British Library.

Printed in Hong Kong

Frontispiece:
MARIANO ANDREU
The Mirror (detail), 1928.
Private Collection.
(Whitford and Hughes, London)

Cover illustration:
TAMARA DE LEMPICKA
*Unfinished Portrait of Tadeusz
de Lempicki,* detail (Plate 38)

ACKNOWLEDGEMENTS

The vast majority of important Art Deco
paintings, especially of a more
conservative and classicising kind,
remain in private hands. This book
could not have been undertaken without
much help from certain specialist
dealers, who have handled much of the
material, and have kept good records ot
it. In New York, I owe especial thanks to
Barry Friedman Ltd; in London, to
the Fine Art Society and Whitford &
Hughes. I also owe a great debt of
gratitude to my editor at Phaidon, Mark
Fletcher, who has been patient with my
vagaries, and an excellent source of
practical suggestions. Many of the
book's virtues (assuming it has any)
are due to him; its faults are my own
responsibility.

The publishers wish to make the
following copyright acknowledgements:
12, 89 © 1990 The Art Institute of
Chicago. All Rights Reserved; 73, 98
Scala, Florence; 48 Reproduced by kind
permission of the President and Council
of the Royal Society; 4, 42, 43 Cliché
des Musées Nationaux, Paris; The
works of Georgia O'Keeffe are
Copyright 1990 The Georgia O'Keeffe
Foundation/ARS N.Y. The works of
Balthus, Casorati, Dupas, Grigoriev,
Léger, de Lempicka, Ozenfant, Picasso,
Pimenov, and Vallotton are © DACS
1990. Those of Boutet de Monvel,
Derain, Laurencin, Lhote, Severini and
Van Dongen are © ADAGP,
Paris/DACS, London 1990.

≡CONTENTS≡

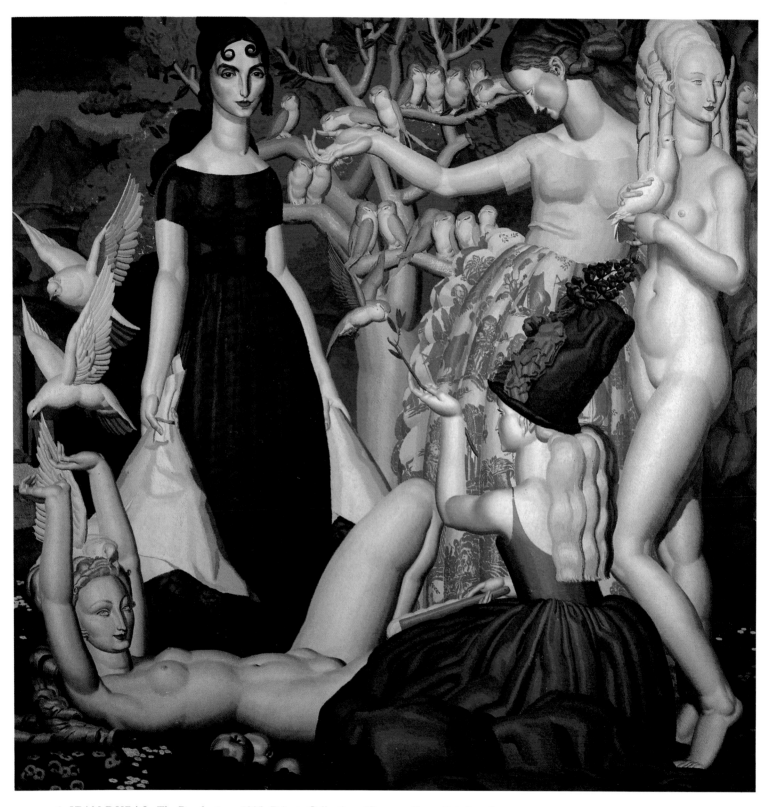

1 JEAN DUPAS. *The Parakeets*. *c*. 1925. Private Collection. (Courtesy Barry Friedman)

INTRODUCTION: THE SOURCES OF ═ART DECO PAINTING═

<div style="text-align:right">1</div>

To many people, the idea of Art Deco painting will appear almost a contradiction in terms. The numerous books on the Art Deco style, published since it returned to fashion towards the end of the 1960s, give little information about painting. Their focus of interest is the applied arts – furniture, ceramics, metalwork, lacquer and so forth. Many of the room settings illustrated in these books – either genuine period pieces or recreations – contain only a few framed pictures. Exceptions are the interiors of Jacques Doucet's spectacular apartment in Neuilly which were shown in *L'Illustration* in May 1930. However, Doucet's often thickly crowded paintings tend to be earlier in date than the furniture which he commissioned from Pierre Legrain and other leading designers of the time. In his sitting room, for example, the huge sofa by Marcel Coard had the Douanier Rousseau's *La Charmeuse de Serpents* hanging above it. This had been painted nearly a quarter of a century before, in 1907.

Yet the Art Deco style did extend its influence into fields which were allied to painting. It had a tremendous impact on poster design, and the posters designed by artists such as Cassandre are now considered to be summits of this particular art form, fully equal to the posters created by Toulouse-Lautrec during the *belle époque*.

Art Deco was also important for book and fashion illustration. The drawings and prints of illustrators such as Georges Barbier and Georges Lepape are rightly admired today. It is unlikely that Art Deco would have no impact on painting, given its international success and its power of penetration into all fields of design, and indeed, a number of leading Art Deco illustrators, such as Bernard Boutet de Monvel (1884–1949), had successful parallel careers as easel-painters. Boutet de Monvel was a regular exhibitor in the Paris Salons of the interwar period, showing landscapes, portraits and nudes. Similarly, artists now best remembered as painters, such as Marie Laurencin (1883–1956) and Tsuguharu Foujita (1886–1968), were in regular demand as poster designers.

Any definition of Art Deco painting has to take four factors into account: style; subject-matter; the relationship between this kind of art and the general development of the Modern Movement; and the uses to which paintings were put during the interwar period – in other words, their social function. Not unexpectedly, the first two categories are dependent on the third and fourth. By analogy with Art Deco posters and through comparisons with other objects of the genre, Art Deco paintings might be expected to make much use of silhouette, to be sharp-edged and rather

restless, to favour flat bands and areas of colour rather than elaborate chiaroscuro, to be consciously refined and exquisite, and, where dealing with figures, to show them in rather mannered poses. By and large these expectations are fulfilled, though not to the same extent in every case.

Art Deco paintings deal with a definable range of subject-matter: classical allegories, portraits, genre scenes, landscapes and still lifes. One of the immediately striking things about this repertoire of subjects is its traditional character. It clings to the framework set up in the Renaissance and refined and elaborated at the start of the seventeenth century. In fact, in terms of the subjects chosen, the Art Deco painters remained consistently faithful to long-established ideas. In this area, at least, they saw no need to innovate.

Some aspects of their style of painting may appear rather academic, particularly in the case of the classical allegories, which tackle the kind of subject-matter traditionally prescribed to students at the École des Beaux-Arts in Paris and at other official academies throughout Europe, as part of their professional training. But other aspects seem to be dependent on the non-academic art styles which flourished before the First World War. In particular, there are influences from Symbolist illustrators, such as Aubrey Beardsley, from the Nabis (particularly Maurice Denis and Paul Sérusier), from the Russian designers who dominated the first and greatest period of Serge Diaghilev's Ballets Russes (Leon Bakst and Alexandre Benois), from both Analytic and Synthetic Cubism (though with the latter predominant) and from Italian futurism. There also seem to be influences from contemporary styles, especially from the painters of the Novecento Group in Italy, whose way of painting often has a strong Art Deco flavour to it; and from the more conservative artists of the Neue Sachlichkeit in Germany. These German artists are sometimes grouped separately, and described as Magic Realists.

It is clear from this that any painting which is described as Art Deco is usually thoroughly eclectic: a stylistic amalgam which combines different and perhaps antagonistic tendencies. The explanation is simple. The public to which Art Deco painting addressed itself was the same as that served by the Art Deco designers of furniture and other artefacts. It consisted of two groups. There were the leisured and moneyed private patrons, the equivalent of preceding generations of private patrons who had sustained and guided the visual arts throughout the eighteenth and nineteenth centuries. Yet there were also important differences as wealthy buyers of art now came from a less cultivated background and were often in possession of new fortunes rather than old money. Equally, they were often rootless cosmopolitans, cast adrift by the war. On the one hand, they were obsessed with fashion; on the other, they were imbued with a rather nervous conservatism. The result was a taste for the trappings of modernity, combined with a tendency to shy away from genuine radicalism. The second group possessed the power to give official commissions but its expectations were to a large extent still conditioned by the official art of the pre-war period. Yet at the same time there was also a feeling that official art should move with the times and absorb some, at least, of the lessons of Modernism.

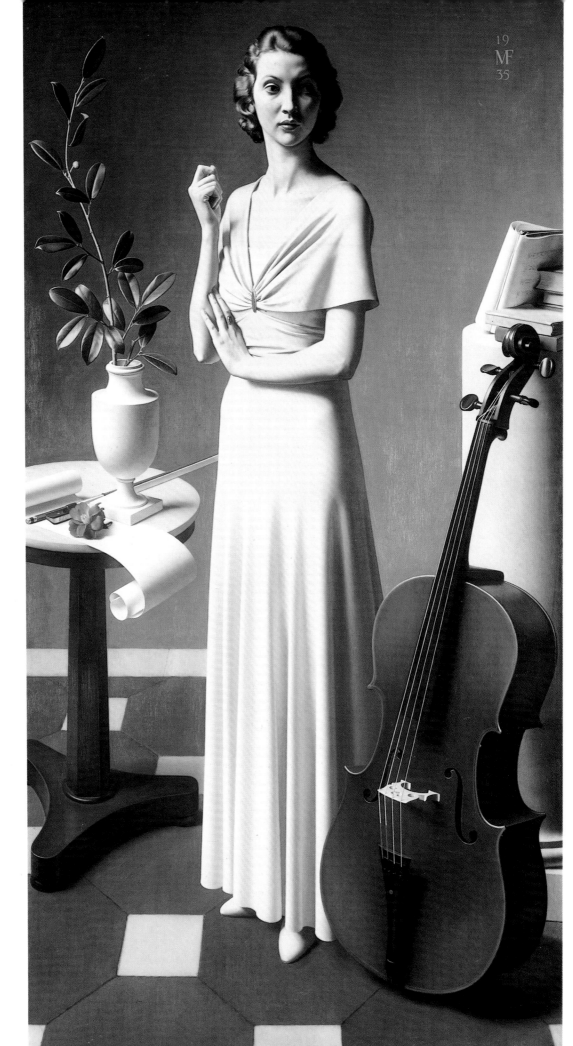

2 MEREDITH
FRAMPTON.
*Portrait of a Young
Woman.* 1935. The
Tate Gallery, London

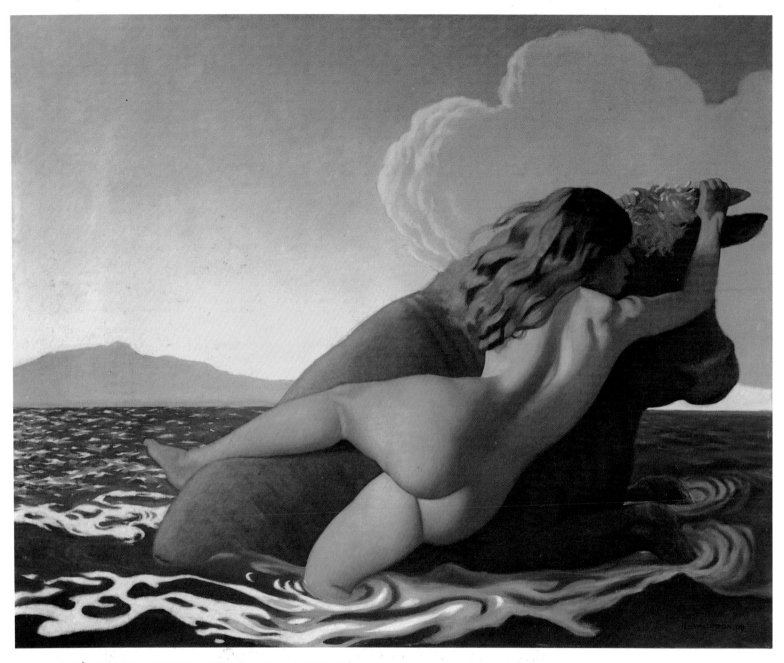

3 FÉLIX VALLOTTON. *The Rape of Europa*. 1908. Kunstmuseum, Berne

4 PABLO
PICASSO. *Bathers,
Biarritz*. 1918. Musée
Picasso, Paris

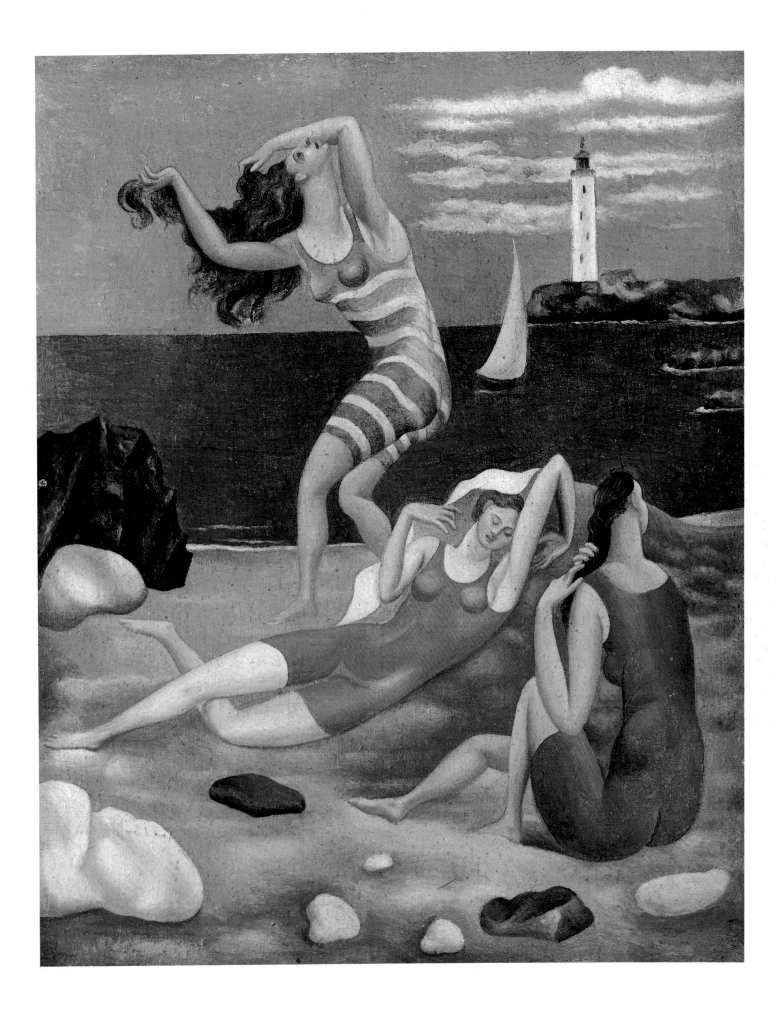

Where the artists themselves were concerned, the desire for further innovation was in conflict with a conservative impulse inspired by the chaos and destruction of the First World War. Many artists, especially those who were already established and moving towards middle age, drew back from the violence of pre-war experimentation. One result was a renewal of interest in academic classicism. Most of these artists had, after all, been trained according to the academic system established at the beginning of the nineteenth century by Jacques-Louis David, and some, at least, now began to regard this style with a certain nostalgia. However, this feeling was often leavened with irony, and the new Art Deco Classicism was given a typically ambiguous twist, so that the viewer was left uncertain whether it was meant to be taken at all seriously.

The return to classicism was not wholly the result of the war. Some painters had begun to experiment with a new version of neo-classicism before 1914. One of the most influential of these was the Swiss, Félix Vallotton (1865–1925), a founder-member of the Nabis, now better remembered as a print-maker than a painter (Pl.3). Just at the end of the war, an important, though temporary, convert to the new classicism was the ever-restless and inventive Picasso. Despite, or even because of, its deliberate mannerism, a painting like *Bathers, Biarritz* (Pl.4), painted in the summer of 1918, already has an Art Deco look. The more stolidly classical compositions which Picasso produced a couple of years later seemed to his contemporaries like a deliberate renunciation of everything which the frenetic *Demoiselles d'Avignon* had stood for.

This classical revival was signalled in a different way by the stylistic change which took place in the work of another vanguard painter of the School of Paris, André Derain. Derain's Fauve manner, which had established his reputation, was modulated into something far more solid in construction and subdued in colour (Pl.42). His new paintings, and especially the fine series of female nudes which he produced at this time, can all be included within the general current of Art Deco. At this period in his career Derain was hugely fashionable. From 1923 he was under contract to the leading dealer Paul Guillaume, who promoted him vigorously. Derain's work of the 1920s and 1930s appealed to the wealthy collectors who were also likely to be patrons of the leading Art Deco designers.

The new interest in classicism was especially marked in Italy, where the *pittura metafisica* created by Giorgio de Chirico and Carlo Carrà during the war years moved fairly easily into the more serious, not to say pompous, style favoured by members of the Novecento Group. This group was founded in 1922, the year of Mussolini's March on Rome. The artists who belonged to it were acceptable to the new Fascist regime, which saw in their work a parallel for its own imperial ambitions. Mussolini, who professed a personal interest in the visual arts, addressed the first meeting of the group, held in 1923 at Galleria Pesaro in Milan.

Just as strong as the influence of a revived classicism, especially in France, was the continuing attraction of Symbolism. The pure symbolist style had been overthrown, but there were surviving variants. The most influential of the post-Symbolist groups was the Nabis, named from the Hebrew for 'prophet'. These painters had banded

5 RAPHAEL
DELORME. *The
Columns (Girl and
Pigeons)*. *c.* 1925.
Private Collection.
(Courtesy Barry
Friedman)

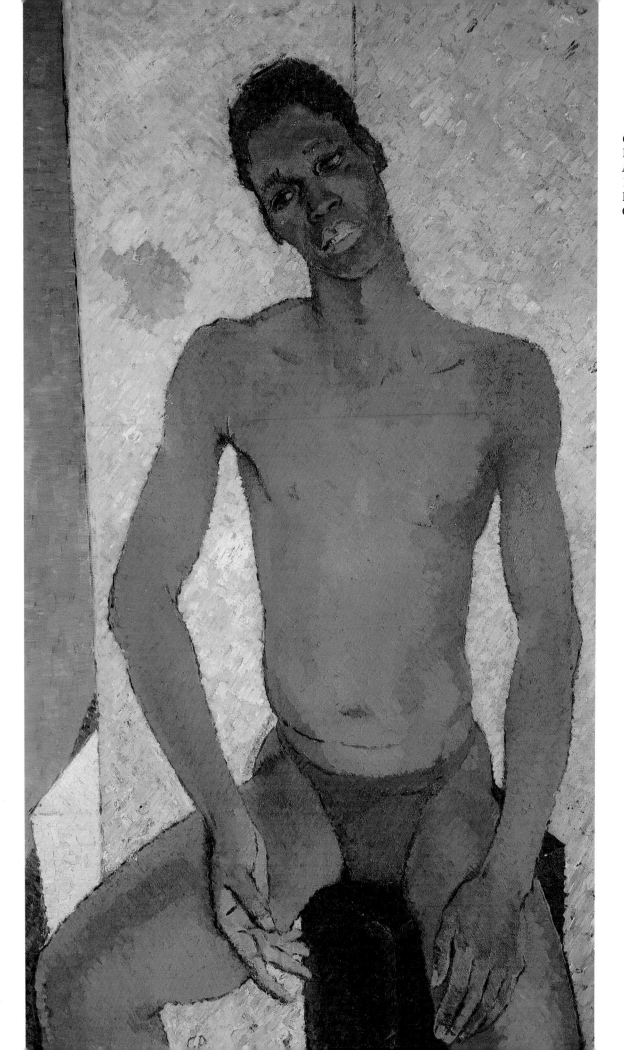

6 GLYN
PHILPOT.
Melancholy Negro.
1936. Royal
Pavilion Art
Gallery, Brighton.

together as early as 1888. The moving spirit was Paul Sérusier (1863–1927) who in that year encountered Gauguin at Pont-Aven in Brittany and was converted by him to the new creed of Synthetism – a simplification of what was seen in order to intensify the sensations produced by visual appearances. As it developed, the Nabi Group split into distinct halves, with the domestic Bonnard and Vuillard (today the most famous members) on one side, and the more didactic Sérusier and Maurice Denis (1870–1945) on the other. It was Denis who said: 'Remember that a picture, before being a warhorse, a female nude or some anecdote, is essentially a flat surface covered with colours assembled in a certain order.'

Denis and Sérusier were much more important for Art Deco than Bonnard and Vuillard. Denis was intensely religious, which is hardly a characteristic of Art Deco painting, but the simplifications he devised turned out to be useful for purely secular purposes as well. His own chief decorative work was the main ceiling painting for the Théâtre des Champs-Élysées, completed in 1912. The decoration of this building, in which the sculptor Bourdelle also had a hand, influenced the whole Art Deco movement. The Théâtre des Champs-Élysées was one of the places where Diaghilev's Ballets Russes performed. The quasi-Symbolist, quasi-orientalist decors devised for the company by Leon Bakst (1866–1924) had a major influence on the development of the Art Deco style, and Bakst was a particular favourite with illustrators such as Barbier and Lepape. Almost equally influential were the fantasies of Bakst's colleague, Alexandre Benois (1870–1960), which he derived from the eighteenth century and Biedermeier. Biedermeier, in particular, had a pervasive but still under-recognized influence.

It is not surprising to find that Art Deco painting also absorbed much from Cubism, though chroniclers of the development of the style have generally traced these influences in the decorative arts, and especially in designs for furnishing fabrics and carpets. There was, in fact, much painting produced during the 1920s and 1930s which no longer showed much inclination towards avant-garde experimentation, but which used the Cubist vocabulary for decorative effect. Even Picasso felt the decorative impulse. One of the most authoritative of his Cubist masterpieces, *The Three Musicians*, was not painted until 1924. Its deliberately decorative qualities are manifest at a first glance, and show Picasso very much in step with the taste of the time.

In general, Art Deco Cubism does not base itself directly on the work of the two Cubist pioneers, Picasso and Braque, but stems from the art produced by various members of the Section d'Or, such as Jean Metzinger, Albert Gleizes and Roger de la Fresnaye. The Section d'Or was founded in 1912, and inherited almost as much from the Nabis as it did from Cubism, and most especially a penchant for decorative stylization.

The most important artist to emerge from the milieu of the Section d'Or was Fernand Léger (1881–1955). Léger's vehement Communism, and his insistence on the democratization of art, have tended to distract attention from his importance in the formation of the Art Deco style. In the years immediately following the First World War he was associated with Purism, a movement founded by Amédée Ozenfant

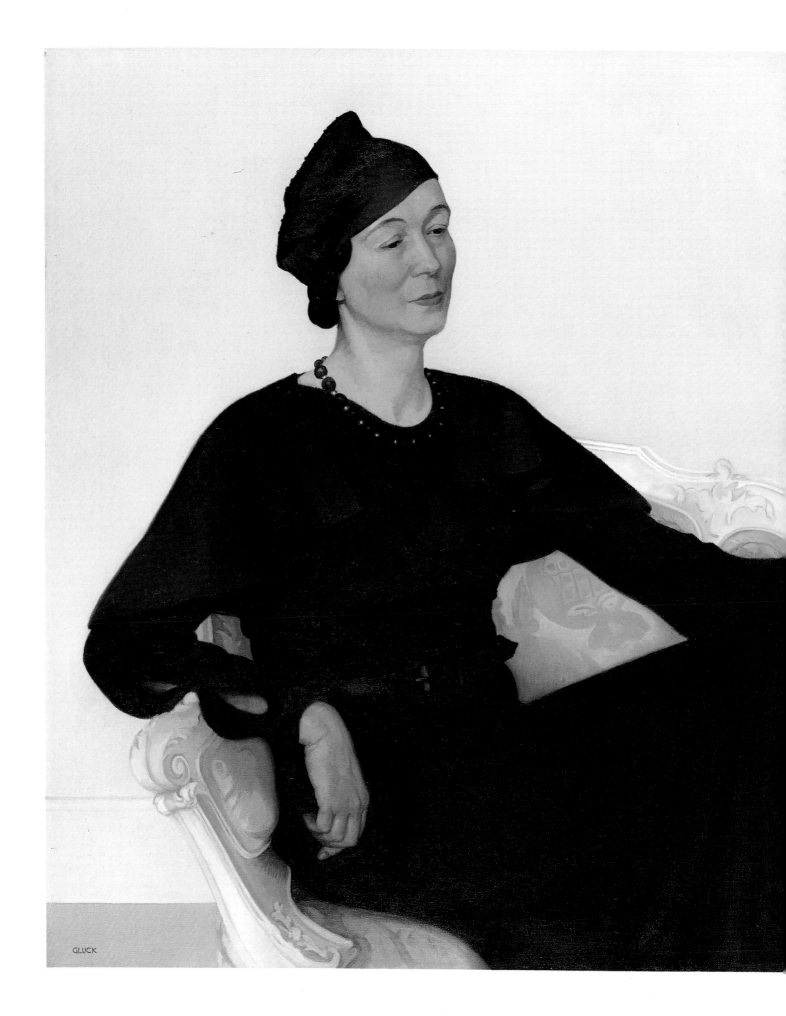

(1886–1966) and Charles-Édouard Jean- neret, who is better known as the leading Modernist architect Le Cor- busier. Le Corbusier's stark Pavillon de L'Esprit Nouveau formed part of the 1925 Exposi- tion des Arts Décoratifs. Among its furnishings was a characteristic painting by Léger, *The Baluster* (Pl.8).

The Pavillon de l'Esprit Nouveau is com- monly interpreted as a tart rejoinder to the rest of the exhibition in that it rejected luxurious materials and traditional crafts- manship in favour of an industrial aes- thetic. This is an oversimplification. Leading Art Deco designers showed a con- sistent interest in machine forms. These are skilfully used for their evocative power in many of the best Art Deco posters, which were in any case concerned with promoting industrial products. Machine forms also appear in the jewellery designed by Jean Fouquet, Raymond Templier and Gérard Sandoz: and in silverware produced by the ultrafashionable Jean Puiforçat. Léger's *The Baluster*, and other of his works from the same period, do very much the same as these designers did. Léger takes common objects, many of industrial origin, and strips them of their banality, stylizing them so that they acquire an alienated, exotic, visually imposing presence.

Linked to this transformation of com- mon objects is a fascination with the urban or industrial landscape, which was now seen as something possessed of an almost hieratic presence. The American painters of the Precisionist Group were among the most convinced and powerful exponents of this attitude, but there are also similar paintings by Boutet de Monvel (Pl.9), who is generally put in a very different category. Charles Sheeler (Pl.11), one of the leading

7 GLUCK. *Miss Susan Ertz*. 1937. Private Collection. (Courtesy Fine Art Society)

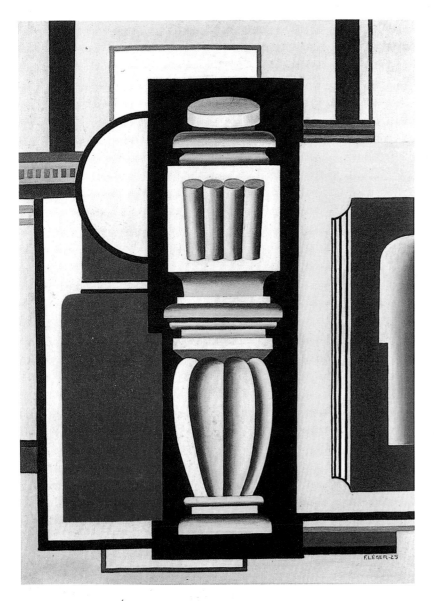

8 FERNARD LÉGER. *The Baluster*. 1925. The Museum of Modern Art, New York (Mrs Simon Guggenheim Fund)

Precisionists, was also a skilful photographer whose work appeared in *Vogue* and *Vanity Fair*. In terms of typography, layout and choice of illustration, these magazines were greatly influenced by the new Art Deco sensibility.

Although Art Deco painting is generally thought of as a reaction against the naturalism and literalism associated with photography, there are in fact strong links between certain paintings which seem to express the Art Deco ethos and the photographs which now seem most powerfully evocative of the 1920s and 1930s. It was the camera which defined the new image of industry, raising hopes that mankind was entering a new technological Utopia, and presenting machines as things which were mysteriously god-like. Léger was not immune, any more than his colleagues across the Atlantic. It was feelings of this kind which helped to pull the work he produced in the 1920s toward formulations which are now recognized as having something to do with Art Deco.

The work of his numerous pupils is often more convincingly Art Deco than that of Léger himself. There are several reasons for this. The pupils usually had no direct experience of Cubism, when this was still in its formative stage, apart from what they absorbed from their master. Instinctively, they sought to reduce this to an easily assimilable formula. Many of them were not French, and they seem to have learned Cubism with the slightly unimaginative diligence which many people bring to learning a foreign language. They were perhaps more interested in the language itself than in what could be said with it, and this led them to fall back on 'decorative' solutions. And indeed, Léger, with his strong respect

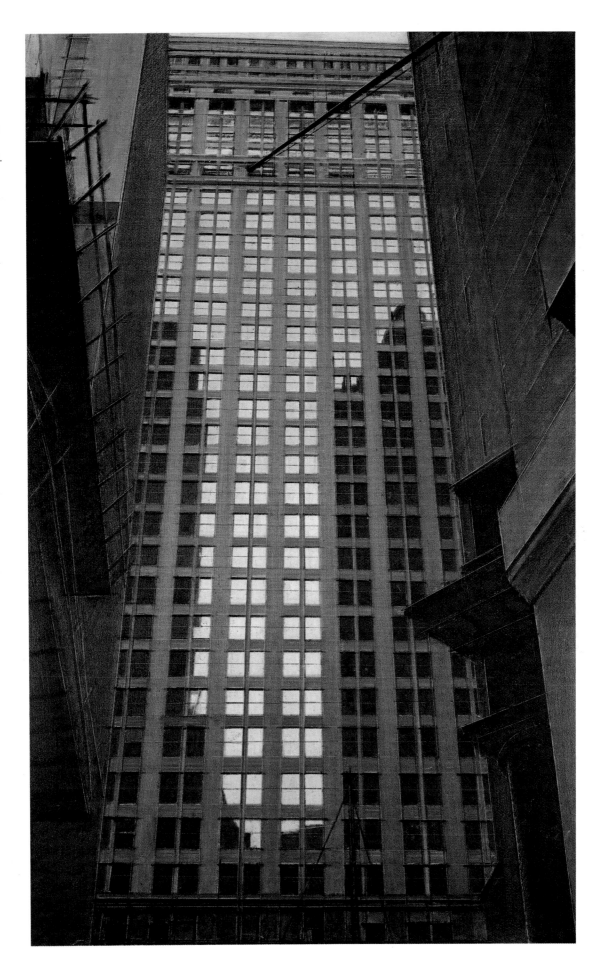

9 BERNARD
BOUTET DE
MONVEL. *New
York. c.* 1930.
Private Collection.
(Courtesy Barry
Friedman)

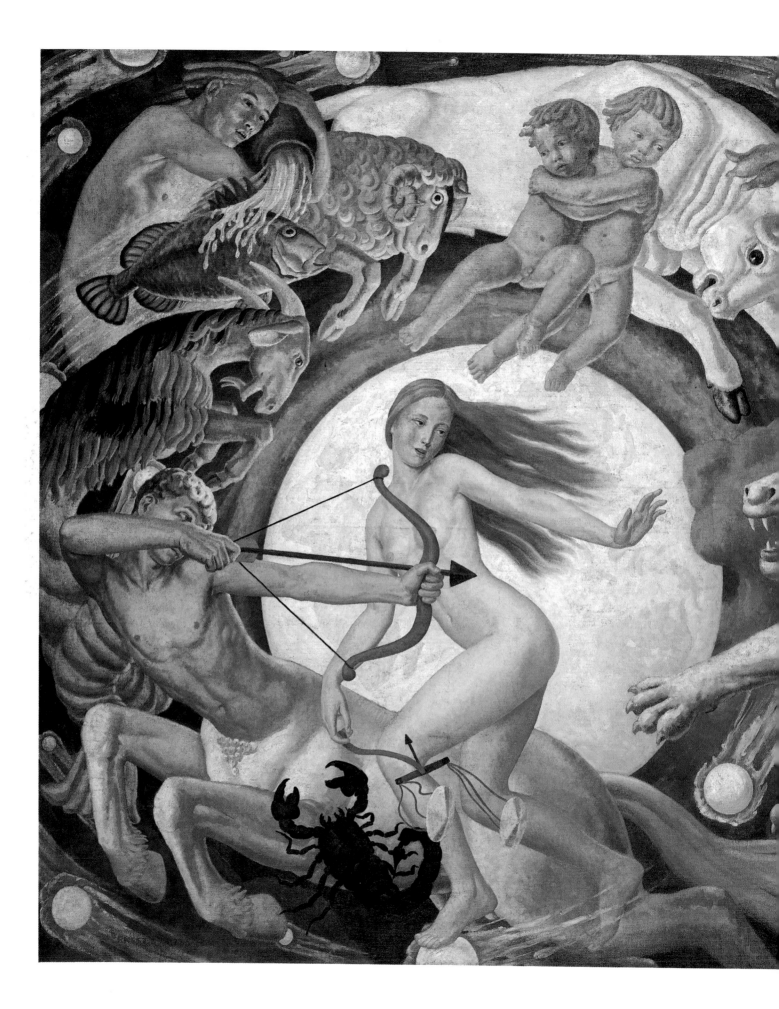

11 CHARLES SHEELER. *Church Street E1*. 1920. The Cleveland Museum of Art, Mr and Mrs William H. Marlatt Fund

10 ERNEST
PROCTER. *The
Zodiac*. 1935. The Tate
Gallery, London

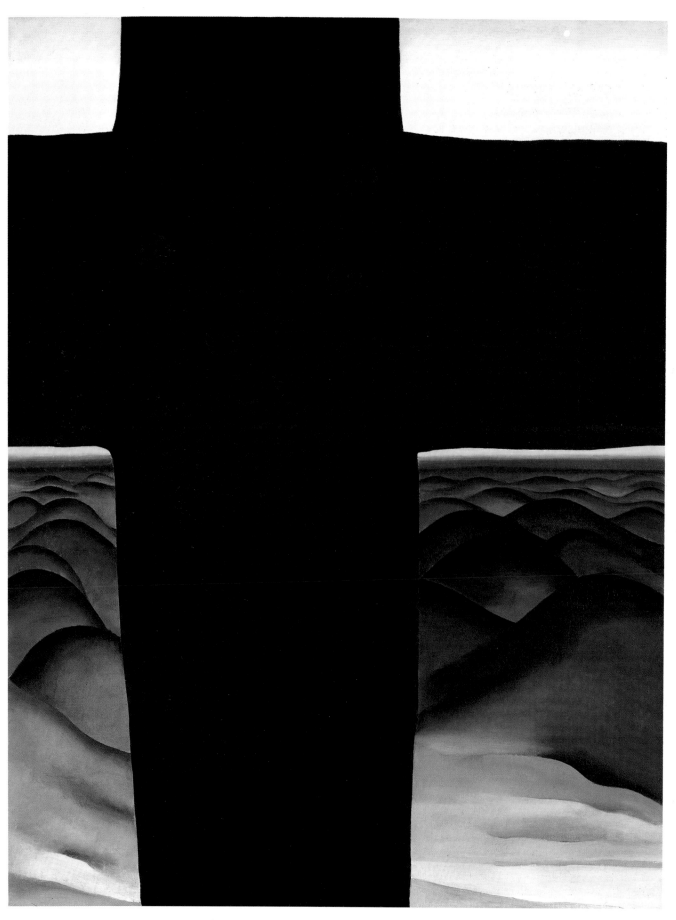

12 GEORGIA O'KEEFFE. *Black Cross, New Mexico*. 1929. The Art Institute of Chicago
(The Art Institute Purchase Fund)

for the old French artisan tradition, taught painting rather as if it was a kind of craft. There was an unexpected area of common ground between Léger's followers and a group of English painters who still retained strong links to the English Arts and Crafts tradition. Artists like Joseph Southall, and late Newlyn School artists like Ernest Procter (Pl.10) and Gladys Hynes (Pl.13), felt that painting should be, first and foremost, a soundly carpentered decorative artefact. The idea that it should perhaps convey emotion remained secondary.

The relationship between photography and Art Deco painting was important in a number of ways. Links can be seen between the portrait photography of the 1920s and 1930s and the most typical Art Deco portraits. Both subscribed to the new concept of glamour. Rather than attempting to impress the spectator with the status of the sitters, portraits now concentrated on the idea that the image was the reflection of a superior personality, and showed a being from another world who had, just for a moment, condescended to make an appearance in this one. Glamour was the stock-in-trade of the Hollywood stills photographer, but also of the Art Deco portraitist, as encapsulated in the paintings of Tamara de Lempicka (Pl.14).

The camera was important to many Art Deco painters in another way: it taught them how to isolate details and to juggle with the spectator's perception of scale. Both devices appear frequently in the work of Georgia O'Keeffe (Pl.12) who, through her marriage to the photographer Alfred Stieglitz (1864–1948), was keenly aware of the medium and its capabilities. O'Keeffe, who is generally associated with the Preci-sionists, is a prime example of an artist whose strong affinities with the world of Art Deco have never been fully acknowledged.

The Mexican artist, Diego Rivera (1886–1957), is an even more striking instance. Rivera is established in the contemporary imagination as a great populist painter, who spoke directly to the Mexican masses through panoramic murals which draw both on Pre-Columbian legend and on the recent history of Mexico. While this description is valid, it falls short of the full truth. Rivera did have populist links, for example with the engravings of José Luis Posada, yet he also painted sleek portraits of fashionable society women (Pl.16) and, in a slightly different vein, decorative compositions showing Indians or, alternatively, female nudes of a more European type, accompanied by great bunches of flowers (Pl.15). These decorative pictures make Rivera's debt to the work of the Douanier Rousseau clearly evident. Some also illustrate the attention he paid to Gauguin. Most of all, they suggest that he had close links to both European and North American Art Deco.

Rivera studied first at the San Carlos Academy in Mexico City (1898–1905) where he followed the regular course of academic instruction which was all that was available at the time. He became involved with *Savia Moderna*, a pro-Modernist group of young artists. At that time, to be a Modernist in Mexico meant admiring Symbolism and its offshoot, Art Nouveau – Rivera's position was rather like that of the young Picasso in Barcelona, who underwent the similar influences. In 1907 Rivera arrived in Europe to study art on a government scholarship. After two years in Spain he went to Paris and the next year followed

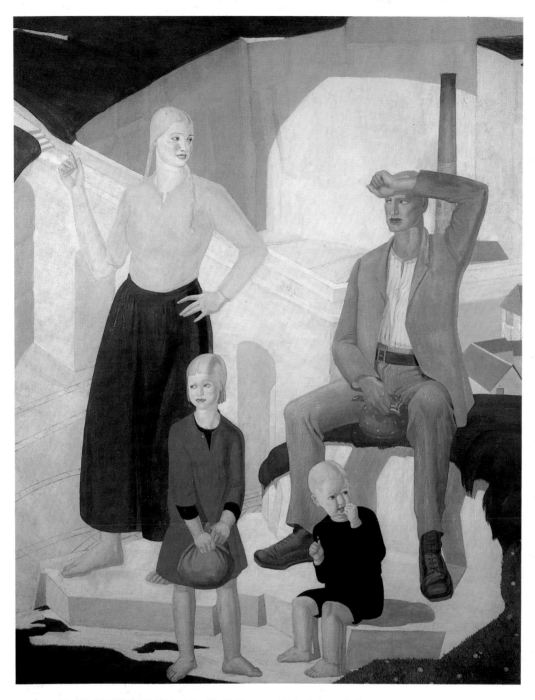

13 GLADYS HYNES. *The Chalk Quarry.* 1922. Private Collection. (Courtesy Whitford and Hughes)

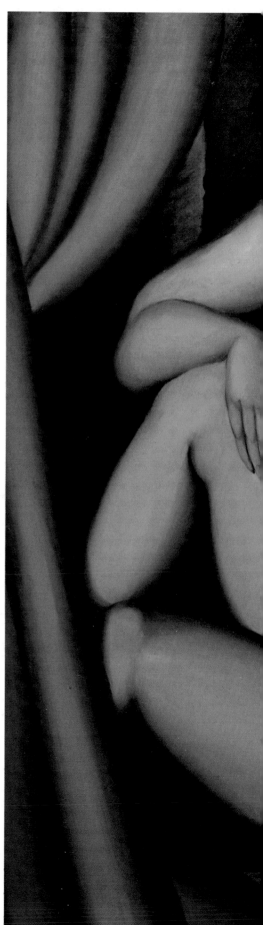

14 TAMARA DE LEMPICKA. *Les Deux Amies.* 1923. Musée Petit Palais, Geneva

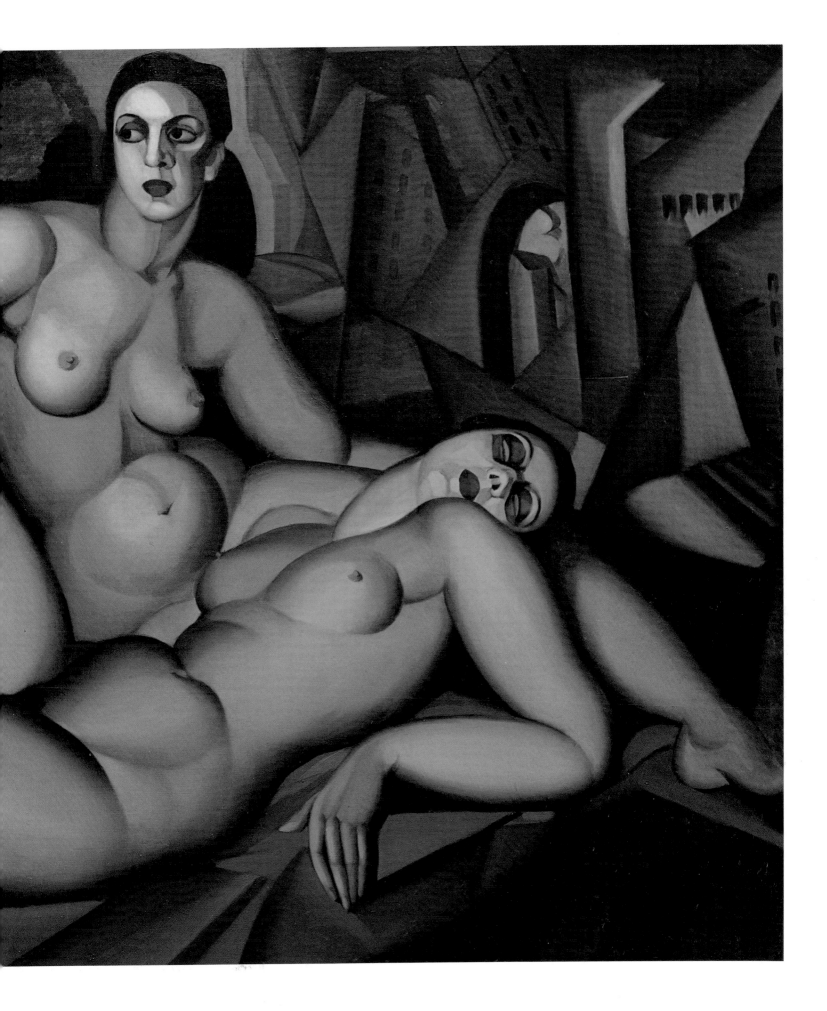

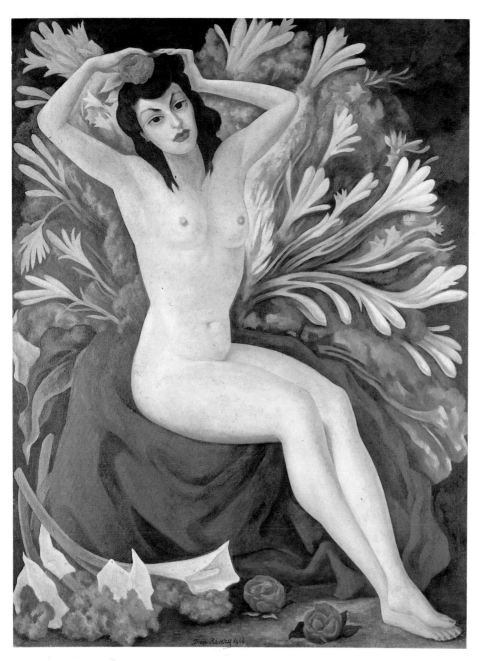

15 DIEGO RIVERA. *Nude with Flowers*. 1944. Private Collection. (Courtesy Sotheby's, Inc., New York)

16 DIEGO RIVERA. *Portrait of Natasha Z de Gelman*. 1943. Gelman Collection

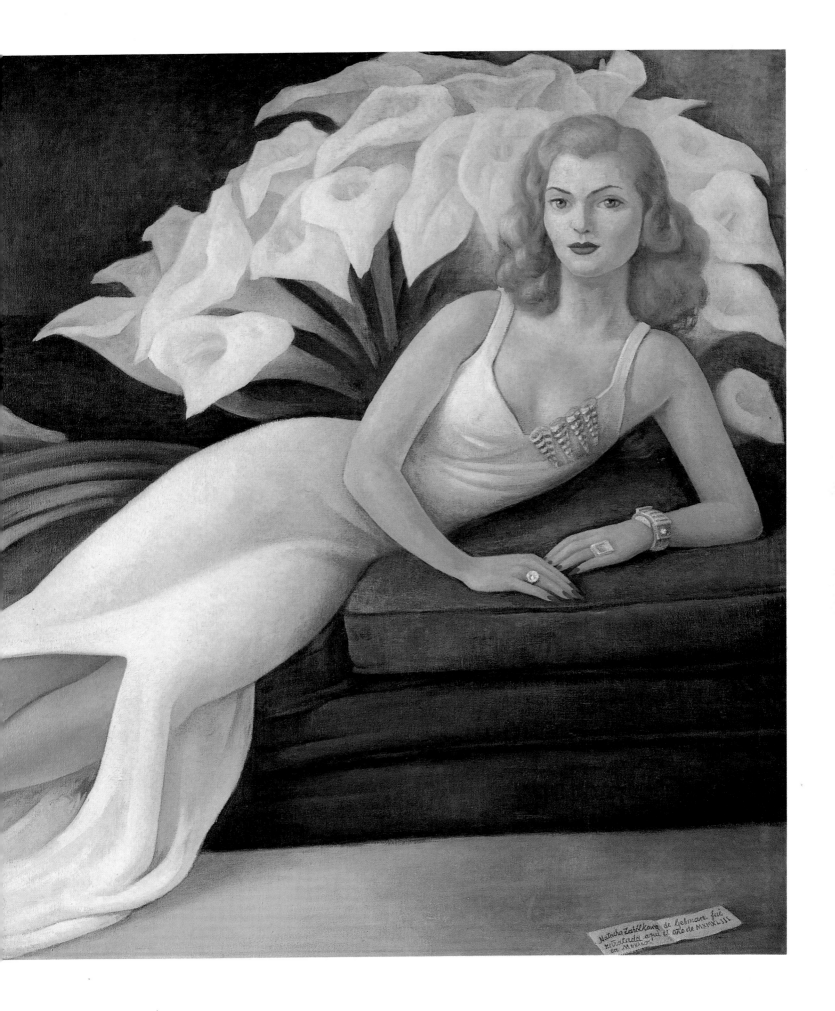

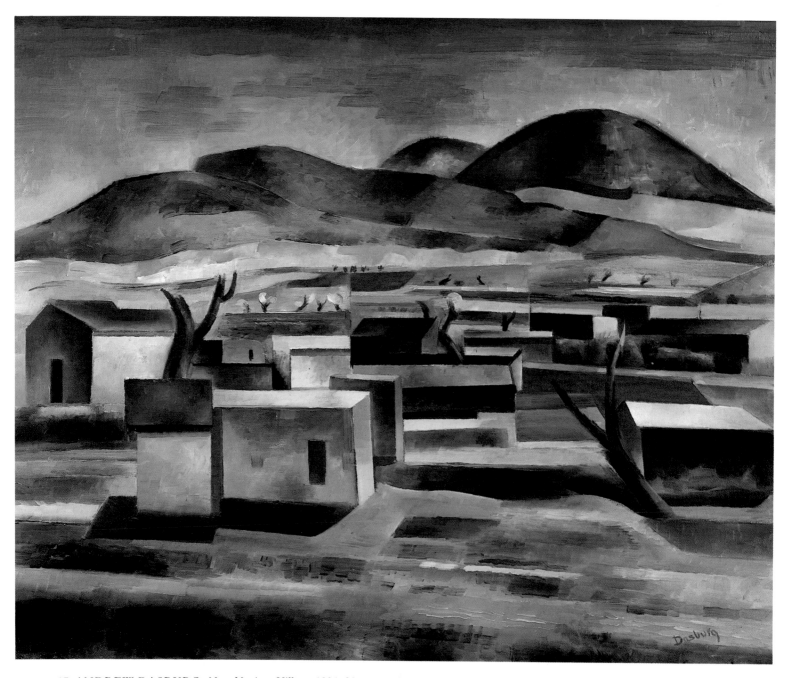

17 ANDREW DASBURG. *New Mexican Village*. 1926. Museum of Fine Arts, Museum of New Mexico
(Gift of Mrs Cyrus McCormick, 1952).

in the footsteps of Gauguin and the Nabis, and visited Brittany. By 1912, after a brief return to Mexico, where he saw the beginnings of the Mexican Revolution against the dictatorship of Porfirio Diaz, he had begun to be involved with the new Cubist Group, then just emerging. Some of the paintings he produced at this period, such as the *View of Toledo* now in the Metropolitan Museum, foreshadow the development of the Art Deco style through their self-consciously 'ornamental' use of Cubist ideas. For a short time Rivera became a convinced Cubist – by 1916 he was part of an artistic circle which included Juan Gris, Gino Severini, André Lhote and Jean Metzinger. This involvement did not endure and by 1918 Rivera, like other artists who frequented the same circle, was moving towards a kind of classicism. In particular, he began to feel renewed interest in the art of the Renaissance. In 1920 he was able to make a long trip to Italy, where he studied the great Renaissance fresco painters and in particular Giotto, Mantegna, Piero della Francesca and Uccello.

In July 1921 he returned to live in Mexico and almost immediately became involved in the great mural painting programme which was then being launched by the Minister of Education, José Vasconselos. Up to this point his development had followed a pattern common among the artists of his generation. Both Gino Severini and André Lhote produced work in the immediately postwar years which can unequivocally be described as Art Deco. Rivera's first work as a muralist was *Creation* in the Amfiteatro Bolivar of the Escuela National Preparatoria in Mexico City. In style it is close to the classicizing wing of European Art Deco and one notes the undoubtedly classical figure of Dance, standing immediately to the left of the central niche.

Commentators on Rivera's work have been at pains to stress both the Pre-Columbian and Cubist elements, as well as the populist contribution made by Posada. The Pre-Columbian borrowings, prominent in what is perhaps Rivera's best-loved cycle of murals, the paintings in the loggia of the Palacio de Cortés in Cuernavaca, are about as authentic as Gauguin's equally seductive renderings of primitive customs in the South Seas. The spatial compression typical of many of the artist's mature murals – for example, the scenes set in niches in the Court of the Fiestas in the Ministry of Education in Mexico City – owes as much to Italian Mannerism as it does to Cubism. It is interesting to compare the Court of the Fiestas with a set of prints by Rosso Fiorentino showing the Olympian gods, in which figures burst out of their niches in precisely the same way.

Once Rivera embarked on the Muralist adventure, any real commitment to Modernism as it is usually understood vanished. What he did was to forge an eclectic style, which certainly made use of the Modernist ideas he had picked up in Paris, but which was obviously traditional in its aesthetic intentions, much closer to the Italian fresco painters than to the Cubists and other avant-gardists who had been his companions in Europe. It was his good fortune to be presented with a unique opportunity thanks to the political and social revolution in Mexico. He recognized that revolutionary politics are usually most clearly and forcefully expressed by reference to art of the past. In fact, the one thing Rivera did not set out to revolutionize was aesthetics.

30

18 ANDRÉ
LHOTE. *The Beach.*
1922. Private
Collection. (Courtesy
Barry Friedman)

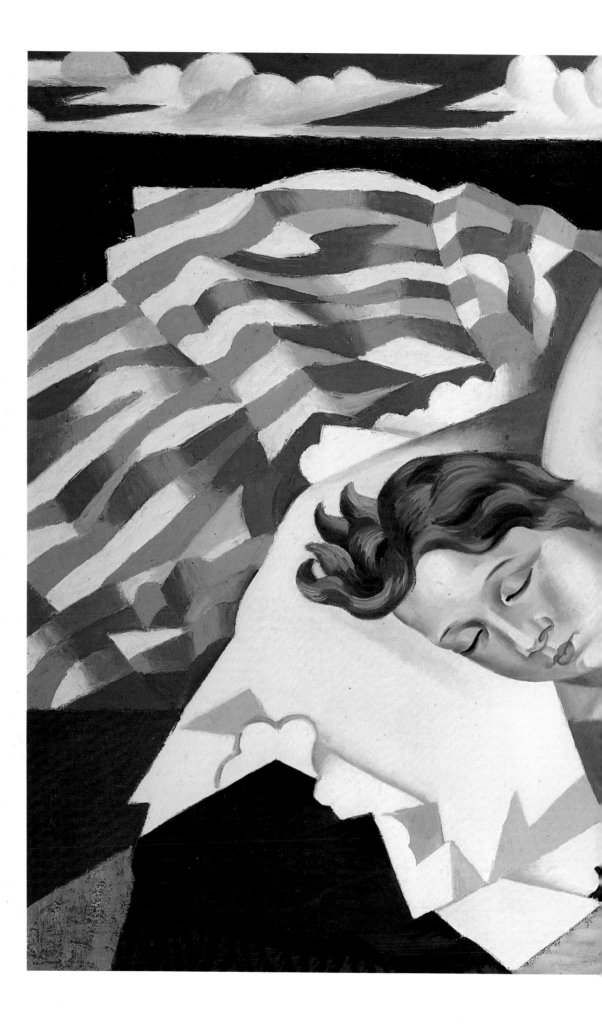

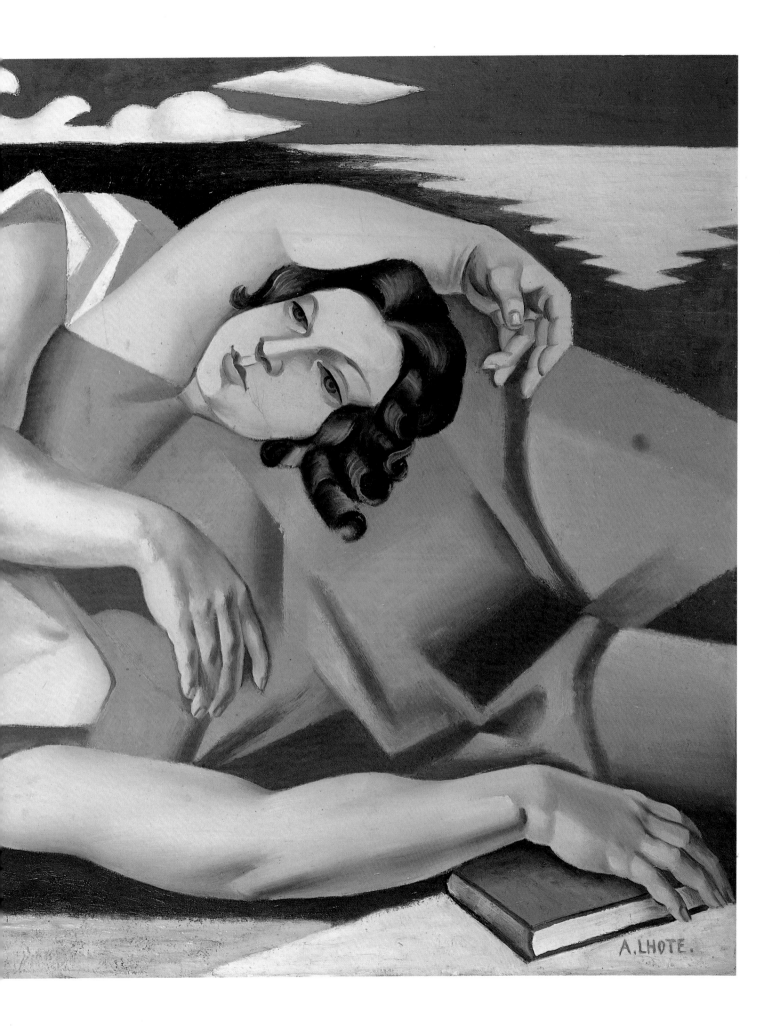

Only Rivera and his Mexican colleagues were presented with an opportunity of this magnitude to create public art. But the way in which Rivera in particular responded finds many parallels in European and North American Art Deco. His brand of mural painting was not completely *sui generis*. One might arrive at a different verdict when studying the work of Orozco. Rivera's work is a good example of the reasons why Art Deco painting has to some extent remained invisible, at least to art historians. It cuts across other, better-established categorizations, most of all the distinction between what is avant-garde and what is conservative. Rivera is pioneering and retrograde at one and the same time. It is a characteristic shared with other painters included here.

The kind of painting discussed under the heading of Art Deco deserves more attention than it has received, not least because it flourished so vigorously in its own day and enjoyed such widespread success. It appeared not only in France, the long-established seed-bed of new art-styles, but in most other European countries, including England, and was also successful in the United States and Latin America. This internationalism was clearly the result of a spontaneous stylistic impulse, rather than the product of determined propagandist organization, as was the case with Surrealism. The essential thesis was always undeclared – that there remained a place for a traditionalist art in the post-war world, but that this art should not be afraid to learn from Modernist experiment.

Because it has no tightly constructed aesthetic theory to support it, the precise boundaries of Art Deco painting remain difficult to define. Most of the artists discussed here were born in the 1880s, and the majority in the first half of the decade. They were therefore not beginners in 1918, when the Deco period is usually thought to begin, but reasonably mature artists. A good many were painters who had been uprooted by the war and had no particular national allegiance. Quite a number were women. Interestingly, there were many more female artists involved with Art Deco than among the acknowledged avant-garde of the interwar period

From the late eighteenth century onwards (the period of Vigée-Lebrun), women painters had started to play an increasingly visible role in European art. Yet, despite the activities of two leading members of the Impressionist Group, Berthe Morisot and Mary Cassatt, women were not on the cutting edge of stylistic development. Paula Modersohn-Becker (1876–1907), an important precursor of German Expressionism, is one of the few exceptions. What women artists have consistently been good at is the interpretation of an existing fashion and at helping it on its way to further development. This is almost the only quality that Vigée-Lebrun shares with Tamara de Lempicka. The main reason why women artists were instinctively cautious is because in the nineteenth and even in the earlier part of the twentieth century, it was still much more difficult for a woman to be accepted as a professional artist at all. A fashion-oriented art, like Art Deco, must have seemed an attractive option.

Art Deco has usually been presented as innocently apolitical, a plaything for the careless rich. However, this was not the case with most Art Deco painting. It was one of the styles in which the art of the interwar period found a political voice. Its

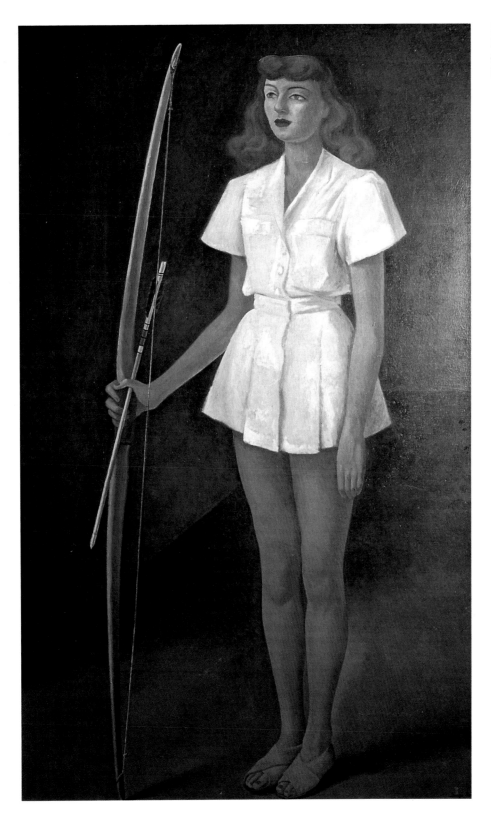

19 DIEGO
RIVERA. *Diana
Cazadora*. 1941.
Private Collection

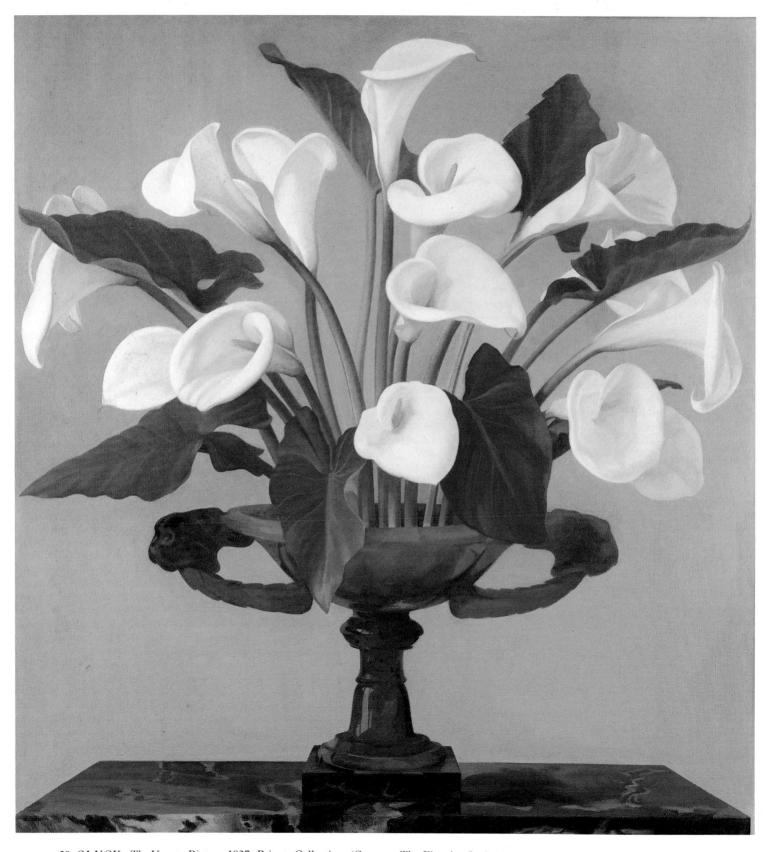

20 GLUCK. *The Vernon Picture*. 1937. Private Collection. (Courtesy The Fine Art Society)

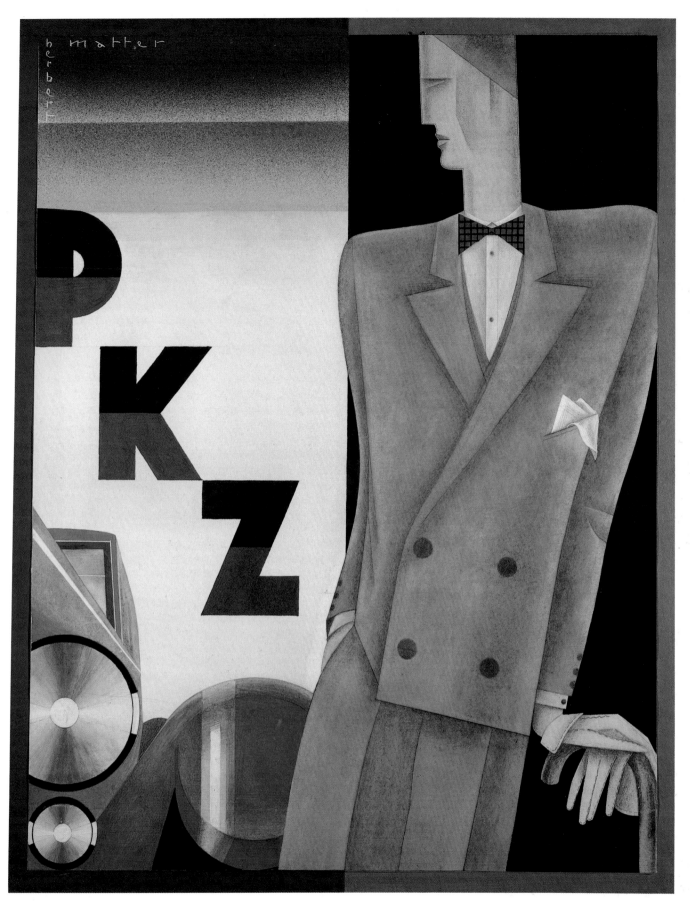

21 HERBERT MATTER. *PKZ. c.* 1925. Original poster design for a Swiss fashion house. Private Collection.
(Courtesy Barry Friedman)

rivals included the Neue Sachlichkeit manner of Otto Dix and George Grosz, the Novecento (in so far as this is distinguishable from Art Deco) and Soviet Socialist Realism. What is perhaps confusing is that in its public guise Art Deco painting became identified with both left and right. Rivera used his version of the style to preach the doctrines of the left. In Italy the Novecento Group identified itself with Mussolini. When at last the painters of this group were offered a great decorative enterprise – the decoration of the vast new Palazzo di Justicia in Milan, not put in hand until 1937 – the solutions they came up with were more obviously Art Deco than the general run of their work as easel-painters. The Nazi takeover in Germany in 1933, and the purge of so-called 'degenerate art' which followed, replaced the hated Expressionists and the equally detested artists of the Neue Sachlichkeit with not one, but several different varieties of National Socialist art. One of these, typified by the work of Adolf Ziegler, much favoured by Hitler, strove to return to the world of the nineteenth-century German Nazarenes but in fact came close to the conservative form of Art Deco Classicism as represented by French painters such as Robert Poughéon. There is also more than a hint of Art Deco Classicism in the kind of art favoured by

Stalin. Socialist Realism differs from its supposed exemplars in Russian nineteenth-century art – the work produced by Ilya Repin (1844–1930) and other members of the Itinerant Group – largely in being less naturalist and more reliant upon classical formulae, which are applied to real-life incidents.

This pliant adaptability to almost all purposes of communication, whatever the actual idea to be communicated, indicates that, in its period, Art Deco was a *lingua franca* shared by many people, used not only for purely decorative ends, but also, paradoxically, when the message took precedence over the actual style of its embodiment. These political involvements were one of the things which helped to give Art Deco painting a particularly bad name when the whole Deco style was in disrepute. What has tended to bring it back into focus, and therefore favour, especially among private collectors, is the now notorious eclecticism of the late twentieth century. While it is perhaps surprising that the gurus of Post-Modernism have not yet laid claim to Art Deco, many of the paintings illustrated here could ironically be called 'prematurely Post-Modernist', just as some renegades from Stalinism were once described as being 'prematurely anti-communist'.

CLASSICAL AND
=ALLEGORICAL THEMES= 2

Perhaps the most easily recognized and acknowledged Art Deco paintings are compositions on classical and allegorical themes. In France, the two artists most often cited in this connection are Jean Dupas (1882–1964) and Raphael Delorme (1885–1962). Together with one or two others working in the same manner, such as Robert Poughéon (1886–1955) and René Buthaud (1886–1986), they make up the so-called School of Bordeaux. During the 1920s and 1930s their work had a particular appeal to the patrons who also were enthusiasts for the more extreme manifestations of the style in the applied arts. Dupas, in particular, received highly prestigious commissions. His work was chosen by Jacques Émile Ruhlmann for the *Maison d'un collectionneur* at the 1925 Exposition des Arts Décoratifs, which displayed furniture by Ruhlmann himself and objects by all the leading Deco craftsmen. In 1935 he was commissioned to create an immense mural in *verre eglomisé* for the liner *Normandie*, which was intended to be a showcase for the best that France could produce in the decorative arts.

Nevertheless, the work of these artists has never been analysed in any detail and has been thought of simply as an adjunct to high-style Deco interiors. The style they practised, though apparently coherent, has roots in many different places. For example, Dupas and his colleagues can be thought of as the last descendants of early nineteenth-century neo-classicism, and especially of Jacques-Louis David. However, in addition to producing solemn history paintings, such as the *Oath of the Horatii* and the *Leonidas*, David painted a certain number of 'boudoir' compositions. The most notorious is the *Paris and Helen* of 1788, commissioned by Louis XVI's brother, the Comte d'Artois. David was to return to this manner in his final years, for example in his *Mars disarmed by Venus*, painted in 1824, when he was living in exile in Brussels. These two paintings have more in common than their erotic mythological subject-matter. Both are composed as if they were painted bas-reliefs. The principal figures rest on a piece of furniture, a couch, which helps to lock them together, and also serves as a base. The compositions are relief-like, with the figures silhouetted against a background whose spatial relationship to them remains uncertain. These characteristics reappear in the work of the Bordeaux School artists. They can be seen, for example, in Dupas's *The Parakeets* (Pl.1) and in Buthaud's *Women with Zebra* (Pl.23). Surprisingly enough, the female types chosen have little to do with the thin, flat-bosomed women now considered typical of the 1920s and 1930s. They are rather the weighty goddesses derived from

22 ROBERT POUGHÉON. *The Dioscurides*. 1939. Private Collection. (Courtesy Barry Friedman)

23 RENÉ
BUTHAUD. *Women
with Zebra* (detail).
c.1925. Private
Collection. (Courtesy
Barry Friedman)

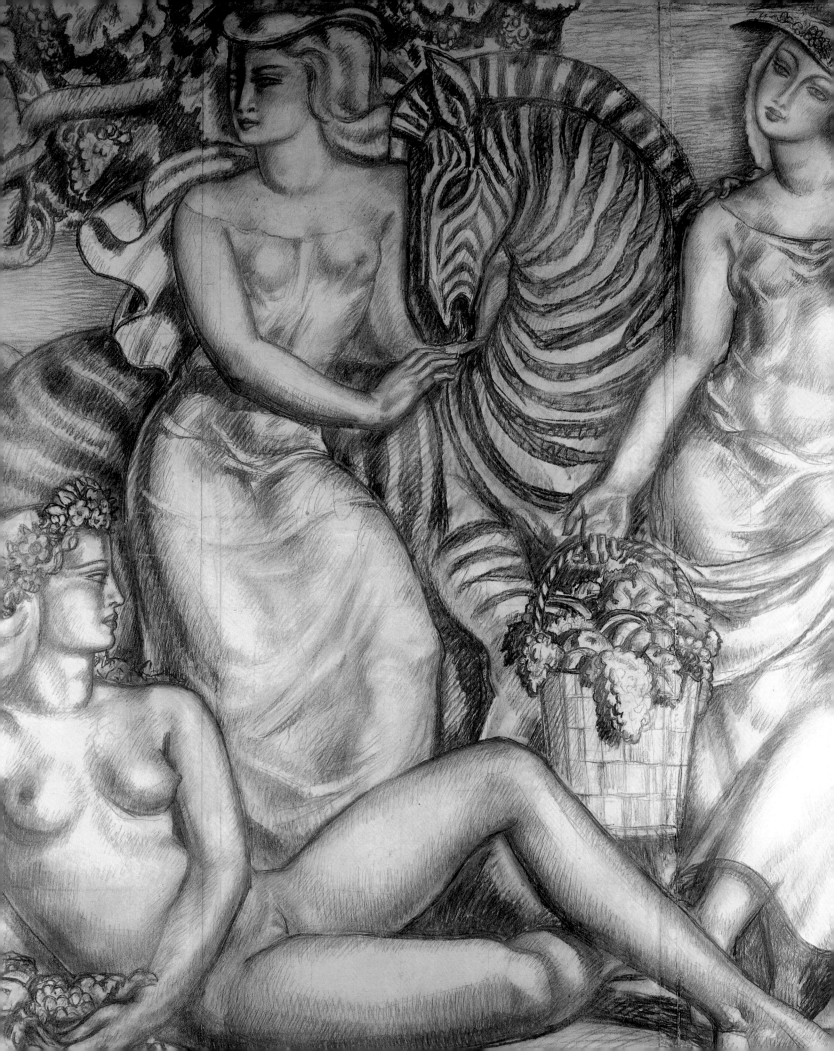

antique prototypes, who were favoured by David.

The Deco painters of this group also looked back beyond David to Poussin. Poughéon's *The Dioscurides* (Pl.22), for example, clearly takes some of its inspiration from the classicism of the French seventeenth century. Exhibited at the Société des Artistes Français (a notoriously conservative venue) in 1939, it also bears an uncanny resemblance to the kind of work being done now at the end of the 1980s by the Californian, David Ligare, and other artists associated with Post-Modernism.

Dupas's *The Judgement of Paris* (Pl.24), painted in 1923, gives a nod towards Poussin, in that it shows classical figures set in a landscape, but is considerably more idiosyncratic. Part of its inspiration comes from Russian art of the immediately pre-war period, and particularly from Russian artists with Symbolist connections, such as Victor Borissov-Musatov (1870–1905) and Kuzma Petrov-Vodkin (1878–1939). Borissov-Musatov was the inventor of a Beidermeier-inspired dream-world which made its impact on French taste through the ballet designs done by Alexandre Benois for Diaghilev. A specific example is *Papillons*, to music by Schumann, one of the quintessential Biedermeier composers. This is one of the earliest Diaghilev ballets, performed in St. Petersburg before the First World War, and only afterwards taken into the Ballets Russes repertoire. Tell-tale signs of this influence in *The Judgement of Paris* are the Biedermeier dresses worn by two of the goddesses (they have nothing to do with the street fashions of the early 1920s) and the conventions used for the architecture and the trees, which are very like those favoured by Borissov-

24 JEAN DUPAS. *The Judgement of Paris* (detail). 1923. Private Collection. (Courtesy Barry Friedman)

Musatov and by Benois after him. Ultimately they derive from the work of the classicizing French Symbolist, Pierre Puvis de Chavannes (1824–1898), and the likeness to Kuzma Petrov-Vodkin appears in the two nude figures, which have the slightly chilly mannerism of those painted about a decade earlier by the Russian artist.

Another, quite different, influence upon the Art Deco painting of the Bordeaux School is to be found in Italian Mannerism. The landscape just discussed finds forerunners in the mythological landscapes of Niccolo dell'Abbate (*c.* 1512–71), one of the Italian painters who worked for Francis I of France at Fontainebleau. In dell'Abbate's *Rape of Proserpine* in the Louvre small mythological figures are placed against a sweeping panorama. The most influential model, however, seems to have been Agnolo Bronzino (1503–72), court painter to Cosimo I de Medici. One painting which obviously made a particular impact on Dupas is Bronzino's *Venus, Cupid, Folly and Time* in the National Gallery, London.

In the 1920s a fashion for sixteenth-century Mannerism was less widespread than one for the eighteenth century. Once again, this was propagated by Diaghilev and his Ballets Russes. One landmark was the ballet *The Good Humoured Ladies*, to music by Domenico Scarlatti, which received its premier in April 1917; another was *Le Astuzie Femminili*, to music by Cimarosa arranged by Respighi, which was first presented in May 1920. It is clear that Dupas also responded to this. Some of his most charming minor works are a series of female heads wearing fantastic hats, based on eighteenth-century caricature prints of ridiculous hair-styles. The *Woman with Ship Hat* (Pl.25) of 1928 is particularly close

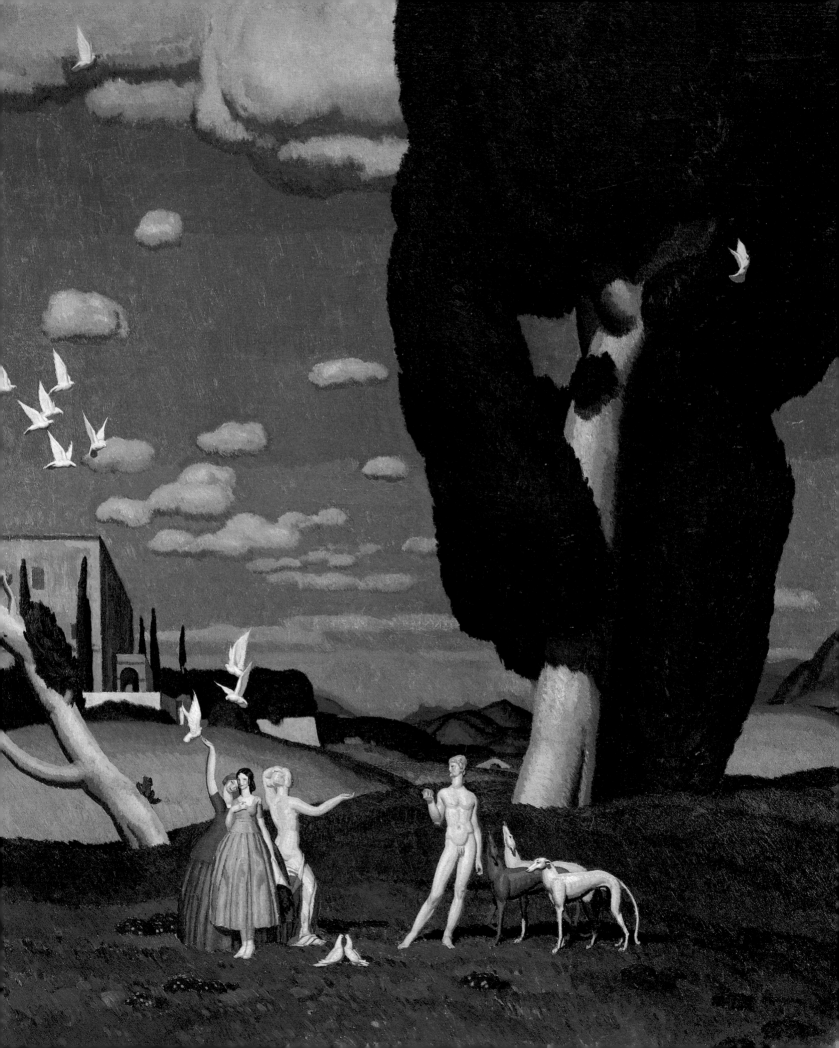

42

25 JEAN DUPAS.
Woman with Ship Hat.
1928. Private
Collection. (Courtesy
Barry Friedman)

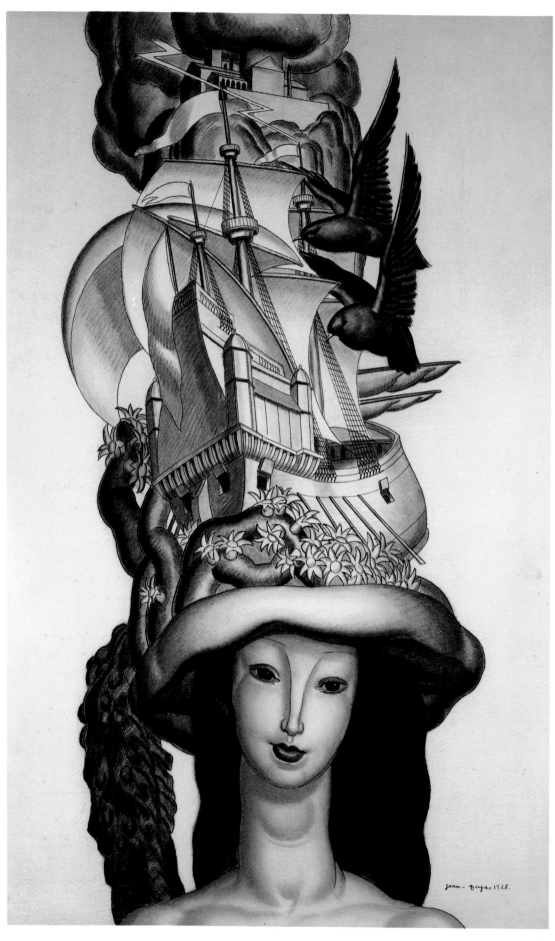

to an eighteenth-century original. Dupas was influenced by contemporary sculpture, in particular by the work of Antoine-Émile Bourdelle (1891–1929), one of the pioneers of the Art Deco style in general with his relief decorations for the Théâtre des Champs-Élysées in Paris, completed in 1912. A number of monochrome works by Dupas have the air of being either designs for, or imitations of, relief sculpture.

Dupas's chief rival, Raphael Delorme, began his career as a painter and designer of theatrical sets, and it is not surprising that the taste for theatricality strongly affected his easel-paintings. His work was also influenced by the neo-classical revival of the 1920s and he too found in the work of David a cue for exploring a rather frigid kind of eroticism. His painting *The Columns* (Pl.5) is a good example, as is the even more ambitious allegory of *Architecture* (Pl.26). Both of these, but especially the latter, also have something rather Surrealist about them. A parallel can be detected with the work of the Belgian Surrealist, Paul Delvaux (b. 1897). The resemblance to a certain kind of fashionable Surrealism is still closer in other works by Delorme, notably the *Baroque Fantasy* (Pl.27) illustrated here. The arcades in the background, and the two isolated Corinthian columns, are strongly reminiscent of Giorgio de Chirico in his early 'metaphysical' phase which was an inspiration not only to Delvaux, but to the whole Surrealist Movement. In the foreground is a kind of female triton, whose body terminates in a fantastic decorative scroll. Behind, and slightly to the left, is another female figure, in full eighteenth-century costume. The only reason why this fails to qualify as Surrealist is that it is too frivolous. Surrealism was an art movement which always took itself very seriously, even in the hands of Salvador Dali.

In addition to artists of French origin, Paris also attracted others who had been born elsewhere, and who came to the city either as political refugees or because they were attracted to it as a centre for the visual arts. One of these, Tamara de Lempicka (1898–1980), was a notable recruit to the Art Deco Group. Indeed, since the rediscovery of her work in the early 1970s, Lempicka, even more than either Dupas or Delorme, has come to be thought of as *the* Art Deco painter, almost to the exclusion of all rivals. She did not in fact begin to paint professionally until she arrived in France as a fugitive from the Russian Revolution. Her teachers were Maurice Denis and André Lhote (1885–1962). These were significant choices. Denis had been a founder-member of the Nabi Group, and taught at the Academie Ranson, which was still very much identified with Nabi doctrines, especially their emphasis on stylization. Lhote, influenced first by Gauguin, then by the Cubists, now produced work which often crossed the rather vague boundary which divided Synthetic Cubism from what was identifiably Deco.

To these influences Lempicka added a sense of chic which was all her own, plus an alluring whiff of decadence. She is more important as a portraitist than as a painter of classicizing compositions featuring nude figures, but she did nevertheless tackle these from time to time. There are several canvases which are inspired by the *Bain Turc* of Ingres – Lempicka goes out of her way to stress the homoerotic implications of the subject, which clearly corresponded with her own bisexual tastes. Around 1932

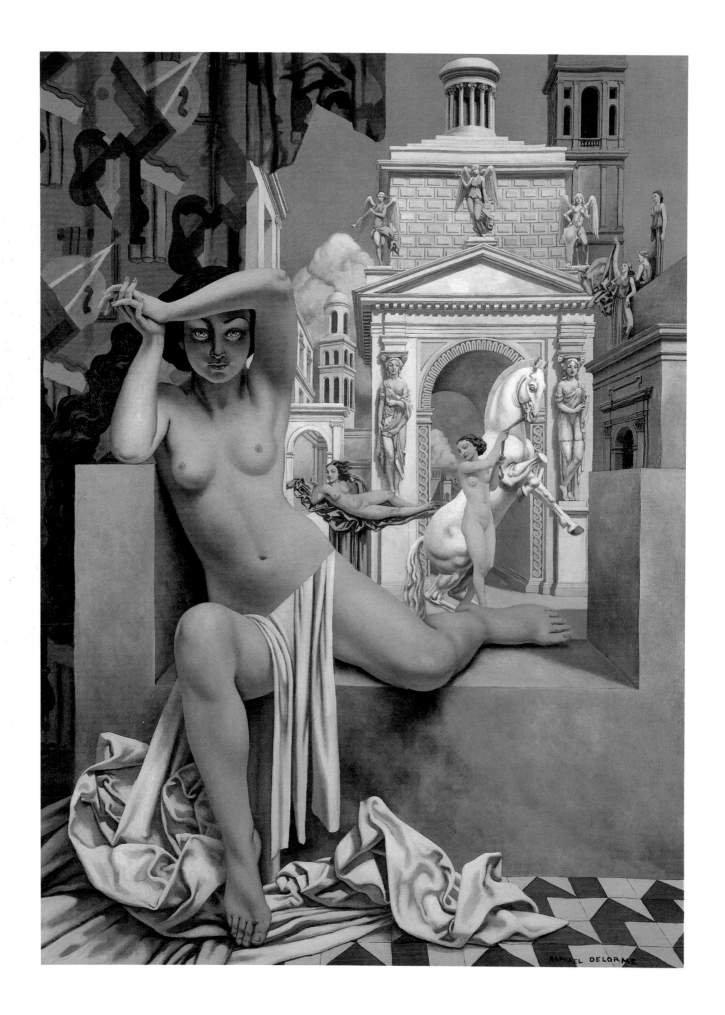

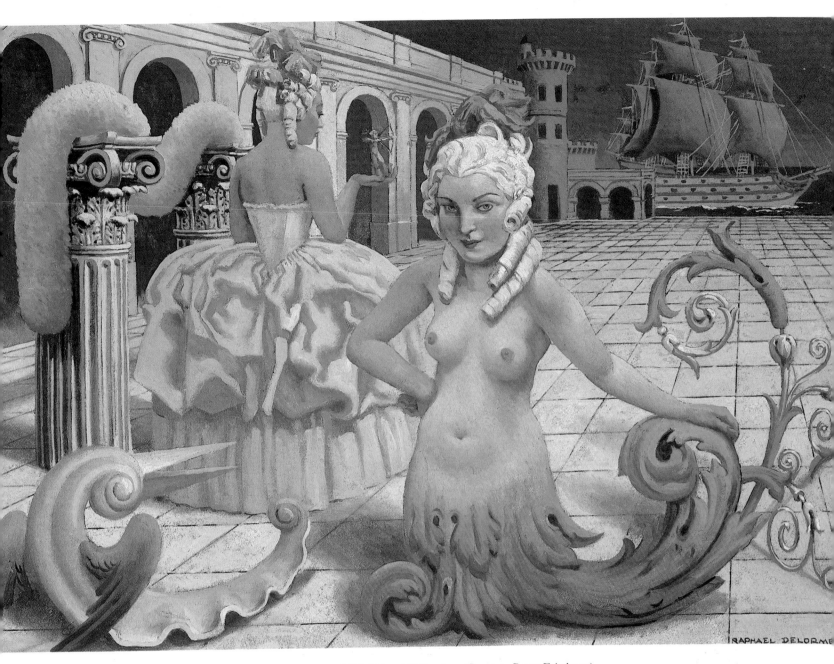

27 RAPHAEL DELORME. *Baroque Fantasy. c.* 1930. Private Collection. (Courtesy Barry Friedman)

26 RAPHAEL
DELORME.
Architecture. c. 1925.
Private Collection.
(Courtesy Barry
Friedman)

she painted a fine version of *Adam and Eve* (Pl.28), which is now in the Petit Palais, Geneva. According to the biography co-authored by the painter's daughter, the model for Adam was a handsome *gendarme*. Lempicka herself told the story as follows:

> When I finished the sketch, I went out into the streets. This was the artist's quarter. I had before me the vision of Adam and Eve. In the street nearby I saw a *gendarme*, a policeman on his beat. He was young, he was handsome. I said to him: 'Monsieur, I am an artist and I need a model for my painting. Would you pose for me?' And he said: 'Of course, Madame, I am myself an artist. At what time do you require me?' We made arrangements. He came to my studio after work and said: 'How shall I pose?' 'In the nude.' He took off his things and folded them neatly on a chair, placing his big revolver on the top. I set him on the podium and then called my model. 'You are Adam, and here is your Eve,' I said.

Because the Art Deco style is so closely associated with France, it is tempting to believe that Art Deco painting can only be found within France itself. However, a version of it developed in England, chiefly under the aegis of the Arts and Crafts Movement. The new style manifested itself in recognizable form some years before the appearance of Art Deco in Paris. An example is the work of Edward Reginald Frampton (1870–1923). Frampton's painting, illustrated here, shows a faun piping to three nymphs (Pl.29). It clearly owes much to the book illustrations made by Aubrey Beardsley and Charles Ricketts, both of whom had a powerful effect on 1920s Art Deco illustrators and makers of fashion drawings in France, their ideas combining easily with others borrowed from Leon Bakst and the world of the Ballets Russes. Frampton's picture also reveals the influence of his parallel activity as a designer for stained glass.

It is easy to understand how the Ballets Russes style favoured by Frampton modulated into the mannered classicism favoured by the English muralist Edward Woore. *Circe and Ulysses* (Pl.30) treats a theme from the Odyssey with a mannerism of pose and gesture that clearly owes something to the revolutionary choreographic style evolved by Nijinsky for his pre-war ballet *L'Après-Midi d'un Faune*. In both, the dancers strike angular poses and twist their bodies into a single plane. In Woore's composition the frieze-like effect is accentuated by the framing architecture. The major figures are placed in separate compartments – the division provided by a slender pillar which splits the whole picture neatly in two. The fact that the medium is tempera rather than oil – tempera being more laborious to use and imposing a more deliberate and craftsmanlike approach – emphasizes the lingering residue of Arts and Crafts attitudes to be found in the picture.

During the interwar period, the English painter whose work most closely resembles that of Dupas and Delorme is Ernest Procter (1886–1935). Procter's importance has not been recognized for several reasons, firstly his premature death, secondly because his career was somewhat overshadowed by that of his wife, Dod Procter (1892–1972), and thirdly because of his association with the Newlyn School. Newlyn, a Cornish fishing village, developed into an artists' colony in the 1880s, largely under the influence of the painter

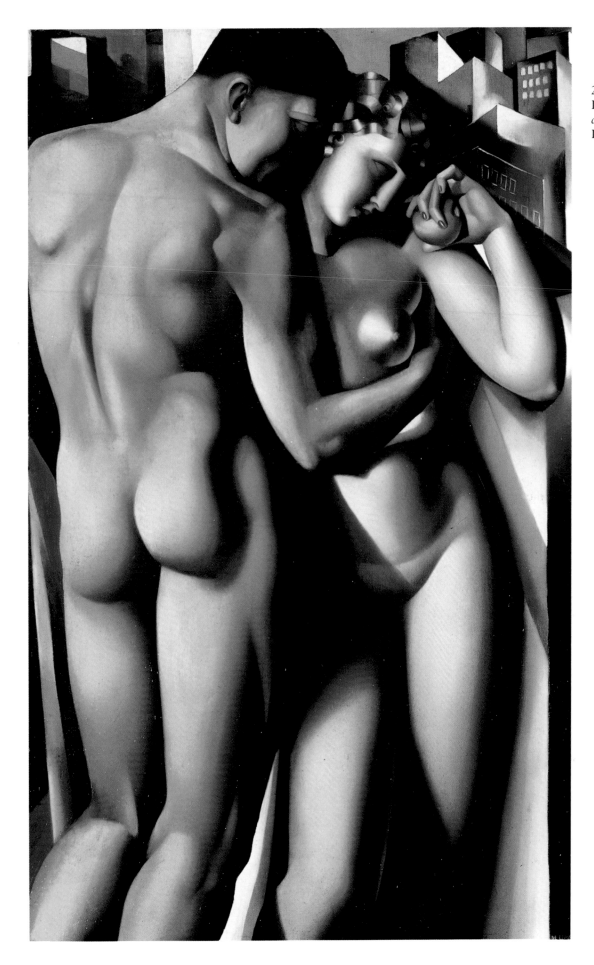

28 TAMARA DE
LEMPICKA. *Adam
and Eve. c.* 1932.
Private Collection

48

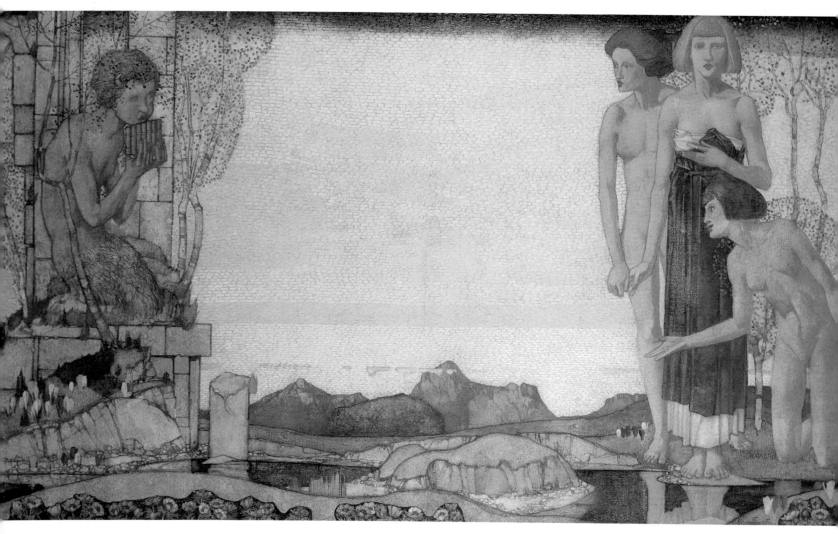

29 EDWARD REGINALD FRAMPTON. *The Voice of Pan. c.* 1922. Whitford and Hughes, London

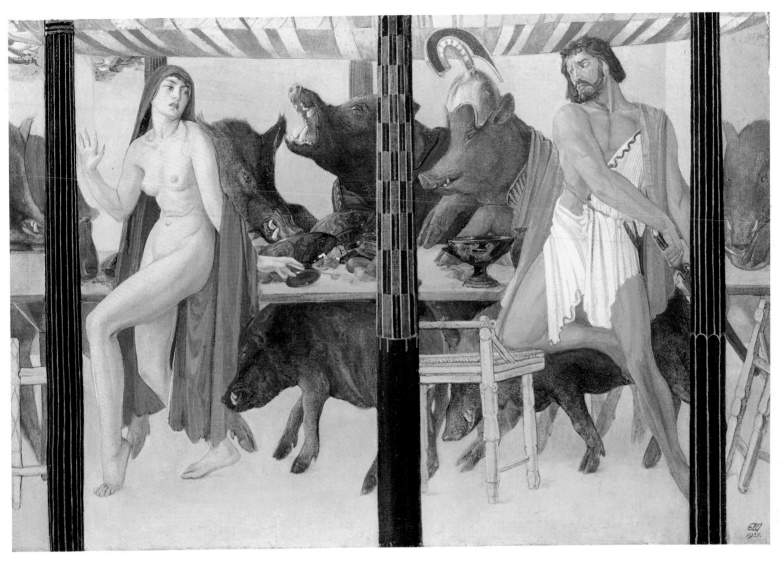

30 EDWARD WOORE. *Circe and Ulysses*. 1929. Private Collection. (Courtesy St Jude's)

31 ERNEST PROCTER. *Aphrodite*. 1936. Private Collection. (Courtesy The Fine Art Society)

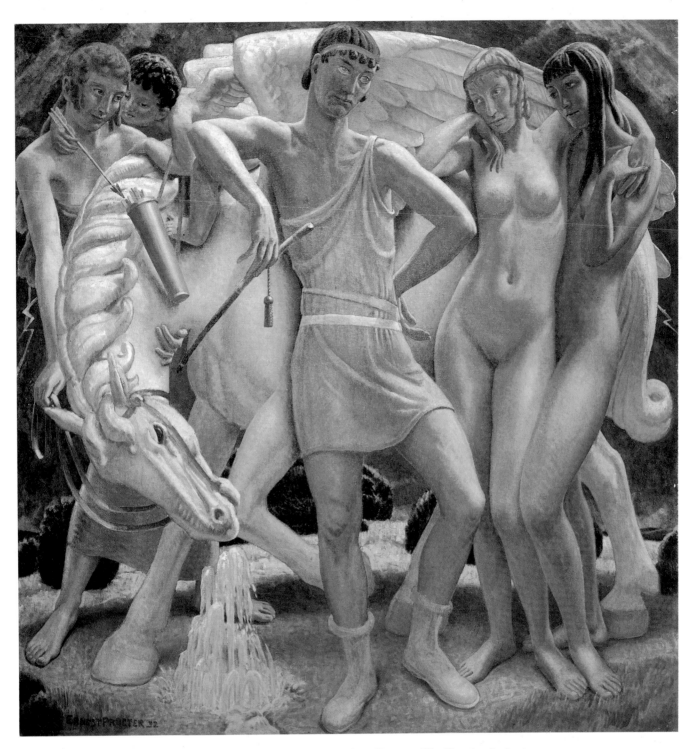

32 ERNEST PROCTER. *Those Who Dare*. 1932. Private Collection. (Courtesy The Fine Art Society)

33 DOD PROCTER. *Morning*. 1926. The Tate Gallery, London

Stanhope Forbes (1857–1947). The early Newlyn style is sometimes hopefully described as English Impressionism, but in fact owes more to the tempered, slightly sentimental realism of Bastien-Lepage. Ernest Procter, a relatively late recruit to Newlyn, must be regarded as a kind of sport.

It seems that his ambitious figure compositions, which date from the mid-1920s until his death, were painted under great pressure, in order to raise money to pay for an expensive life-style. They show no trace of this, and their grand, slightly marmoreal classicism comes as a surprise, given the general condition of the visual arts in England at that time. Of the examples illustrated here, the decorative panel *Aphrodite* (Pl.31), painted in 1930, comes particularly close to the work of Dupas and Delorme. *Those Who Dare* (Pl.32), an earlier work, is more brutal, and has affinities with Mario Sironi and the Italian Novecento Group. Unlike her husband, Dod Procter cannot be classified without qualification as an Art Deco painter, though her work did go through a somewhat Deco phase. During this period, she painted some single figures of young girls (Pl.33) which, in their pared-down simplicity and confident solidity of modelling, prompt a comparison with contemporary work by Derain. Later, after her husband's death, she reverted to a softer, more Impressionist technique. Her interest in Negro models, however, continued to form a tenuous link with the ethos of Art Deco.

The British artist most usually identified with Art Deco is Glyn Philpot (1884–1937). Philpot spent much of his early career as a highly successful society portraitist. He does, however, seem to have had some leanings towards decorative painting, as is proved by the Gauguinesque composition *Dawn* (Pl.34), which dates from 1921. His real break with his previous style did not take place until the beginning of the 1930s. His adoption of a new manner did not become apparent to the public until the Royal Academy Summer Exhibition of 1932, and it was not well received. *Oedipus and the Sphinx* (Pl.35), a reworking of a mural painted for his most important patron, Lady Melchett, is a strange mixture of different and opposing things. The basic idea is borrowed from Ingres's version of the same subject: the confrontation between Oedipus and the Sphinx. The Sphinx offers a hint that Philpot had been looking at Assyrian art – the Assyrian palace reliefs were a frequent source of inspiration for Deco designers, especially in the later phases of the style. The composition is tied together by the use of abstract lines and shapes, borrowed from Constructivism. The total result is somehow unconvincing.

Since Philpot has recently been so much touted as Britain's chief practitioner of Art Deco, it comes as a surprise to discover that Deco compositions which were just as ambitious and arguably far more successful were made by artists who are seldom or never mentioned in connection with the style. A case in point is William Russell Flint (1880–1969), now chiefly remembered as a water-colourist of dazzling technical accomplishment, who specialized in stereotyped compositions showing bare-breasted young women of vaguely Spanish type. His large decorative composition of *The Kite-Flyers* (Pl.37), painted in the early 1920s, is an attractive picture, strongly

34 GLYN PHILPOT. *Dawn*. 1921. Private Collection. (Courtesy The Fine Art Society)

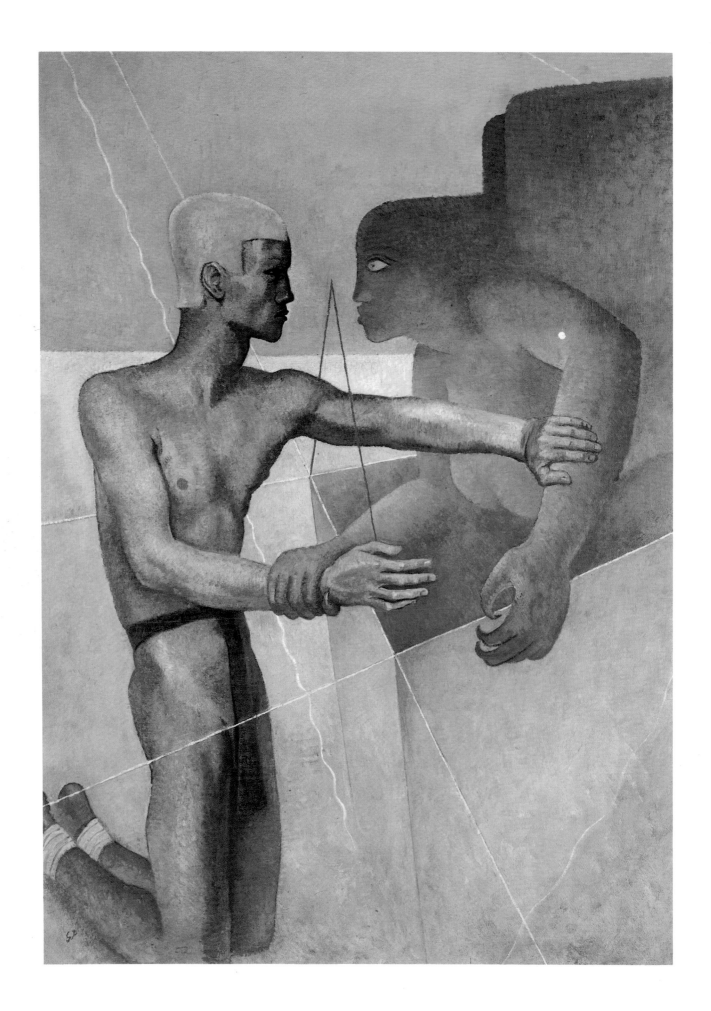

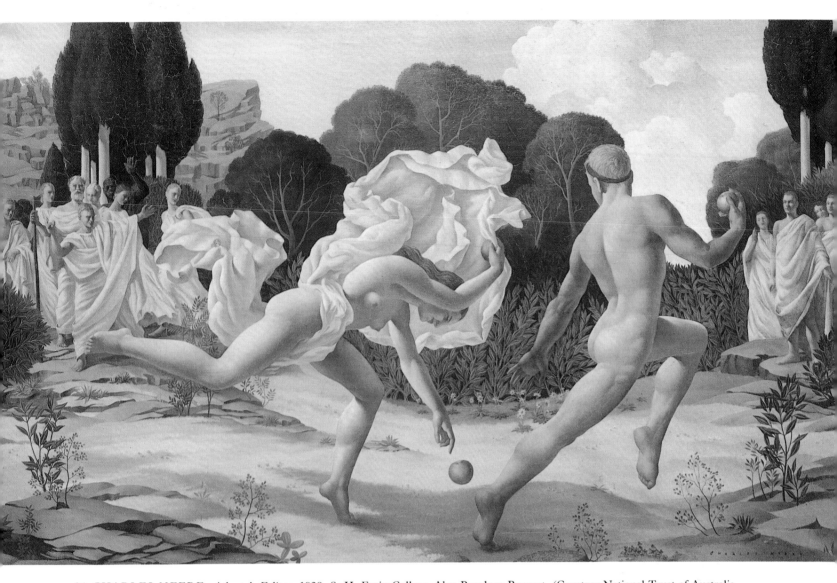

36 CHARLES MEERE. *Atlanta's Eclipse.* 1938. S. H. Ervin Gallery, Alan Renshaw Bequest. (Courtesy National Trust of Australia, New South Wales)

35 GLYN PHILPOT. *Oedipus and the Sphinx.* 1932. National Gallery of Australia, Melbourne (Felton Bequest).

influenced by the Orientalism of the Ballets Russes but still basically classical in its approach.

One Deco classicist who was certainly on a level with Ernest Procter was Charles Meere (1890–1961). Meere was born in England, and trained at the Royal College of Art in London. In 1927 he visited Australia and settled there three years later. He set up a commercial art studio in Sydney, but also tried to make a career as a muralist. *Atalanta's Eclipse* (Pl.36), a full-scale design for a mural, never taken any further for lack of patronage, was painted in 1938. It is surely one of the most elegant and accomplished of all the high-style classical compositions produced by Deco artists, very close in spirit to Poughéon's *The Dioscurides* (Pl.22). Meere eventually made his mark on Australian painting, but not with this picture. His *Australian Beach Pattern* (Pl.72), of 1940, has become one of the popular icons of Australian art.

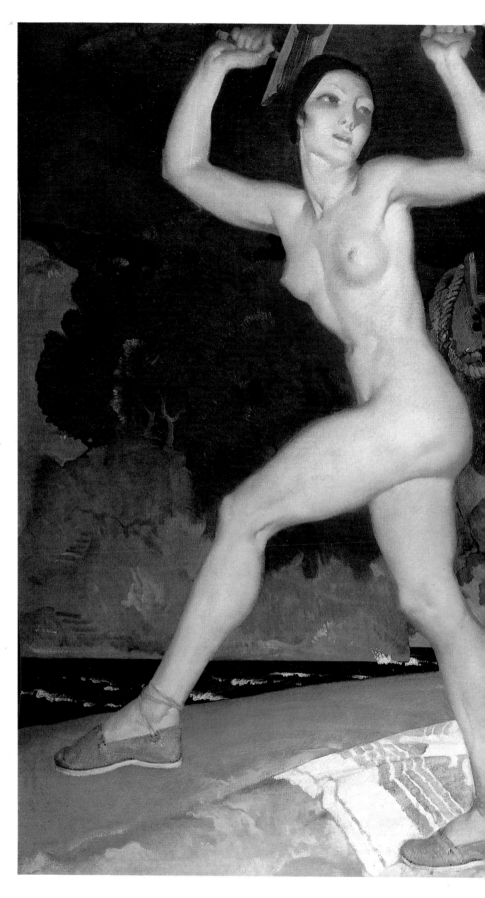

37 WILLIAM RUSSELL FLINT. *The Kite-Flyers.* *c.*1925. Private Collection. (Courtesy Whitford and Hughes)

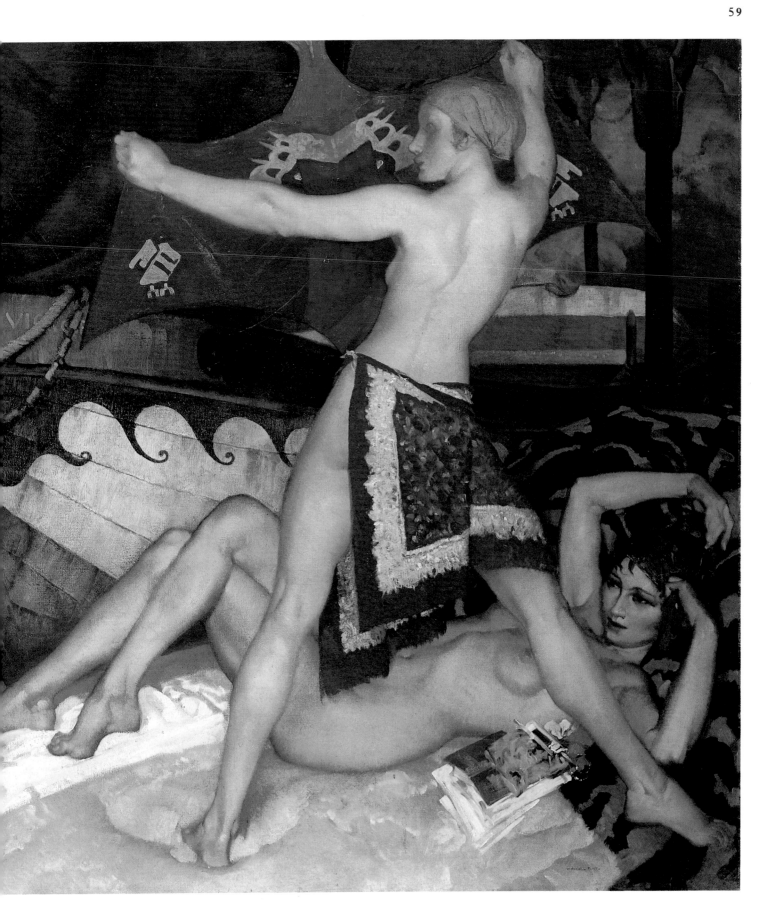

60

38 TAMARA DE
LEMPICKA.
*Unfinished Portrait of
Tadeusz de Lempicki.*
1928. Musée
National d'Art
Moderne, Paris

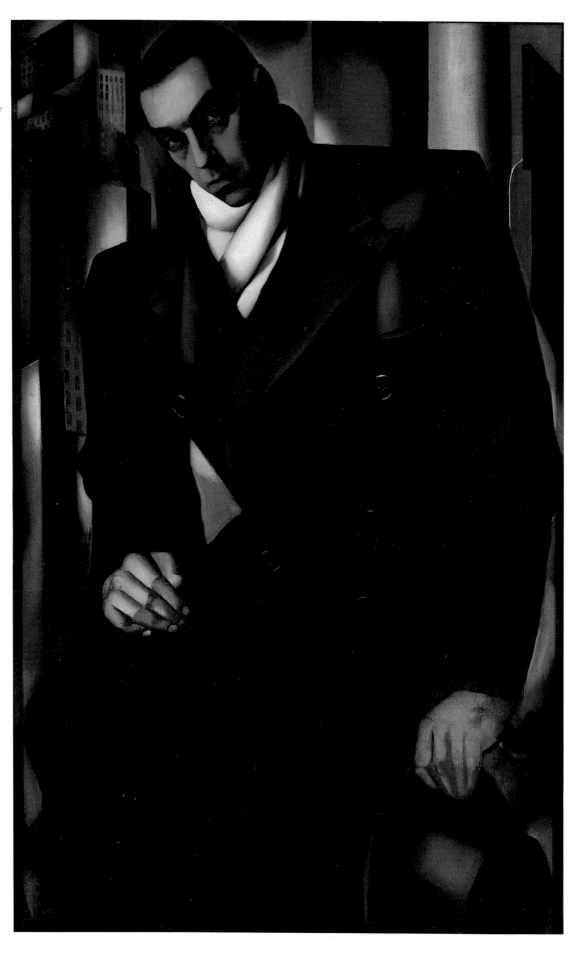

=PORTRAITURE IN FRANCE= 3

It can be argued that the Art Deco spirit expressed itself more naturally through portraiture than through any other kind of painting, the reason being that portraiture is a kind of art in which the painter is forced to interact with his social surroundings. By its very nature, it is something which cannot be produced in isolation.

The quintessential Art Deco portraitist is undoubtedly Tamara de Lempicka. The formulae she used have imposed themselves on the popular imagination to such an extent that fashionable society of the 1920s and 1930s is now perceived very largely through her eyes. Yet she only painted a small segment of it: she shows us a minority of a minority, reflecting only one facet of cosmopolitan high life.

To understand Lempicka one must first of all understand that she was *déracinée*, a refugee. Her first sitters were people much like herself, and with some she had close personal connections. She painted several portraits of her husband Tadeusz de Lempicki (Pl.38), charting the course of a failing marriage. Some of her sitters, female as well as male, were people with whom she had erotic relationships – her frequent model, Ira Ponte (Pl.39), and the Marchese Sommi Picenardi, with whom she had an affair in Italy, for example. Others were refugees like herself, such as the Russian Grand Duke Gabriel, of whom she did a particularly striking likeness, or members of a 'smart set', richer in patents of nobility than in money. She used their faces and personalities as the basis for a powerful fantasy in which deliberate aloofness mingled with hints of far-from-innocent sensuality. Her sitters' collaboration in the projection of this fantasy is eloquent about the condition of the post-war world. These early portraits brought her enough celebrity to attract a different class of sitter. These were the cosmopolitan possessors of new money, men such as Doctor Boucard (Pl.40), who had made a fortune from the patent medicine Lacteol, or the American millionaire Rufus Bush. For these people, a portrait by Lempicka was a kind of certificate of fashionability. The vogue for her work was powerful, but did not last long. It began to decline in the early 1930s, soon after the Crash, and was more or less at an end by 1939, when Lempicka left for the United States with her new husband, Baron Raoul Kuffner.

From a stylistic point of view, Lempicka's portraits are a carefully calculated amalgam. It is clear that she looked at the painting of her own time, and also that of the Old Masters, with a coolly acquisitive eye. Through one of her teachers, André Lhote, she was well grounded in the decorative aspects of Cubism, and her early portraits, in particular, make insistent use

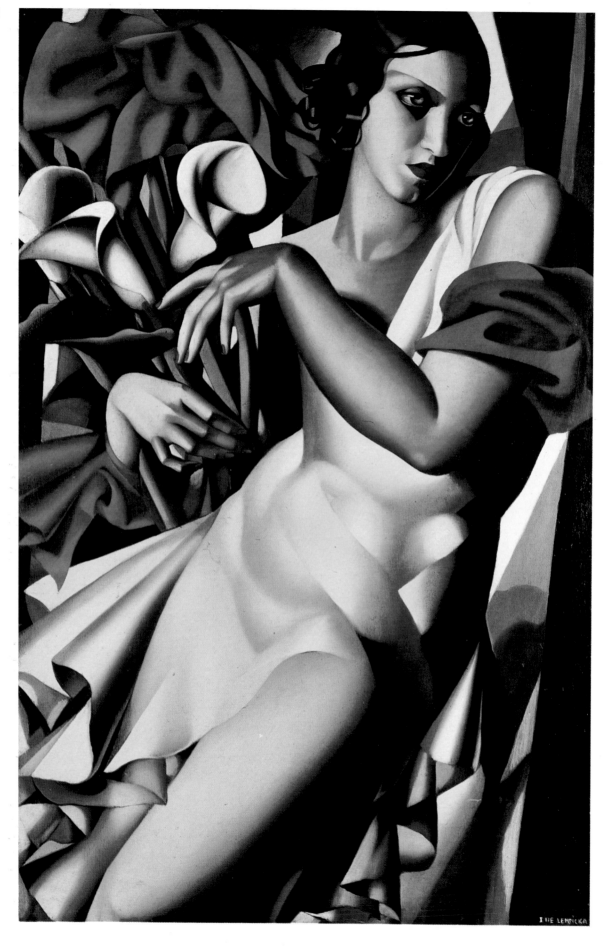





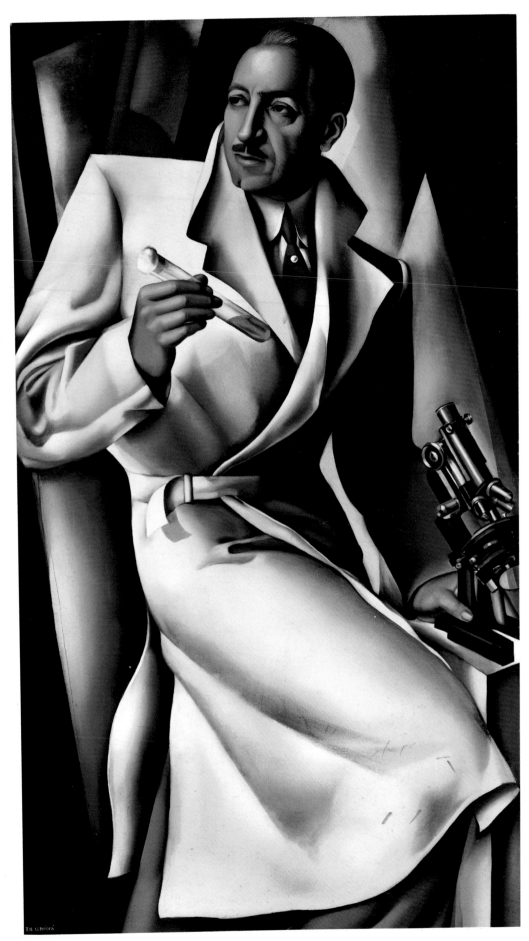

39 TAMARA DE LEMPICKA. *Portrait of Ira P.* n.d. Private Collection

40 TAMARA DE LEMPICKA. *Portrait of Dr. Boucard.* 1929. Private Collection

of Cubist faceting. She paid frequent visits to Italy during the 1920s and showed her work successfully in one of the most fashionable galleries in Milan, the Bottega di Poesia, run by Count Emmanuele Castelbarco, son-in-law of the conductor Toscanini. She studied the Florentine masters in the Uffizi, Botticelli and Pontormo in particular. It is also clear that she took a careful look at what her contemporaries in Italy were doing, though this was something that she was less anxious to publicize than her study of the Old Masters. In her early days in Paris she had got to know Marinetti, the founder of the pre-war Futurist Movement, who was still active in the world of the visual arts. Her portraits often have backgrounds composed of tottering 'modernistic' buildings which show a Futurist inspiration. Additionally, her Italian visits must have brought her into contact with the work being done by the artists of the Novecento Group, and also with that of certain independents such as Felice Casorati (1883–1963) and Cagnaccio di San Pietro (1897–1946).

Other Art Deco portraitists include Bernard Boutet de Monvel who is perhaps even better known for his urban views than for his portraits. Boutet de Monvel's likeness of the celebrated American decorator, Elsie de Wolfe (Pl.41), painted after she married the British diplomat Sir Charles Mendl and took up residence in a house at Versailles, shows the interwar society portrait in a fairly conservative guise. What links the picture to the ethos of Art Deco is not only its refined craftsmanship and a faint feeling of preciocity, but the extremely adroit use of silhouette. Here, too, as in Lempicka's paintings which are otherwise so very different, the influence

of Italian Renaissance painting can be felt.

One suspects that Lempicka's clients were usually not committed collectors of pictures and acquired her paintings simply because they responded to them. The same is probably true of those who came to Boutet de Monvel for portraits. It is interesting, by contrast, to look at the portraits commissioned by clients who were not only wealthy, but who had a sophisticated knowledge of Modernism. There are good examples in the Walter-Guillaume Collection, now housed in the Orangerie in Paris. Paul Guillaume, who formed the collection, was a critic, a publisher and a highly successful dealer in modern art, and was instrumental in creating the superb Barnes Collection in Merion, Pennsylvania. After his death in 1934 his wife Suzanne married the industrialist Jean Walter. The collection contains two portraits of Suzanne done during the period of her first marriage: one by André Derain (Pl.42), the other by Marie Laurencin (Pl.43). Derain's connection with the Deco ethos is fully confirmed here, in a likeness painted around 1928–9. The artist is at pains to stress not only the good looks but the fashionable elegance of his sitter – one small emblem of which is her Art Deco diamond watch.

Laurencin began her career as an associate of the Cubists, chiefly through her liaison with their propagandist, the poet Guillaume Apollinaire. It has often been noted, however, that her work shows few Cubist characteristics. Laurencin was the creator of a delicate dream-world, even more stylized, in its own way, than the one created by Tamara de Lempicka. It is typified by childlike figures of women rendered in delicate pastel shades, and has strong

41 BERNARD BOUTET DE MONVEL. *Portrait of Elsie de Wolfe. c.* 1930. Private Collection. (Courtesy Barry Friedman)

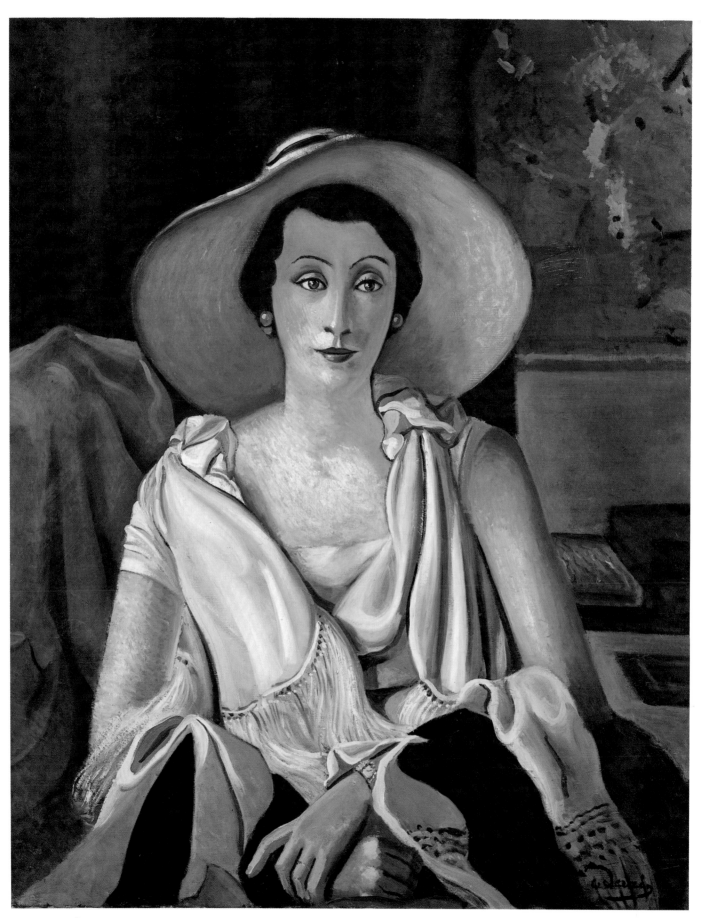

42 ANDRÉ DERAIN. *Portrait of Madame Paul Guillaume in a Large Hat. c.* 1928–9. Musée de l'Orangerie, Paris. Collection Jean Walter and Paul Guillaume.

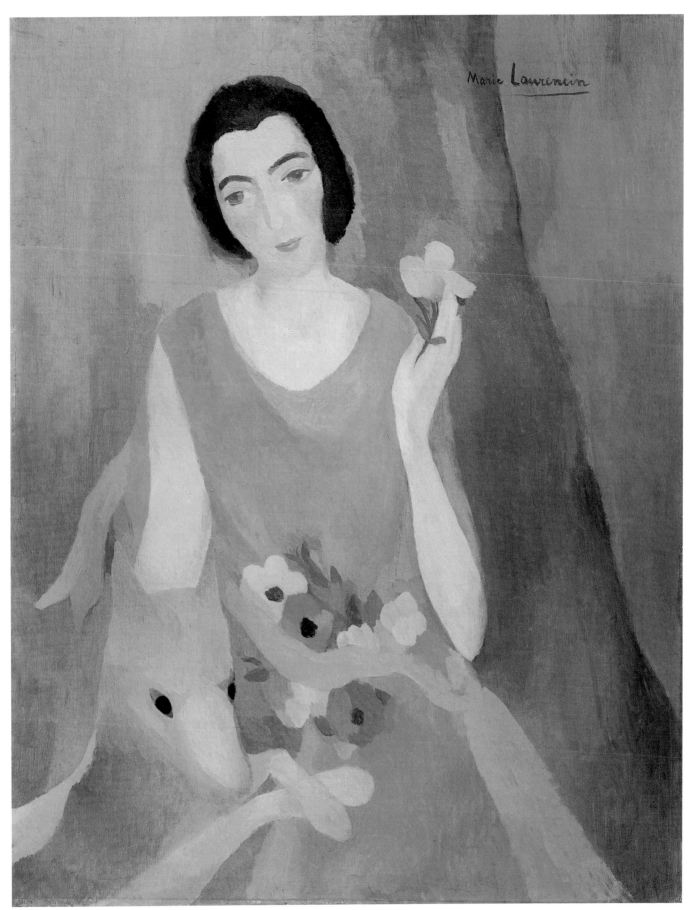

43 MARIE LAURENCIN. *Portrait of Madame Paul Guillaume*. 1924 or 1928. Musée de l'Orangerie, Paris. Collection Jean Walter and Paul Guillaume.

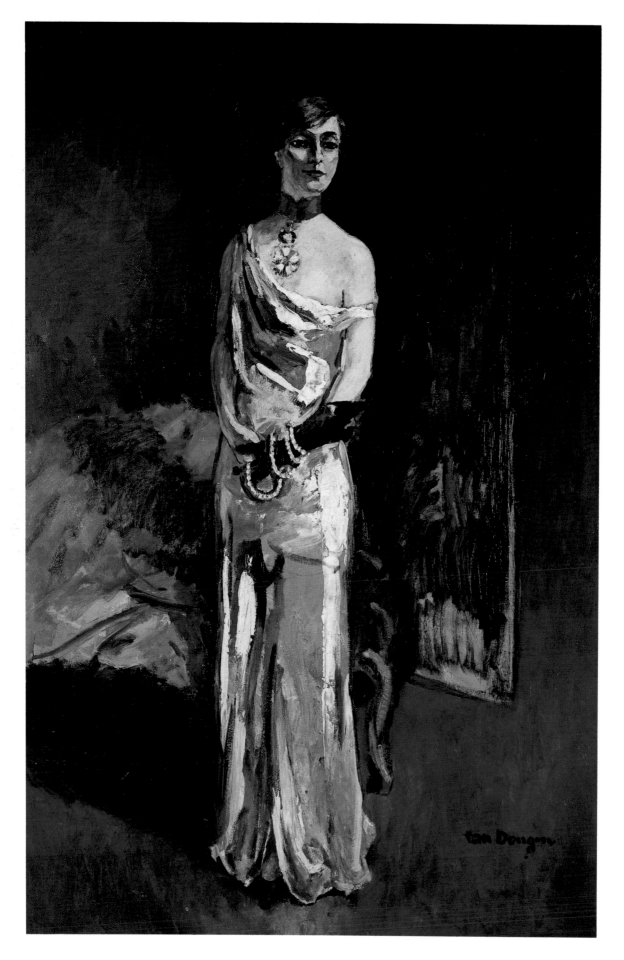

44 KEES VAN DONGEN. *Countess of Noailles*. n.d. Stedelijk Museum, Amsterdam

links of sympathy with the more 'feminine' aspect of Art Deco. The alluring, but apparently pre-pubescent, female was, after all, one of the most important icons of the 1920s, personified by the film-star Mary Pickford. Like Lempicka, Laurencin was adept at suggesting hidden perversity, which was no doubt the reason why Diaghilev chose her to design the ballet *Les Biches* in 1924. In her portrait of Suzanne, Laurencin makes the sitter conform to this already well-established formula.

Paul Guillaume had himself been portrayed by the ex-Fauve, Kees van Dongen (1877–1968), though the result is rather disappointing. However, it was during the 1920s that Van Dongen, by this time very successful, became involved with the *beau monde* and began to portray sitters like the poet Anna de Noailles (Pl.44), in her own way as important a taste-maker as the dressmaker Coco Chanel. Van Dongen's tempered version of the Expressionism with which he had begun also seems congruous with the Art Deco spirit and he occasionally tackled themes which were characteristically Deco, such as the *garçonne* or androgynous boy-woman (Pl.45). So too does much of the work which Balthus produced in the early part of his career. Balthus (1908–81) is usually presented by critics as a completely isolated phenomenon, or else is vaguely linked to 1930s Neo-Romanticism. Though he is largely self-taught, one of the artists who gave him advice at the beginning of his career was Maurice Denis. Later, in the early 1930s, he came under the influence of Derain, who had already turned towards classicism. In between, he spent time in Italy, studying Piero della Francesca as well as Masolino and Masaccio. His artistic

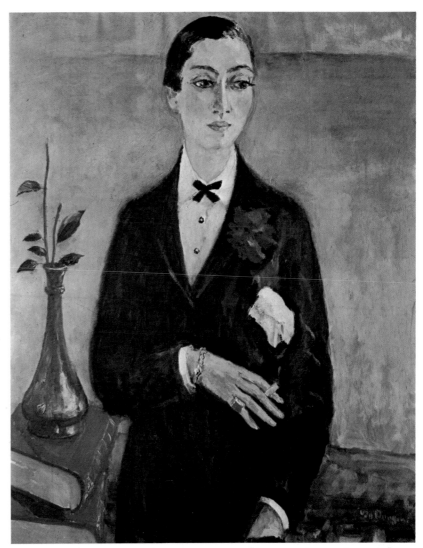

45 KEES VAN DONGEN. *La Fumeuse. c.* 1923. Private Collection

pedigree is thus not wholly unlike that of Tamara de Lempicka. It is in fact in his early portraits that Balthus comes closest to the Art Deco spirit. Cases in point are *The Window* (Pl.46), a portrait of the fifteen-year-old Elsa Henriquez, painted in 1933; and the portrait of *Madame Pierre Loeb* (Pl.47), wife of a well-known dealer, painted the following year. In this there is a deliberate clash between the fashionable dress worn by the sitter and her rather miserable surroundings. Mischievous discords of this type seem to have been a staple ingredient of the more ambitious kinds of Art Deco portraiture in France.

70

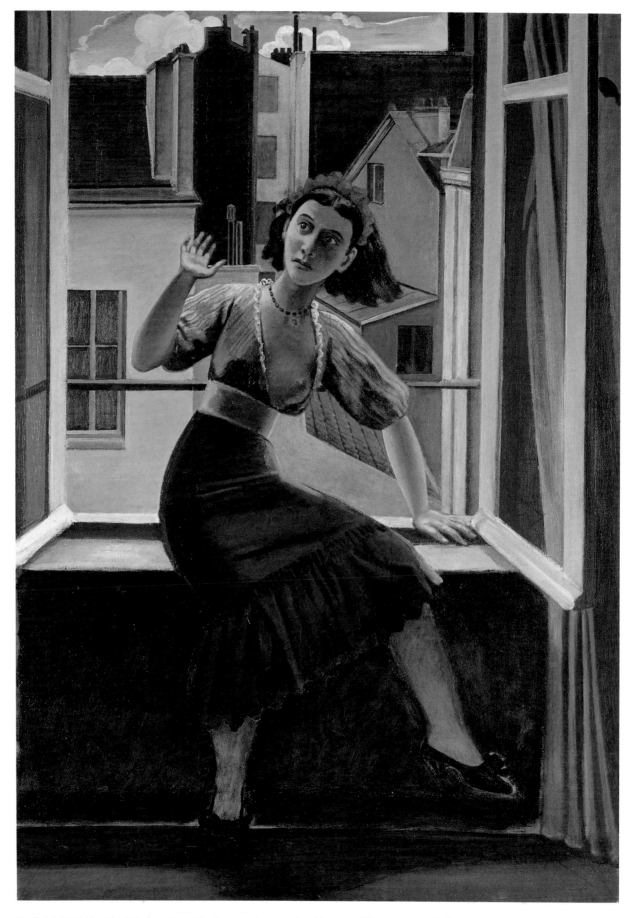

46 BALTHUS. *The Window*. 1933. Indiana University Art Museum. Bloomington, Indiana

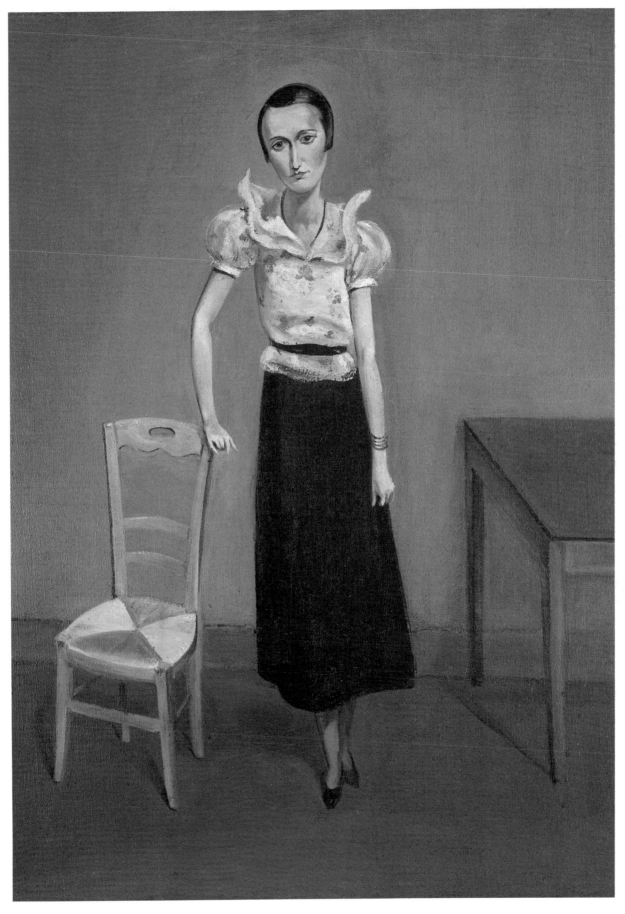

47 BALTHUS. *Portrait of Madame Pierre Loeb*. 1934. Collection Albert Loeb, Paris.

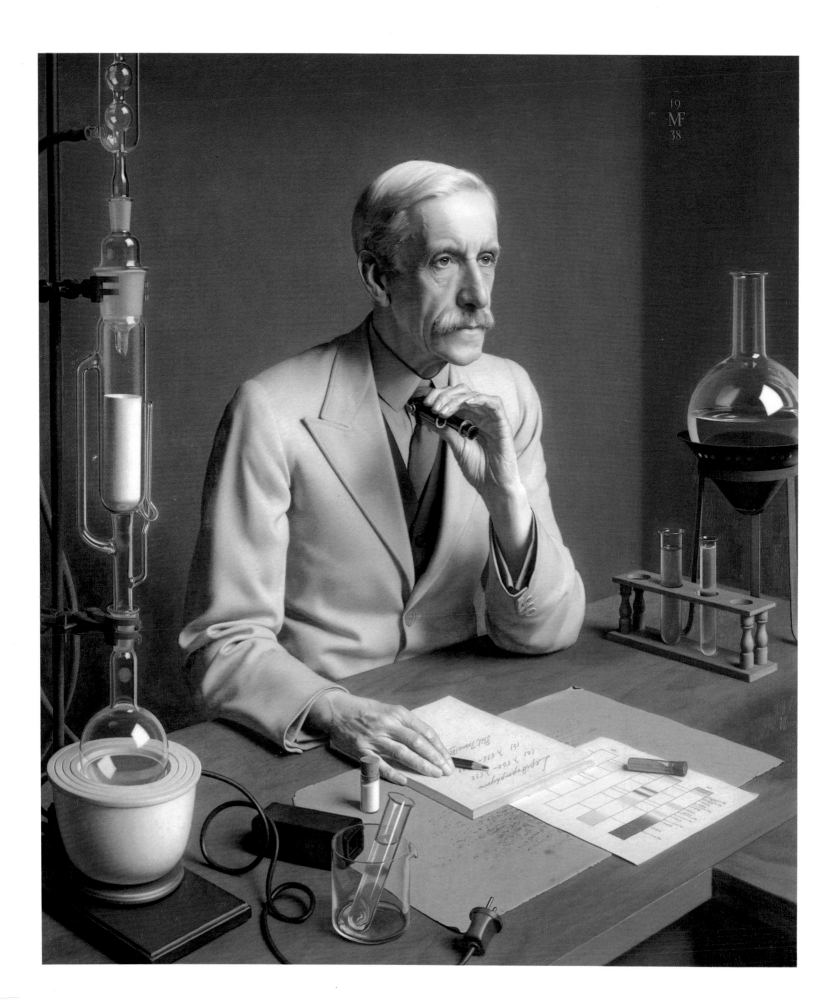

PORTRAITURE
OUTSIDE FRANCE

The Art Deco portrait flourished vigorously in other countries besides France, though perhaps never with so much chic. Portraits of this type appeared early on the other side of the Channel, although they were consistently more timid in style. For instance, William Strang (1859–1921), who was associated with the New English Art Club, produced a series of portraits in distinctly Deco style during the last eight years of his career. *The Japanese Fan* (Pl.49), painted in 1914, gives some idea of their flavour. A probable influence is Alphonse Legros (1837–1914), a French painter and print-maker who settled in England in 1863, and who was appointed Professor at the Slade School in succession to Sir Edward Poynter in 1876. Legros was on friendly terms with the Impressionist painters Pissarro and Monet, who came to London as refugees from the Franco–Prussian War of 1870, but his own style had a hard clarity which had little to do with Impressionism. Another, more general influence on a whole group of English painters, Strang among them, was the Arts and Crafts Movement. It led a number of portraitists to reject the Impressionist-derived pyrotechnics of John Singer Sargent and his imitators.

The outstanding British 'craftsman painter' of the interwar period was undoubtedly Meredith Frampton (1894–1982). He was the son of the sculptor Sir George Frampton (1860–1924), whose best-known work is the statue of Peter Pan in Kensington Gardens, London. Edward Reginald Frampton was not a relation. Meredith Frampton's career began immediately after the First World War, and its most characteristic images were produced during the 1930s. The majority are likenesses of distinguished professional men: a particularly stunning example is the portrait of the biochemist, *Sir Frederick Gowland Hopkins* (Pl.48), painted in 1938, which belongs to the Royal Society, of which the sitter was President from 1930–5. But Meredith Frampton also made occasional excursions into the fashionable world. The most beautiful society portrait painted in England during the decade is surely his *Portrait of a Young Woman* (Pl.2) of 1935. Nothing in the painting is accidental – the sitter's dress was selected by the artist from an issue of *Vogue*, and then made by her mother; the vase to the left was designed by Frampton, and then made in mahogany to his specifications. The whole thing has the exquisite, glacial perfection which is rightly associated with one aspect of Art Deco.

Because of the demanding nature of his technique, Frampton was an extremely slow worker, and his output was correspondingly small. It was left to others to establish themselves in the public eye as

48 MEREDITH FRAMPTON. *Sir Frederick Gowland Hopkins*. 1938. The Royal Society, London

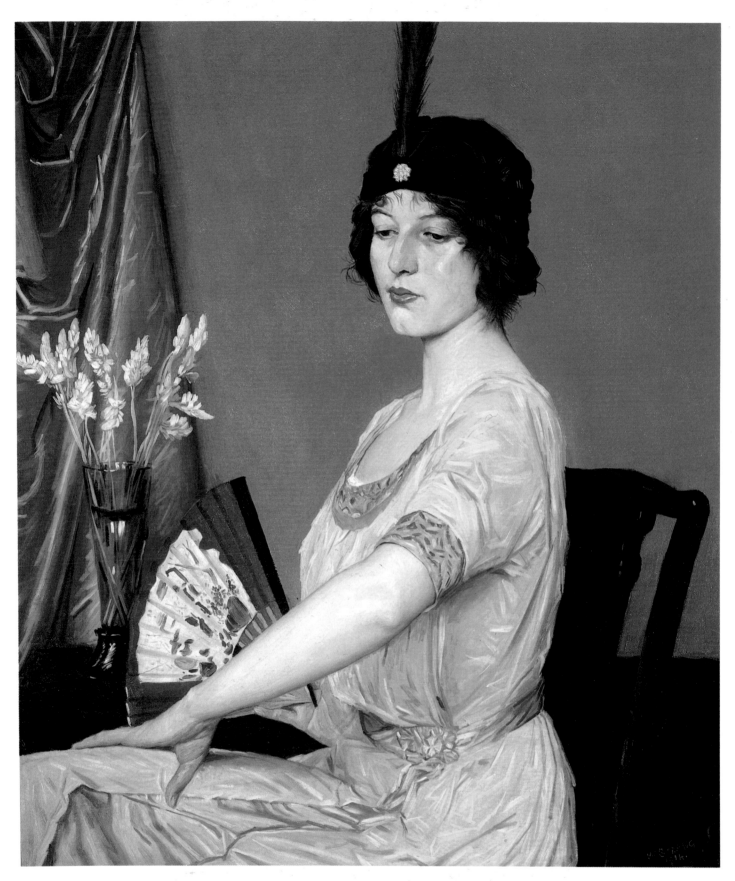

49 WILLIAM STRANG. *The Japanese Fan*. 1914. Private Collection. (Courtesy The Fine Art Society)

50 SIR GERALD
KELLY. *Lady Kelly*.
1924–6. Kelly
Collection, London
(Courtesy Bridgeman
Art Library)

76

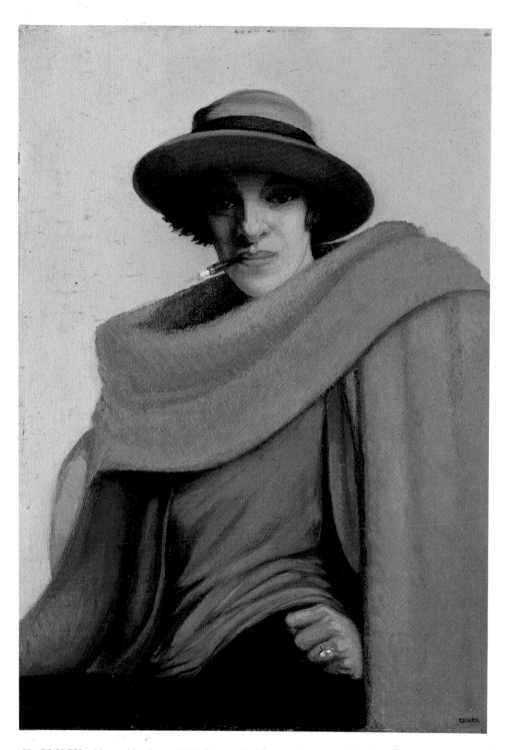

51 GLUCK. *Nancy Morris. c.* 1932. Private Collection. (Courtesy The Fine Art Society)

52 GLUCK.
Medallion. 1936.
Private Collection.
(Courtesy The Fine
Art Society)

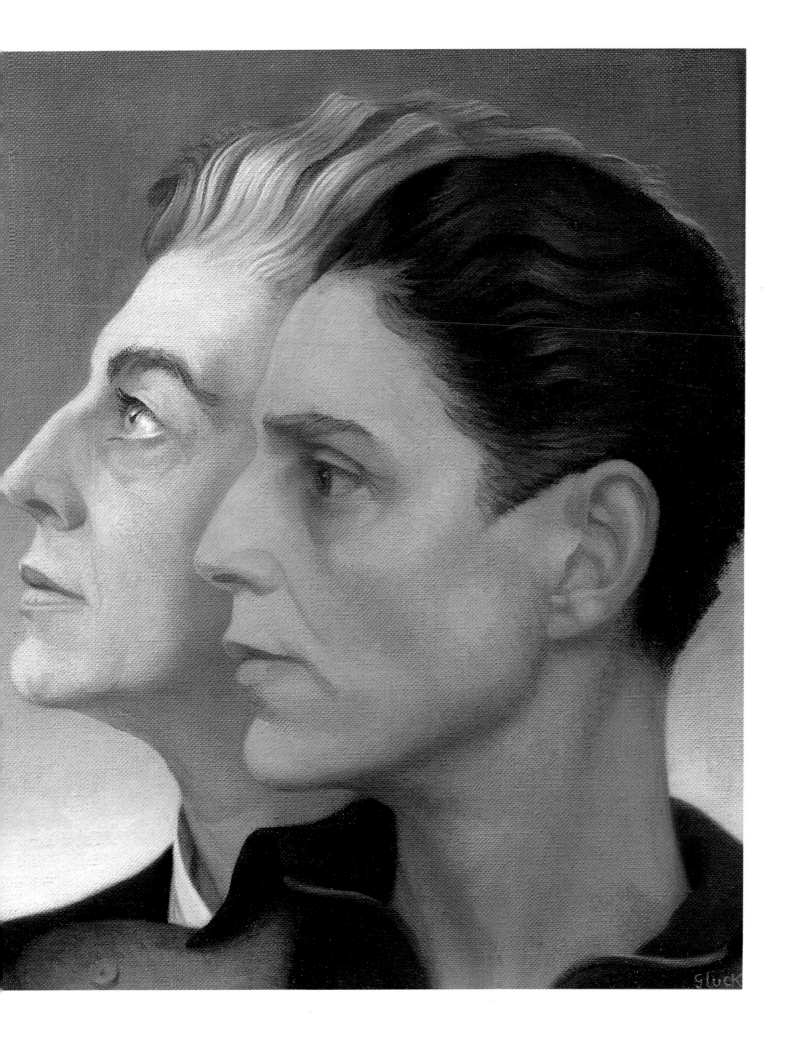

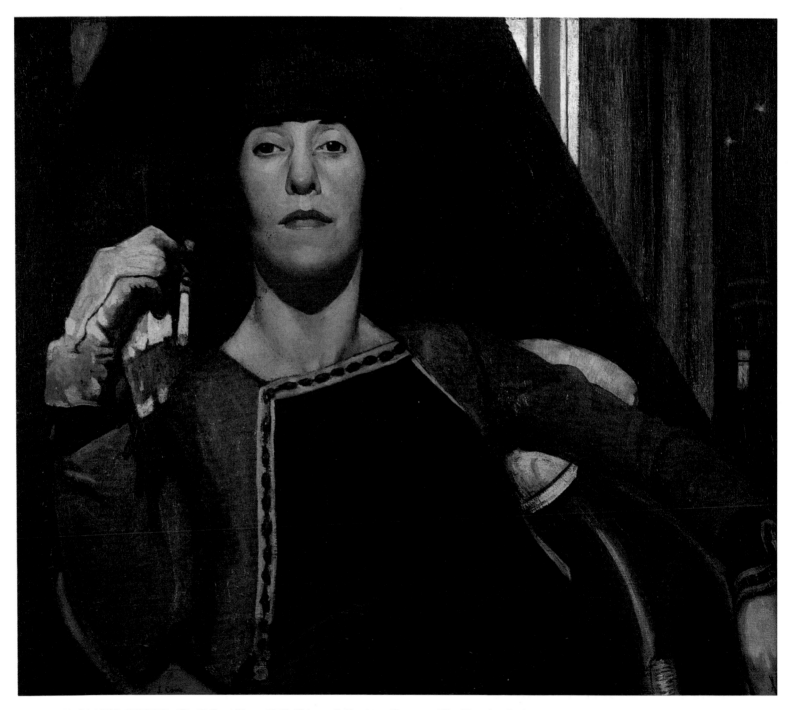

53 JAMES GOWIE. *The Yellow Glove*. 1928. Private Collection. (Courtesy The Fine Art Society)

fashionable portraitists. One academic portraitist who was certainly touched from time to time by the Art Deco spirit was Sir Gerald Kelly (1879–1972) who eventually became President of the Royal Academy in 1949. His full-length portrait of his wife Jane (Pl.50), painted in 1924–6, has a certain degree of Art Deco stringency, without being fully committed to the idiom.

The best-remembered Art Deco painter to have appeared in Britain is the woman painter Gluck (1895–1978). In a number of respects she can be regarded as an English equivalent of Tamara de Lempicka: she was an outsider in the art world of her time, she had a sense of chic, and a feeling for stylization, and another point in common was a taste for relationships with members of her own sex, though Gluck differed from Lempicka in being exclusively homosexual. There were important differences, too. Gluck came from a wealthy and privileged background, being the only daughter of Joseph Gluckstein, one of the founders of J. Lyons & Co., which operated popular tea-rooms all over London. Her struggle was not one to make a living, but first to gain the consent of her family in her pursuit of a career as an artist, and then to win acceptance as a serious and dedicated painter. Gluck's early artistic contacts included Dod and Ernest Procter, and one can perhaps see a minimal influence from both in her early paintings, but she soon developed an extremely individual style. Her portraits are always adroit renderings of character. *Nancy Morris* – undated, but probably painted in the early 1930s – is an epigrammatic representation of one of the salient types of the time, the androgynous *garçonne*, with a flamboyant scarf, and a

cigarillo stuck in the corner of her mouth (Pl.51). *Miss Susan Ertz* (Pl.7), painted in 1937, is a convincing likeness of a sophisticated society woman, given life by the introverted, yet wryly humorous expression. It shows Gluck's skill in finding an authoritative silhouette. One of her most memorable paintings is the double portrait she entitled *Medallion* (Pl.52). This shows Gluck herself (in the foreground, with dark hair) and her lover Nesta. It is interesting for several reasons. Compositionally, it offers a striking example of the use of the profile pose often adopted by Art Deco portraitists in imitation of the Italian Renaissance. Socially, it is a deliberate defiance of convention, not only because it proclaims an irregular alliance, but because it is so ambiguous about the actual gender of the sitters.

Though Meredith Frampton and Gluck are the two most important British Art Deco portraitists of the interwar period, they are by no means alone. There is, for example, a distinctly Deco look to some of the portrait work done by the Scottish artist James Gowie (1886–1956). *The Yellow Glove* (Pl.53), painted in 1928, is a striking example. Another, very different, artist who was touched by the Deco spirit when painting portraits was William Roberts (1895–1980). *The Red Turban* (Pl.55), painted in 1921, very soon after the collapse of the Vorticist Movement which first brought Roberts to prominence, is already imbued with it. The more ambitious *Double Portrait of Maynard Keynes and Lydia Lopokova* (Pl.54), painted in 1932, is also easily classifiable as Deco. Both the choice of painter and the choice of style are significant. Keynes, the great economist, was also a leading member of the Bloomsbury circle

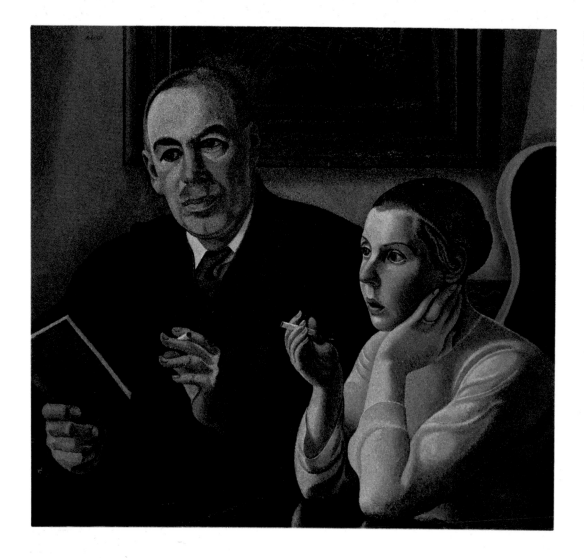

54 WILLIAM
ROBERTS. *Maynard
Keynes and Lydia
Lopokova.* 1932.
National Portrait
Gallery

55 WILLIAM
ROBERTS. *Red
Turban.* 1921.
Sheffield City Art
Galleries

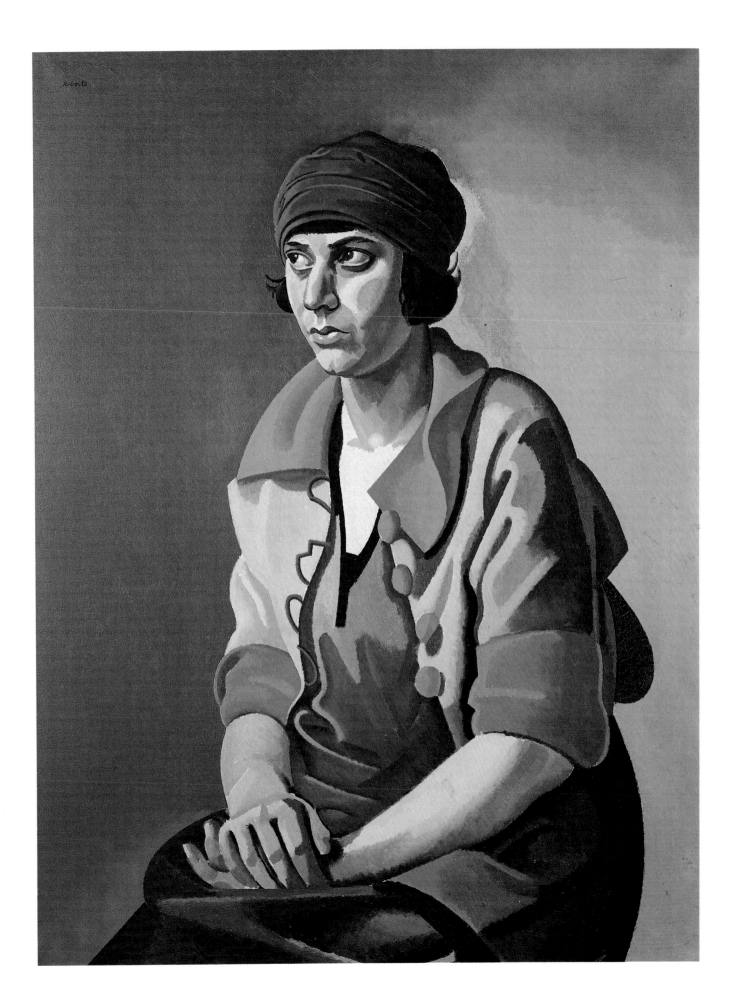

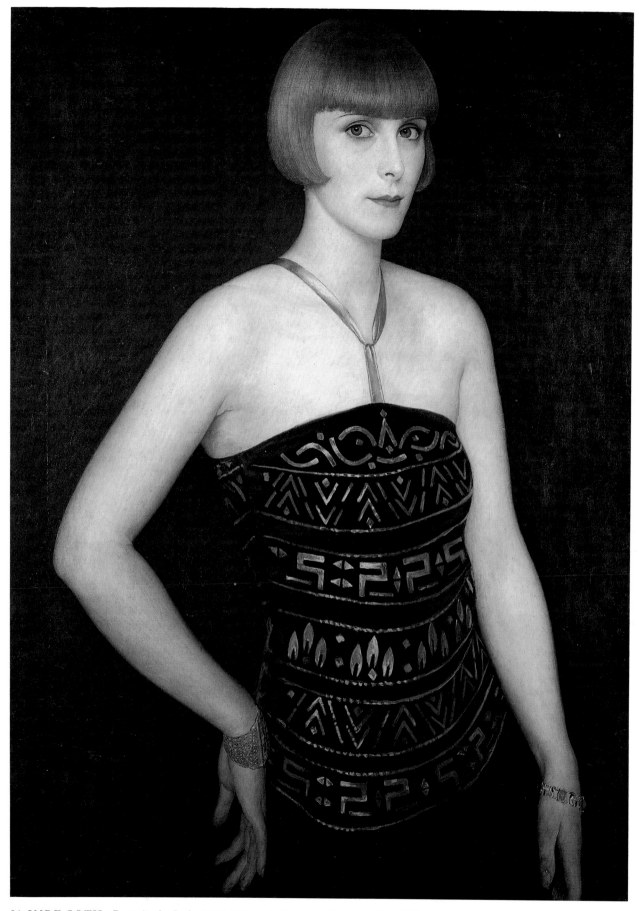

56 IMRE GOTH. *Portrait of a Lady*. 1929. Private Collection. (Courtesy Barry Friedman)

and a noted collector of paintings and promoter of art.

He had already been responsible for founding the Contemporary Art Society, an organization which existed to buy Modernist paintings on behalf of museums (largely the Tate Gallery and major provincial galleries in England) which otherwise had no hope of obtaining them, either for lack of funds or because of the opposition of certain trustees. His wife, Lydia Lopokova, had been a leading ballerina with the Ballets Russes. Roberts's painting shows what was considered appropriate for a commission of this kind.

English portraiture retained a national coherence. The demand for fashionable portraits was, however, an international one, and the purveyors of society portraits were frequently rootless artists, not to be identified with any national school. One case in point, among very many, was the Hungarian-born Imre Goth, who studied in Budapest, then in Berlin, and who was already well established as an artist before he moved to England in 1935. There he exhibited successfully at the Royal Academy Summer Exhibitions, and also at private galleries. Later still, he went to California, where he painted various Hollywood stars. The portrait shown (Pl.56) is from an early phase of his career – it is signed and dated 1929. It conveys a marvellous image of high fashion as it was then understood in Central Europe. The only really secure clue to the geographical origins of the picture is not the sitter's clothes – she might, after all, have chosen these in Paris – but the slightly Holbeinesque technique. Art Deco here glances nostalgically back, towards the portraiture of the German Renaissance.

Similar influences manifested themselves in the work of the Neue Sachlichkeit and Magic Realist artists of Weimar Germany. It is an open question whether or not work by artists such as Christian Schad (b. 1894) and Anton Raderscheidt (1892–1970) can properly be classified as Art Deco. Another example of an artist whose work lies on the borderline between Magic Realism and Art Deco is Frans Willems, whose *In the Spotlight* (Pl.58) is illustrated here.

Certain Italian painters of the same period also lie on the borderline. As well as Casorati and Cagnaccio di San Pietro there was the less well-known Vinicio Paladini (1902–71). Paladini went from Futurism, which he embraced with some enthusiasm in 1921 but abandoned in 1923, after political disagreements with the right-wing Marinetti, to a smartened-up version of Russian Socialist Realism, as evinced by his ambitious *Group Portrait with Artist* of 1930 (Pl.57), which shows Paladini with two elegant female friends. During the decade 1925–35 he made a number of trips to Russia, and was well aware of what was taking place in the visual arts there. His own work shows that he was unable to rid himself of the yearning for classicism, which affected many Italian artists at this time. He solved this dilemma in 1935, after a final trip to Russia, by choosing to emigrate to the United States, where he committed himself to architecture, which had been the subject he chose to study at Rome University.

In Russia in the 1920s there were native portraitists who also show some trace of the Deco spirit. One was Boris Grigoriev (1886–1939), who began as a young associate of the pre-Revolutionary World of Art Group in St. Petersburg, founded by

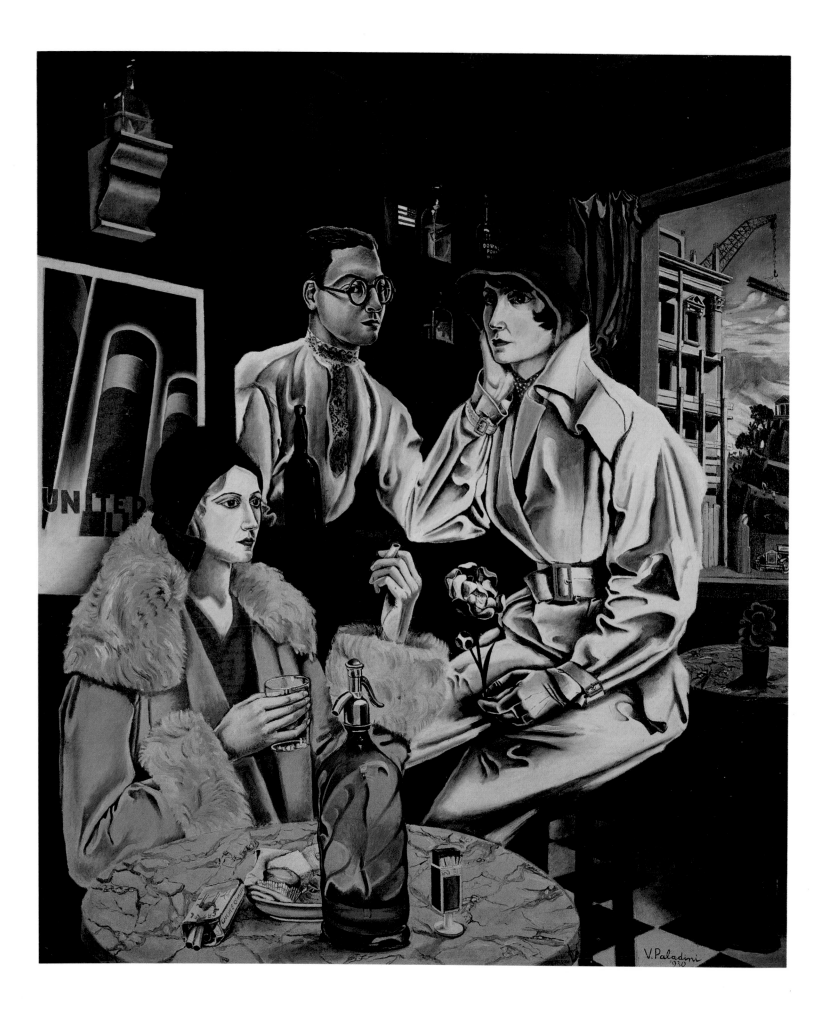

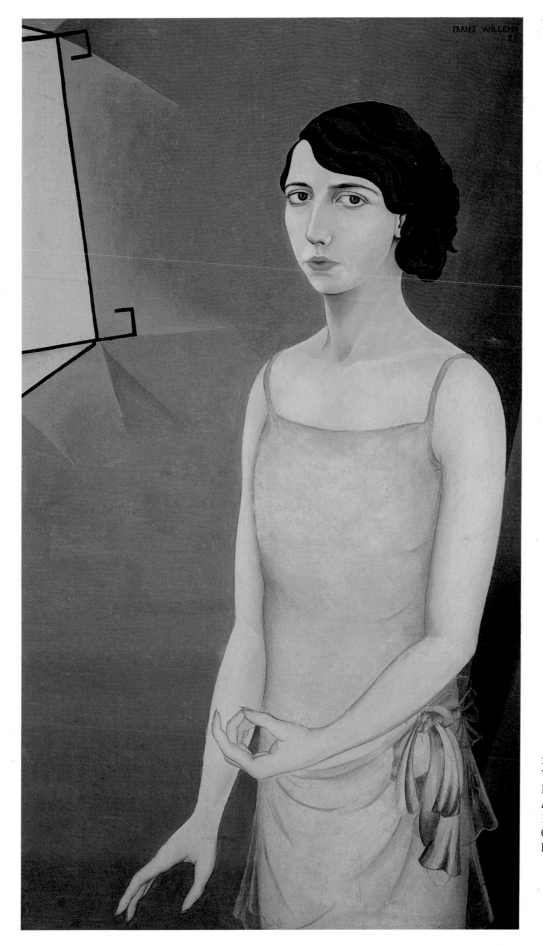

58 FRANS
WILLEMS. *In the
Spotlight*. 1928. Private
Collection. (Courtesy
Barry Friedman)

57 *Far Left:*
VINICIO
PALADINI. *Group
Portrait with Artist*.
1930. Private
Collection. (Courtesy
Barry Friedman)

86

Benois in 1899 and later associated not only with Benois but with Diaghilev, who for a while edited the *World of Art* journal. Grigoriev first visited Paris in 1915, but did not finally break his ties with Russia and settle in France until 1929. The portrait illustrated here was painted after the Revolution, but while he was still based in Russia. *Self-Portrait* (Pl.59) has Cubist overtones in the treatment of the background and of the clothing and it shows affinities to Lempicka; it also has affinities, because of its stress on realism, with what the artists of the Neue Sachlichkeit, such as Otto Dix and George Grosz, were about to produce in Berlin. Most of the paintings by them which seem related to this one by Grigoriev were not in fact produced until a year or two later.

Grigoriev sometimes has an affinity with a more conservative Deco style. His work can resemble that of the Belgian portrait painter Louis Buisseret (1888–1956). In fact, granted the difference in nationality, Buisseret's background and Grigoriev's were in some ways similar. Both emerged from the world of the late Symbolism – the World of Art Group was profoundly affected by Symbolist ideas, while Buisseret was a pupil of the leading Belgian Symbolist Jean Delville (1867–1953). Both artists were attracted to the new classicism of the 1920s, as it emerged in the ever fashion-conscious Paris art world.

59 BORIS GRIGORIEV. *Self-Portrait.* 1921. Private Collection. (Courtesy Barry Friedman)

88

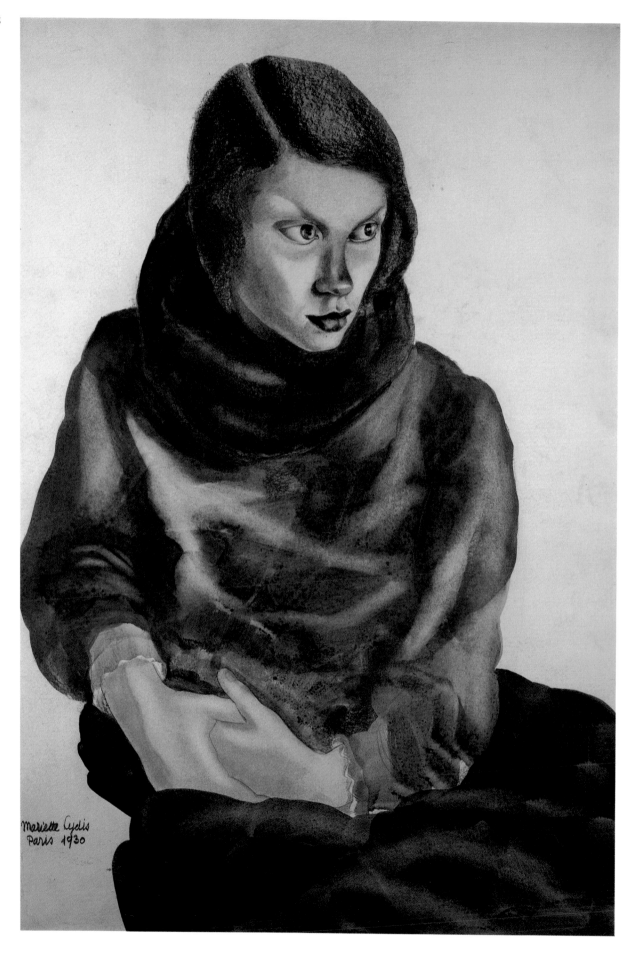

DEPICTION OF ≡EVERYDAY LIFE≡

It is natural to think of Deco painting as a *grande luxe* style, interested only in the fashionable and prosperous, which is understandable given the circumstances in which it was produced and the kind of public which responded to it. In fact, the Deco artists were not immune from a certain *nostalgie de la boue*. Lempicka's more unexpected productions include a handful of paintings of street types, for instance, *The Refugees* (Pl.62), in the Musée d'Art et d'Histoire, Saint-Denis. This dates from the mid-1930s, when Lempicka no longer had to fight to create a reputation in the fashionable world. It indicates that even she, for all her notorious ambition and self-centredness, was aware of the political climate of the time.

She had long been preceded in the exploration of this kind of subject-matter by the Austrian-born artist Mariette Lydis (1890–1970), who took up residence in Paris in 1927, and who attracted an enormous amount of attention during the 1930s. The chief text on her work, by the novelist Henri de Montherlant, was published in 1938, when she was at the height of her reputation. Lydis specialized in the depiction of the *demi-monde*: lesbians, prostitutes and criminals. She was enthusiastically described as 'the Botticelli of the world of Dostoevsky'. Her work has a little in common with that of her compatriot Egon Schiele, and with that of another Paris-domiciled Central European, Jules Pascin (1895–1930). She also has affinities with Moise Kisling (1891–1953), a Jewish artist from Cracow, who settled in Paris in 1910. Kisling's elegant draughtsmanship owed something to the example of Modigliani, who had been his friend in his early days in Paris, and he too can be thought of as an artist on the borderline of the full-blown Art Deco style.

After Pascin's much-publicized suicide, Lydis, with her very similar range of subject-matter, must have looked like his predestined replacement, and her real success begins at about that date. Her work is attractive thanks chiefly to its delicate purity of outline, and lacks Pascin's gift for colour (Pl.60). Like that of another very successful woman artist of the period, Marie Laurencin, it has a tendency to become formulaic. The formula relies on carefully calculated ambiguity – great charm on the one hand, a whiff of corruption on the other. If Schiele and Pascon were two of Lydis's artistic ancestors, then another, remoter in time but close in spirit, was Jean-Baptiste Greuze. This is not the only instance of a hidden correspondence between the Deco sensibility and that of the French eighteenth century.

Despite these excursions into low-life subjects, Art Deco was generally

60 MARIETTE LYDIS. *Young Woman with Cowl Collar*. 1930. Private Collection. (Courtesy Barry Friedman)

90

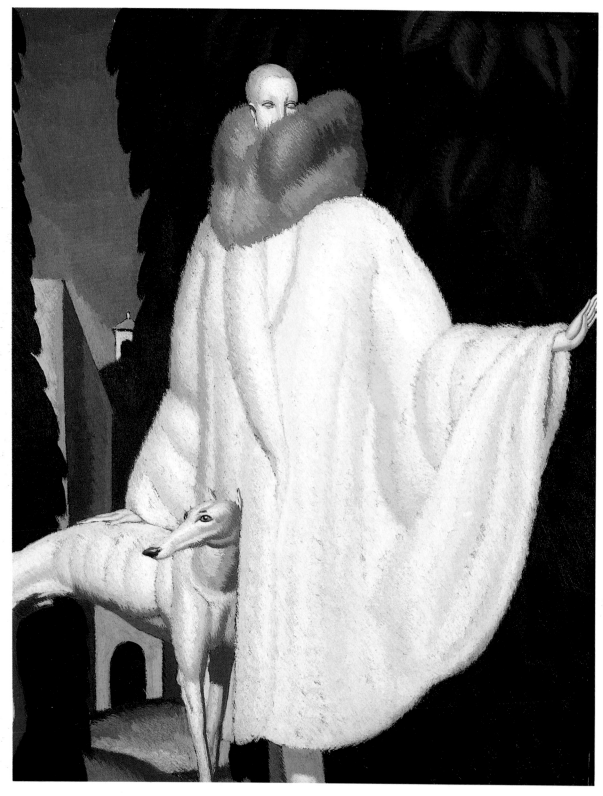

61 JEAN DUPAS. *Woman with Stole*. 1929. Private Collection. (Courtesy Barry Friedman)

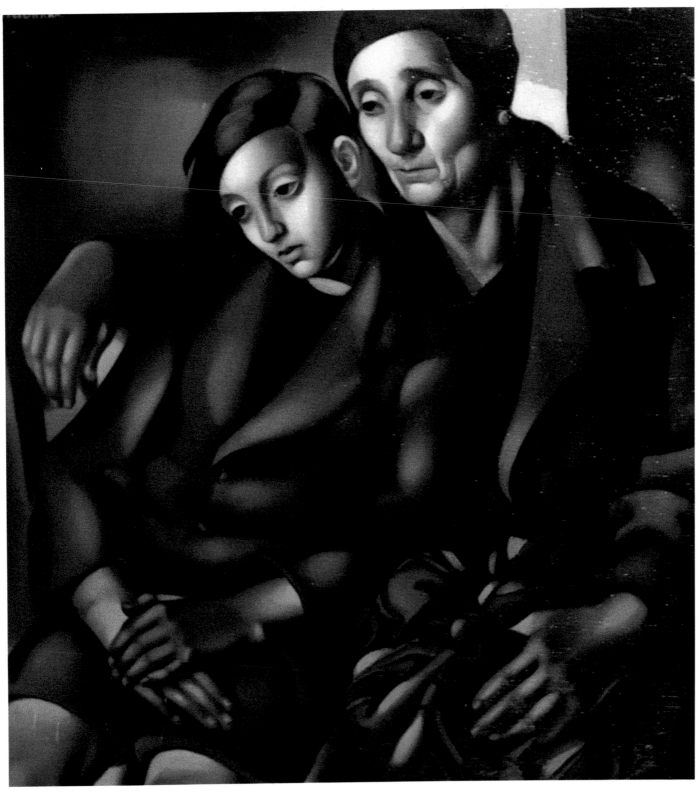

62 TAMARA DE LEMPICKA. *The Refugees*. 1937. Musée d'Art et d'Histoire, Saint Denis (on loan to the Musée Nationale d'Art Moderne)

indifferent, or even downright hostile, to the idea of direct confrontation with reality, as favoured by the artists of Weimar Germany. In this it followed the tastes of its patrons. Reality was tamed and made controllable through an inventive use of stylization. At the bottom of the scale, some Art Deco paintings are little more than worked-up and elaborated fashion drawings. This is the case with Jean Dupas's *Woman with Stole* (Pl.61), which dates from 1929. The stylization here is a traditional one, inherited from sixteenth-century Mannerism. The figure is tall and thin, with an impossibly tiny head in proportion to her body. A less attenuated stylization was invented by Gauguin, and was passed on by him to his disciples among the Nabis. Paul Sérusier and Maurice Denis are immediate ancestors of this kind of interwar art. A more domestic version of the same style was practised by Gladys Hynes (1888–1958), a still underrated member of the Newlyn Group who was the contemporary at Newlyn of Dod and Ernest Procter. Her painting *The Chalk Quarry* (Pl.13) shows her feeling for strong, monumental forms. Here, it is not merely the influence of the Nabis which is apparent, but that of Italian Renaissance painting. Piero della Francesca in particular, with his impassive, solidly planted, sculptural figures, cast a potent spell over many artists at this time. Hynes's *The Chalk Quarry* reflects the cult of the healthy outdoor life which was so prevalent in the 1920s and 1930s. *The Chalk Quarry* is a mixture of symbolisms, some at odds with one another. The chimney in the background relates to the Cornish quarrying and mining industries, which were thought of as contributing to the wild picturesqueness of the Cornish landscape. The

adult figures are clothed in the loose informal garments which Augustus John had already popularized in his pre-war paintings of gypsies. The man, wearing a shirt with no collar and what seems to be a working-man's corduroy suit (the painting is deliberately unspecific about textures), carries what must be a picnic lunch tied in a large spotted handkerchief. However, it is also clear that the group is not going to wander very far, since three of the four figures are barefoot.

Idyllic country scenes of this type make an interesting contrast with the much more straightforward depictions of fashionable life, which are found most frequently among painters who based themselves in France, but which also indicate the cosmopolitanism of the fashionable world during the interwar decades. Van Dongen's *Bar in Cairo* (Pl.63), painted at the beginning of the 1920s, is a spirited evocation of the peripatetic 'smart set' of the time. The location is fixed only by the waiter in the background, who wears the Egyptian fez. The world it evokes could hardly be more different from that of Gladys Hynes.

Philpot perhaps hints at disapproval of foreign hedonism in his *The Entrance to the Tagada* (Pl.64), which is known to have been painted in Paris in 1931, during a period when the artist was renting a studio at 216 boulevard Raspail. The impact made upon Philpot by Van Dongen's work is nevertheless clearly evident. The most prominent element in the picture, the negro doorman, is a reminder of the cult of the negro which swept the world of high fashion during the 1920s and 1930s – one of its chief promoters was the writer and publisher Nancy Cunard. Philpot himself was always keenly interested in painting

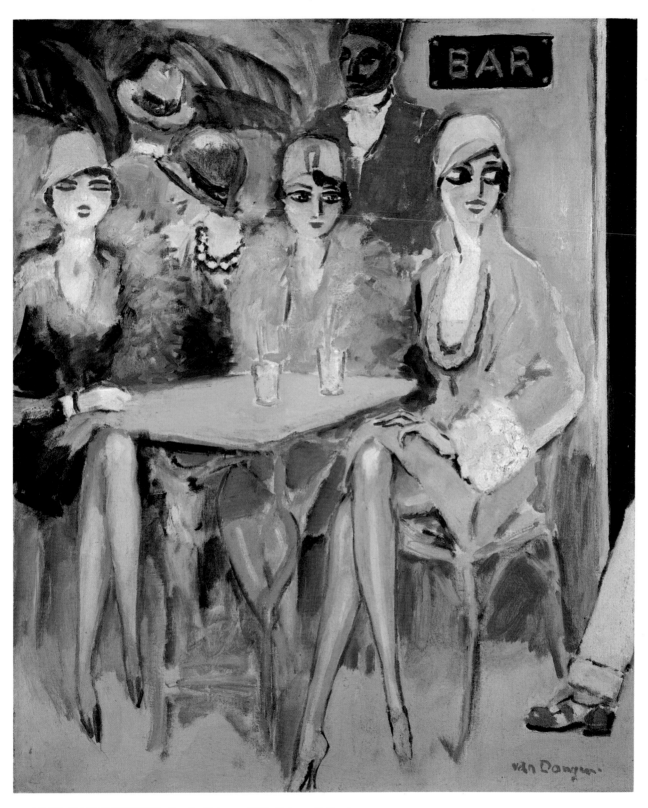

63 KEES VAN DONGEN. *Bar in Cairo. c.* 1920. Private Collection

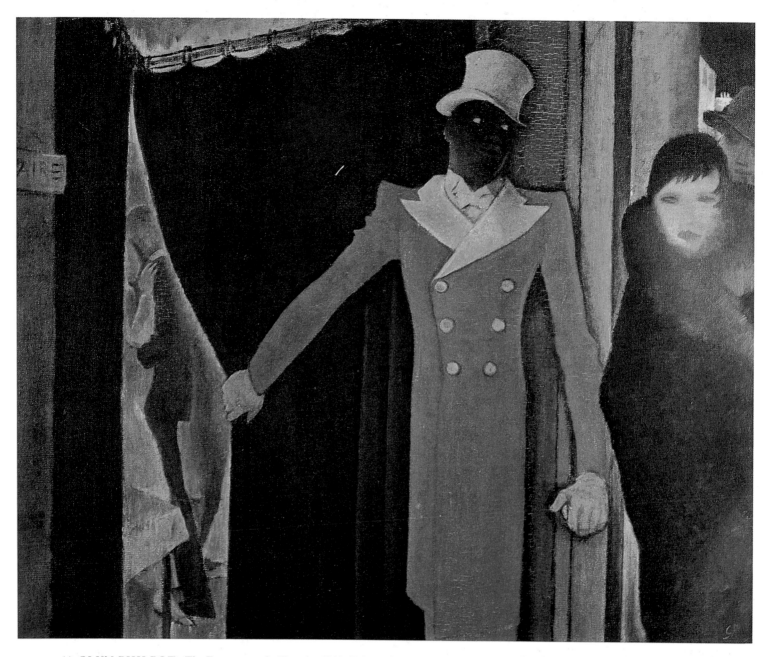

64 GLYN PHILPOT. *The Entrance to the Tagada*. 1931. Private Collection

65 GLYN PHILPOT. *Weight-Lifting, Berlin*. 1931. Private Collection. (Courtesy The Fine Art Society)

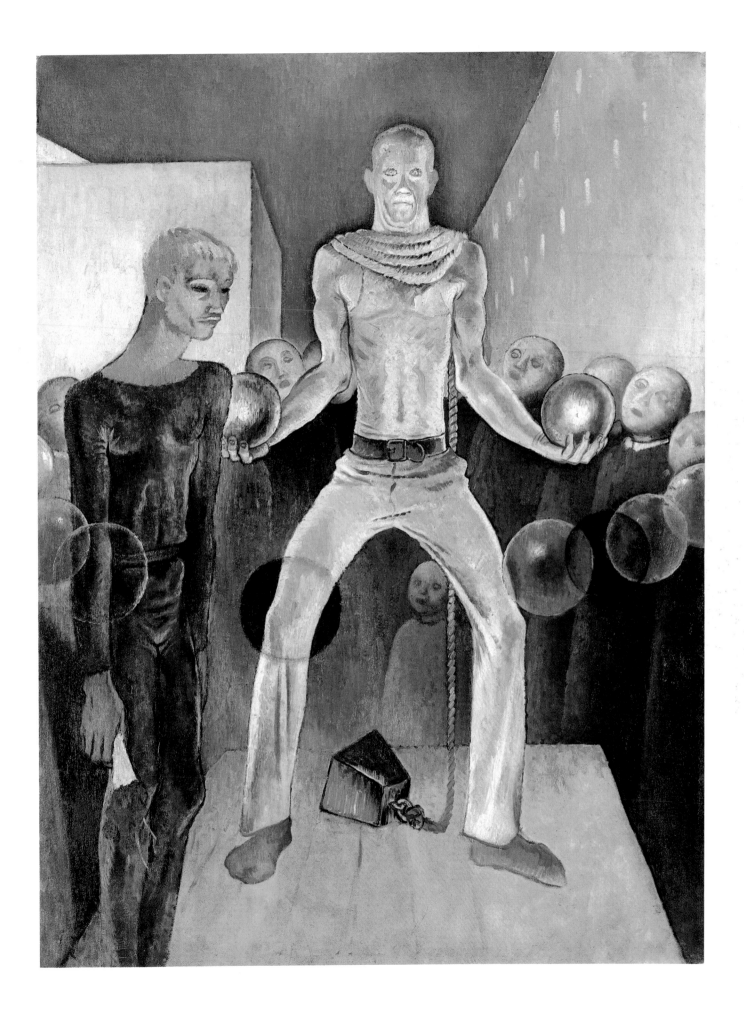

blacks, and a number of his best figure paintings are studies of his negro servant, Henry Thomas (Pl.6). Philpot's rather disconcerting variability of style is demonstrated by another 'real-life' work of almost the same date. *Weight-Lifting, Berlin* (Pl.65) represents his reaction to Weimar Germany in its last throes, and the influence of Van Dongen has been abandoned for that of Otto Dix. Philpot remains in many ways an uncategorizable artist because he never quite knew how to categorize himself.

American painters of the interwar period include a number who fit well into the ethos of Art Deco, even though American critics seldom allude to the link. Depictions of fashionable women, often shown as being rather formidable, occur frequently in the work of Guy Pène du Bois (1884–1958). Pène du Bois infuses realist subjects drawn from contemporary life with a kind of sculptural solidity which shows a debt to Cubism, and also once again to the Renaissance masters (Pl.66). What is original and personal in his work is the consistent presence of a sinister undertone, which seems to imply a judgement on urban life and on the New York life-style in particular. This is the other side of the coin from the innocent pastoralism of Hynes and a number of other painters connected with Art Deco.

This pastoralism does appear in America and is frequently to be found in paintings made under the auspices of the Federal Art Project, set up to help artists during the Depression. William Gropper (b. 1897) is usually associated with fierce attacks on American capitalism. But his *Suburban Post in Winter* (Pl.69), painted in 1934–6, as a sketch for one of the numerous murals commissioned for local post offices by the Project, makes use of a style which is very close to that of Maxwell Armfield. The landscape consists of flat planes or bands, with the figures, buildings and other objects shown in silhouette. A distant ancestor is the Dutch seventeenth-century painter of winter scenes, Hendrik Avercamp. More sophisticated, and more ambiguous in tone, are the lively genre scenes painted by Paul Cadmus in the 1930s. *The Fleet's In!* (Pl.67) has a vigour and a grotesquerie which obviously owe something to Bruegel, but also a carefully considered rhythm which calls attention to deliberately 'decorative' qualities.

When depicting contemporary life, the painters who can be described as Art Deco seem to have made use of several approaches, each of which involved a slightly different form of stylization. There was, first of all, the attempt to give what was contemporary a classical weight and solidity. However, this must be distinguished from the actual use of classical subject-matter. André Lhote's large *The Beach* (Pl.18), for example, shows two young women asleep on the seashore. It is clear that they are not nymphs or goddesses but contemporary figures, indulging in the new cult of sunbathing. But the way in which they are represented is not naturalistic: it carries an echo of the idealized females depicted by Jacques-Louis David and his followers. The painting was produced at just about the time when Lempicka was in close contact with Lhote, and it is easy to see what she got from him. It is equally easy to see the link between Lhote and Picasso's experiments with neoclassicism.

This style was popular throughout

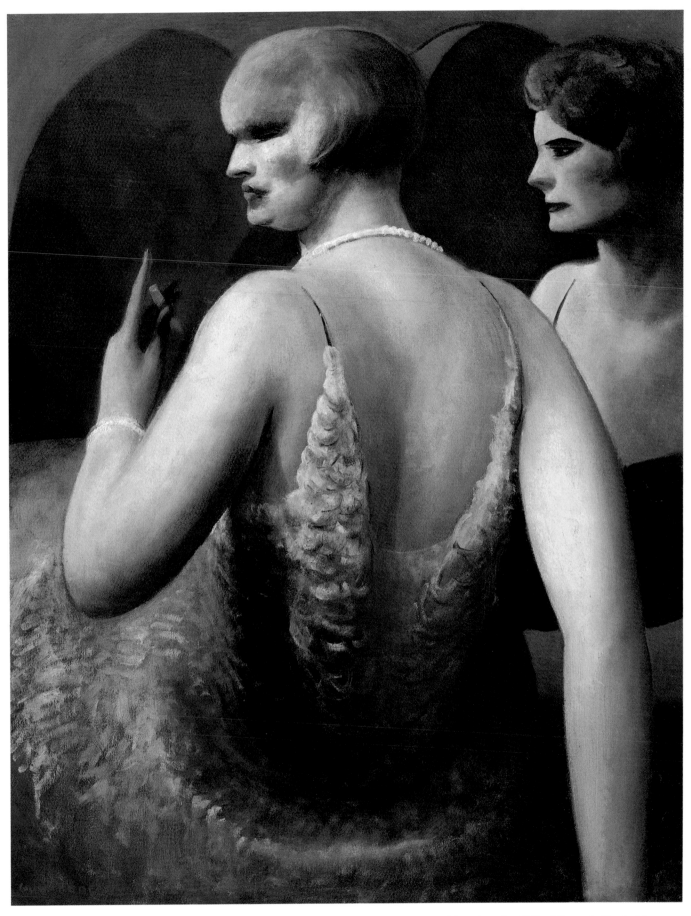

66 GUY PÈNE DU BOIS. *Woman with Cigarette*. 1929. New York, Whitney Museum of American Art (Gift of Gertrude Vanderbilt Whitney)

67 PAUL CADMUS. *The Fleet's In!* 1934. Naval Historical Center, Washington D.C. (Official U.S. Navy Photograph)

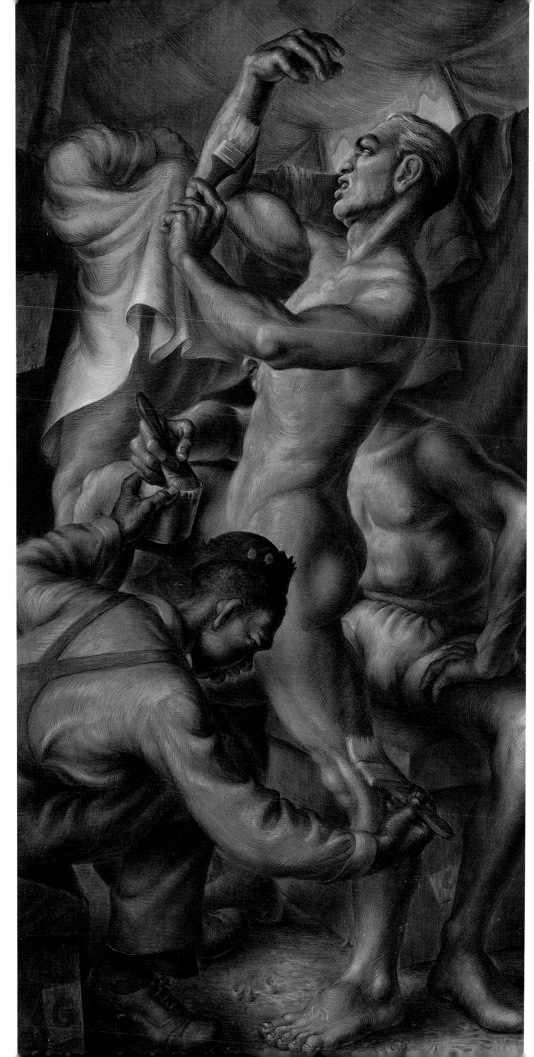

68 PAUL CADMUS.
Gilding the Acrobats.
1935. The Metropolitan
Museum of Art, New
York. Arthur Hoppock
Hearn Fund.

69 WILLIAM GROPPER. *Suburban Post in Winter, Freeport*. 1934–6. The Art Gallery, University of Maryland at College Park (on permanent loan to the Art Gallery)

70 FERDINAND ERFMANN. *Soccer Players*. 1937. Private Collection. (Courtesy Barry Friedman)

71 YURI PIMENOV. *Children of the City*. 1930. Private
Collection. (Courtesy Barry Friedman)

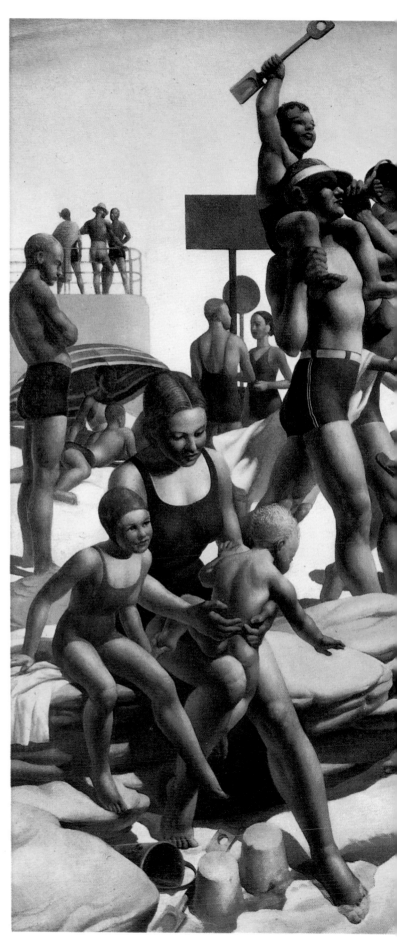

72 CHARLES
MEERE. *Australian
Beach Pattern*. 1940.
Art Gallery of New
South Wales

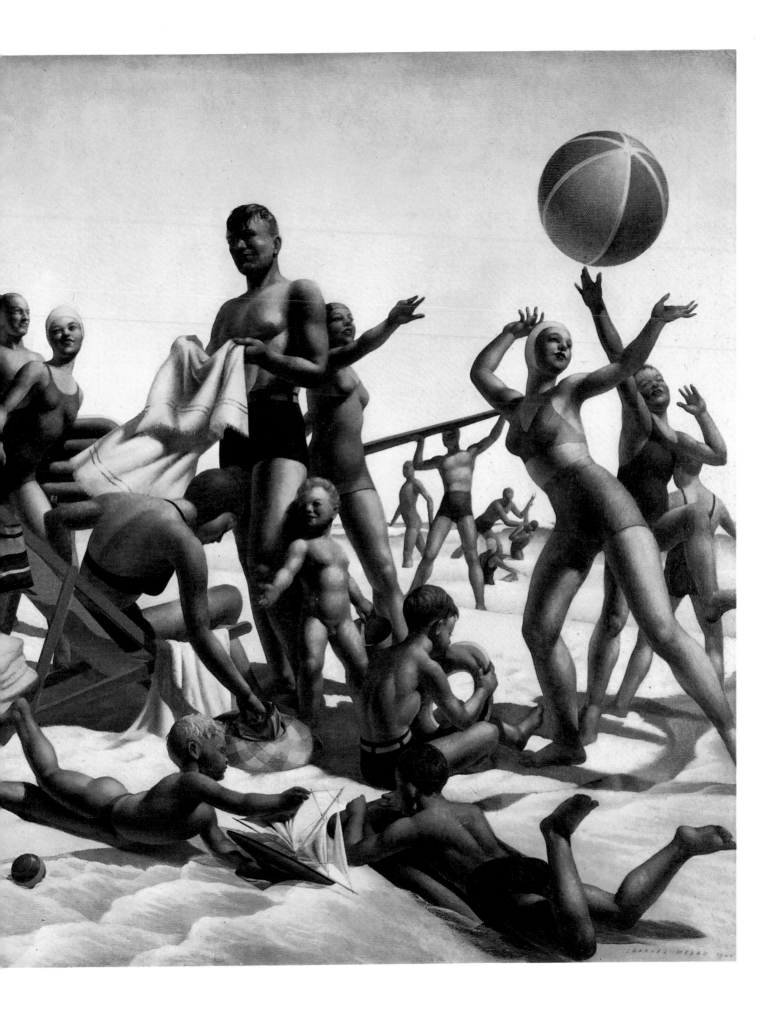

Europe, and also had an impact in the United States, with the work of Guy Pène du Bois. One especially gifted exponent, though less well known than he should be because he came from a peripheral country, was the Dutchman, Ferdinand Erfmann (1901–68). Dutch art has always had a strong inclination towards classicism, from the emergence of the De Stijl Group onwards. The members of De Stijl insisted that a true modern classicism must also be entirely abstract. Erfmann rejected this, believing it could still be combined with a feeling for ordinary life, as can be seen from paintings executed in the late 1930s, including the *Soccer Players* (Pl.70) of 1937. The *Soccer Players* owes something to the Douanier Rousseau's version of the same subject, painted in 1902, but this may be an adventitious resemblance, simply because of the use of identical subject-matter. It is worth remembering, however, that Rousseau's work had a persistent influence, not merely on the art of Diego Rivera, but on Art Deco painting in general.

The most impressive of these classicizing sporting scenes hails, not from Holland, but from Australia. Charles Meere's *Australian Beach Pattern* (Pl.72) is an astonishing work, a rapturous celebration of the purely physical life which is at the same time a salute to the emergence of a new kind of society: one which was almost entirely materialist, yet happy and confident in its own materialism. The picture expresses gratitude for the good things which immigrant Europeans had found in this new continent. The painting is an intricate composition of many figures. The excuse for their near-nudity is not some classical legend, as is the case with Meere's *Atalanta's Eclipse* (Pl.36), but modern tastes and

recreations. Despite the fact that the subject-matter is so emphatically contemporary, the painting demonstrates the continuing vitality, even in the twentieth century, of a tradition which stretched back to Poussin and beyond him to Raphael. One of its closest parallels among the Old Masters is Raphael's *Repulse of Attila*, in the Stanza dell'Eliodoro in the Vatican, which contains the same wildly energetic rhythms within a stringently geometrical framework. Yet the contrast in subject-matter is at least as significant as the stylistic relationship. Meere is able to take his subject far more seriously than Dupas and Delorme were able to take the traditional classical allegories with which they sometimes busied themselves.

Another example of the application of this classicizing style to a scene from ordinary life comes from Russia. It makes the point that Deco stylization of this sort can be regarded as being the chief way in which official art responded to the challenge offered by Modernism. Yuri Pimenov's *Children of the City* (Pl.71) was painted in 1930, when the Stalinist freeze was already beginning to set in. Pimenov (1903–77) was one of the first generation of students who trained at the Vkhutemas (Higher Technical Artistic Studios), an institute set up in Moscow in the wake of the Revolution, along somewhat the same lines as the Bauhaus, and with the benefit of Kandinsky's advice. Despite this 'experimental' background, Pimenov went on, like his contemporary Alexander Deineka (1899–1969), who also studied at the Vkhutemas, to become a successful official artist, an active member of the Soviet Academy of Arts, who was eventually awarded both the Lenin Prize and the USSR State Prize.

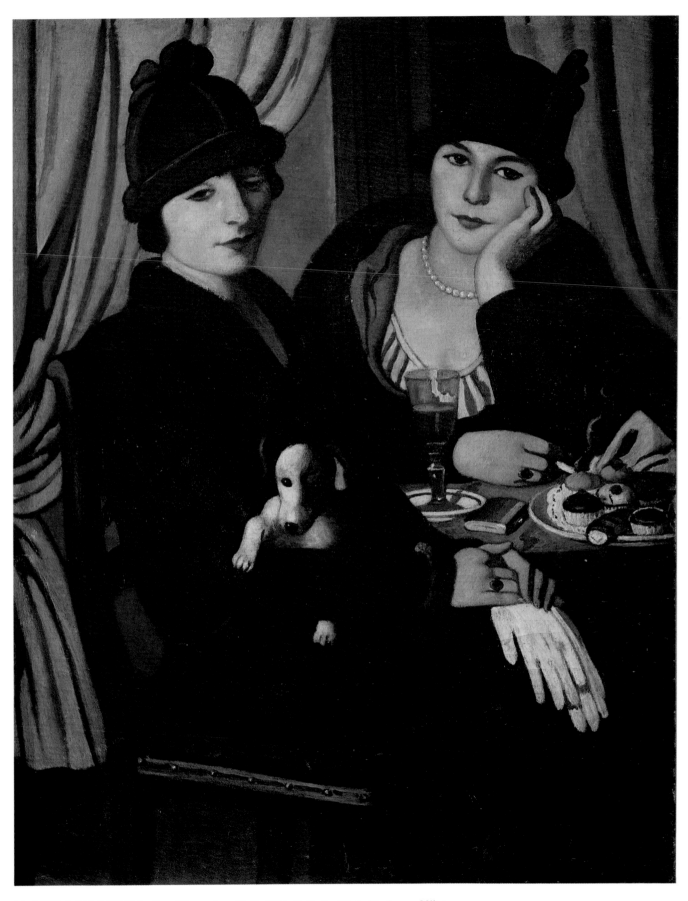

73 PIERO MARUSSIG. *Two Women in a Café*. 1924. Galleria d'Arte Moderna, Milan

Deineka's work covers a whole gamut of themes generally considered typical of Art Deco. He painted sportsmen, negro musicians, even an image of a fashionable woman seated in a Paris café. His most successful works, such as his 1934 painting of the *'Dynamo' Aquasports Stadium, Sevastopol* (Pl.74), demonstrate his ability to combine classicism and contemporaneity.

The classical style was naturally popular in Italy, because it seemed to make direct reference to the Italian heritage. One of the most striking examples of its use in combination with contemporary subject-matter is *Two Women in a Café* (Pl.73), by Piero Marussig. His classicism is not exclusively attributable to the new Italian nationalism, though the painting was produced in 1924, at the beginning of the Fascist period. Marussig, born in Trieste, which was an international crossroads, particularly in the years just before the First World War, travelled widely in his youth and was familiar with pre-war Vienna, Munich and Paris. *Two Women in a Café* is a French *belle époque* picture (using subject-matter familiar to artists such as Manet, Degas and Toulouse-Lautrec), rethought in new terms.

Weighty, rounded classicism was not the only solution tried by the artists of the interwar period in their attempt to come to terms with what they saw around them, yet give it decorative value. Another way of tackling the problem was the use of flat areas of strong colour, combined with emphatic silhouettes. This formula, too, was internationally adopted. A Dutch example is Johan van Hell's *Flowerseller* (Pl.76) of 1927, in which the simplification is much more brutal than it usually

74 ALEXANDER DEINEKA. *'Dynamo' Aquasports Stadium, Sevastopol.* 1934. Tretyakov Gallery, Moscow

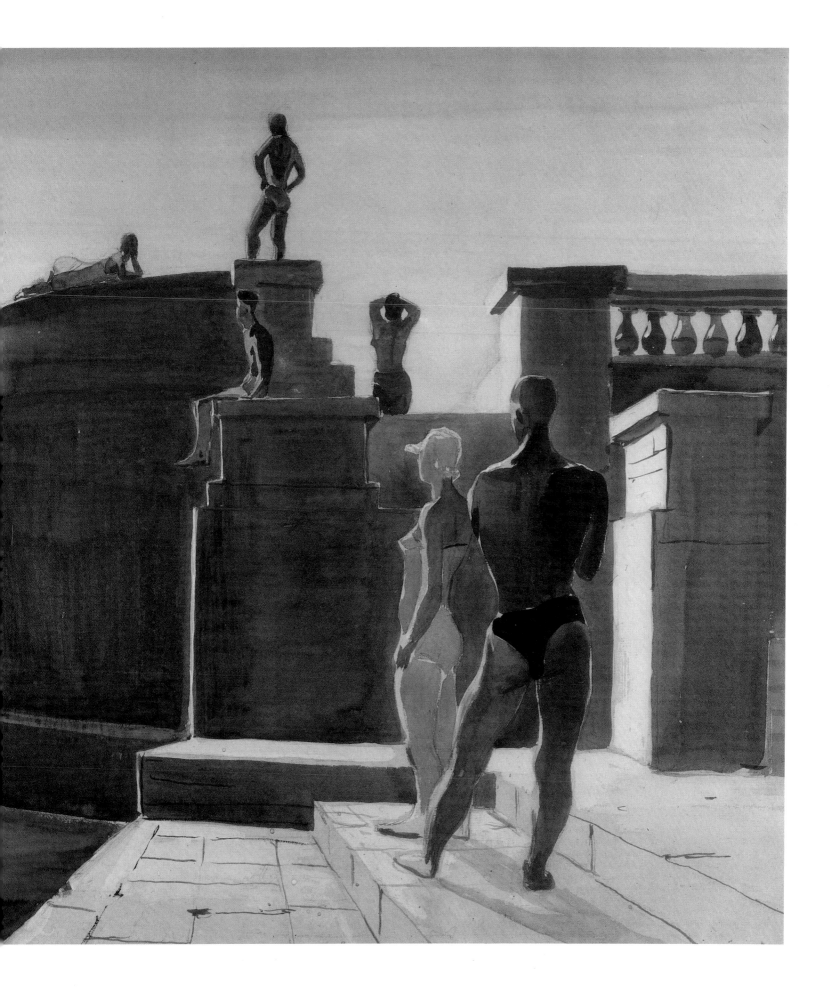

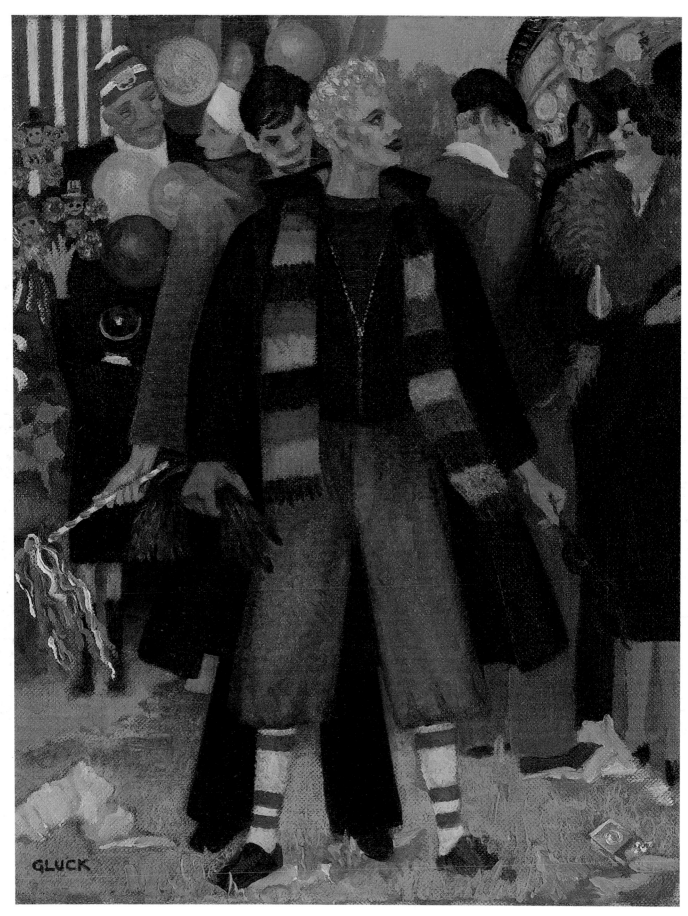

75 GLUCK. *Bank Holiday Monday*. 1937. Private Collection. (Courtesy The Fine Art Society)

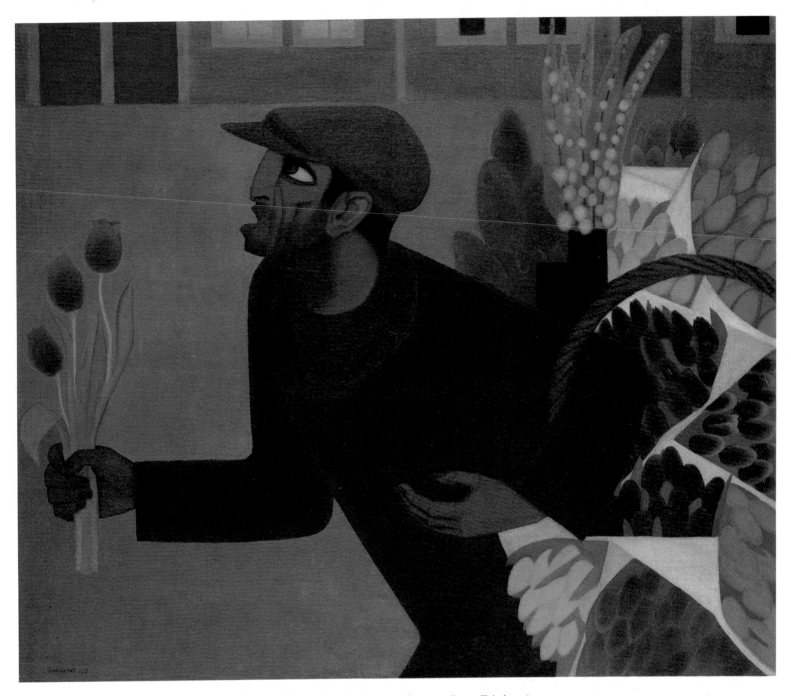

76 JOHAN VAN HELL. *Flowerseller*. 1927. Private Collection. (Courtesy Barry Friedman)

becomes with other artists, such as Arm-field. A less drastic version of the same manner appears in Gluck's *Bank Holiday Monday* (Pl.75), of around 1936. It is a point of some interest that this version of Art Deco style was usually the one considered most suitable for working-class subjects. Sometimes, in these circumstances, flat patterning was somewhat strangely combined with ideas borrowed from Expressionism. Fernand Bouton's *Working-class Family* (Pl.77), dated 1919, shows the influence of the Nabis, and particularly of those members of the group who were most closely involved with Gauguin and Pont-Aven. A clue is the landscape in the background, dominated by an immense symbolic flower. The painting also seems to show a knowledge of German Expressionism, and in particular of the work of the artists of Die Brücke. The painterliness of Kirchner and Schmidt-Rottluff has, however, been replaced by an emphatic use of flat patterning.

A later example of the assimilation of certain Expressionist devices can be seen in *Three Belles of Paddington* (Pl.78), by the British artist Victor Reinganum (b. 1907). Dated 1928, this takes a favourite theme of both the *belle époque* and Expressionism, prostitution. The women are turned into stylized mannequins, emblems of their profession, rather than being presented with unflinching realism, as would have been the case with one of the realists working in Germany at the same time. Some German artists, labelled Expressionist or even Realist by their contemporaries, do now seem to have elements of Deco. One of the tactics adopted by artists to 'control' reality, and thus make it suit the purposes

of decoration, was not only to impose pattern, but to make everything slightly toy-like. The 1920s, in particular, had a cult of childhood which manifested itself in many ways – the cult of the child-woman in fashion being only one. This childish element appears strongly in the paintings of Ernst Fritsch (1892–1962), though Fritsch was also avant-garde enough to earn himself a place among the so-called 'degenerate artists' who were banned by the Nazis. An example of the deliberately childish simplifications which appear in his work is *Man and Woman in front of a House* (Pl.79). The two figures – the perfect German bourgeois and his wife – striding away from each other, their alienation stressed by the bare tree which divides the painting, may indeed express a feeling of anxiety about the condition of German society at a time of runaway inflation. But the conventions adopted once again distance whatever might seem threatening in the picture.

Though the visual conventions used varied, the aim of the Deco or Deco-influenced painter when tackling everyday themes was in general always to distance them, to make them manageable emotionally and if possible to inject an element of playfulness. Any element of social commentary remained oblique and ironic, and so did any declaration of the artist's own personal feelings. This was an art which fitted itself, though sometimes rather wryly, to the prevailing circumstances of the time. This is perhaps one reason why Deco realism flourished both in 'liberal' societies, especially if these were by instinct somewhat conservative, as was the case in Britain, and in totalitarian states such as the Russia of Stalin and the Italy of Mussolini.

77 FERNAND BOUTON. *Working-class Family*. 1919. Private Collection. (Courtesy The Fine Art Society)

79 ERNST FRITSCH. *Man and Woman in front of a House.* 1922. Private Collection. (Courtesy Barry Friedman)

78 VICTOR
REINGANUM.
*Three Belles of
Paddington.* 1928.
Private Collection.
(Courtesy Whitford
and Hughes)

≡TRADITIONAL GENRES≡ 6

It is indicative of the essentially conservative nature of Art Deco painting that it so largely preserved the traditional genres which had governed painting since the Renaissance, with certain readjustments at the beginning of the seventeenth and nineteenth centuries. As well as the most important of the traditional categories – 'history painting', which had now so far lost its validity that painters were forced to treat it in a largely frivolous spirit, portraiture and genre-scenes: the portrayal of some aspect of ordinary life – Art Deco painters busied themselves with a number of other categories such as landscape, still life, and the portrayal of the nude, this last an activity which, ever since Boucher, had hovered between history painting on the one hand and something much more domestic on the other.

They were also active in one or two specialized fields like the portrayal of the theatre. The two great ages of theatrical depiction had been the mid-eighteenth century (the Age of Hogarth) and the final years of the nineteenth century – with Degas's ballet-scenes, followed by Lautrec's depictions of cabaret and operetta, followed in turn by W.R. Sickert's tributes to the music hall. Art Deco often used theatricalism as a way of making reality seem less threatening, as in the paintings of *punchinelli* (Pl.80) done by the one-time Futurist, Gino Severini (1883–1966), at the beginning of the 1920s. These are direct descendants of the paintings and drawings by G.D. Tieplo dating from the end of the eighteenth century and offer a similarly ironic commentary on a world in which all the old values seem to be dissolving. Nevertheless Art Deco artists also made direct records of theatrical performances. Sometimes the theatre simply supplied them with new formats for portraiture. Gluck, portraying the actor Ernest Thesiger (Pl.81), chose to show him on stage, awaiting his turn to perform in one of the intimate reviews so fashionable in London at the time. Thesiger's slightly lugubrious aspect in this picture is a reminder of one of the best anecdotes about an actor who inspired many. Late in his career he was accosted by a complete stranger, while travelling on the London Underground. 'Excuse me, but weren't you Ernest Thesiger?' she asked. 'I *was*, madam, I *was*,' came the reply.

Gluck can also unleash a splendid dynamism when inspired to show performers in the middle of their act. The Three Nifty Nats (Pl.82) were a turn in one of the elegant cabaret-like entertainments produced by the impresario C.B. Cochran. Gluck makes them the pretext for an energetic jazz-age design similar to the drawings of the Mexican caricaturist Covarrubias.

80 GINO SEVERINI. *Two Punchinelli*. 1924. Collection Haags Gemeentemuseum – The Hague

81 GLUCK. *Ernest Thesiger Awaiting His Turn*. 1925–6. Private Collection. (Courtesy The Fine Art Society)

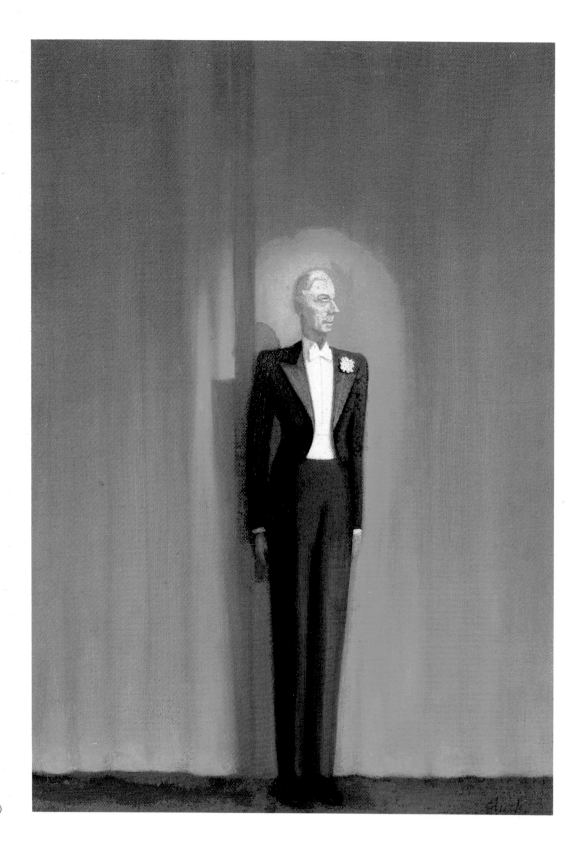

82 *Far right:* GLUCK. *The Three Nifty Nats* (detail). 1926. Private Collection. (Courtesy The Fine Art Society)

83 ANDRÉ LHOTE. *Nature Morte, Louis-Philippe.* 1922. Whitford and Hughes, London

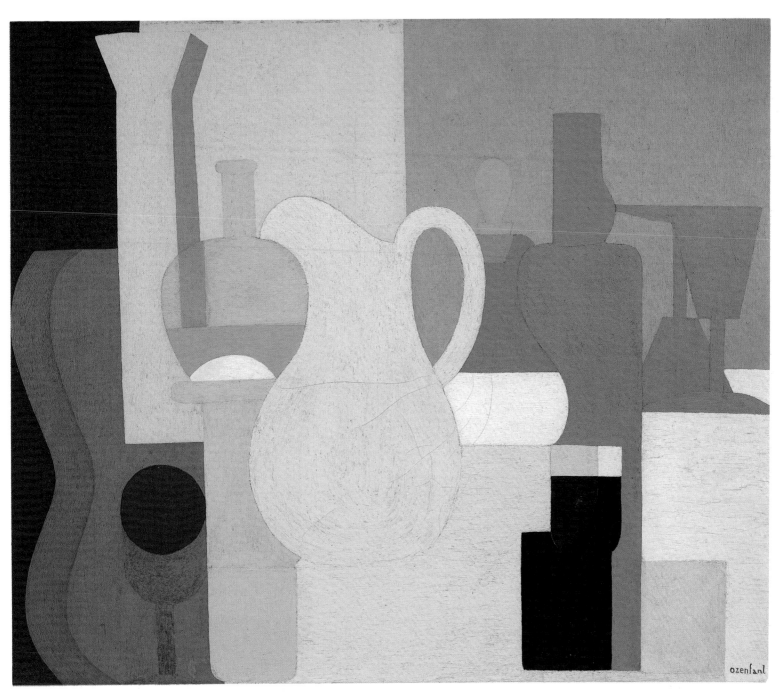

84 AMÉDÉE OZENFANT. *Still Life with Jug. c.* 1925. Private Collection. (Courtesy Barry Friedman)

Art Deco painters were equally skilful in adapting the basic genres of landscape and still life to their own aesthetic purposes. Still life was a comparative newcomer in European art and only became a fully independent genre at the beginning of the seventeenth century. Still life paintings were sometimes *memento mori* or moral emblems. On occasion they developed into statements about the artist's relationship with reality. This was the case with Chardin, but happened only rarely with other artists. Or such paintings were simply decorative objects, often contributing to larger schemes of decoration. In fact, Art Deco still lifes seldom aspired to anything more ambitious than this.

Typical of Art Deco still life is a painting by Gluck (Pl.20). Here a vase of flowers is presented as a precious object, with the flowers themselves dilineated with great precision, but also with a certain stylization. Gluck's bouquet consists entirely of white arum lilies – a favourite with the artists of the 1920s and 1930s and particularly prevalent in the work of Diego Rivera (Pls.15&16). Gluck's painting conformed to tradition in that it was designed to occupy a specific position – above a mantelpiece in Vernon House, Carlyle Square, London.

Where still life painting is concerned, it is not surprising that the boundary between Art Deco and late Cubism becomes a little blurred. Lhote's *Nature Morte. Louis-Phil-lipe* (Pl.83) is only nominally Cubist as the faceting typical of the style is used very cautiously, and for purely decorative effect. The tilting planes characteristic of Cubism are barely hinted at. *Still Life with Jug* (Pl.84), by Amédée Ozenfant, the ally of Le Corbusier and leader of the Purists, is at first sight more radical. The overlapping flat planes proclaim Ozenfant's allegiance to Synthetic Cubist procedures, and so too does the guitar at the extreme left – this instrument had become a kind of Cubist signature. On closer examination, however, the air of Cubist orthodoxy soon disappears as the overlapping silhouettes are treated not in a structural way, as a means of description, but as purely decorative shapes.

A more interesting conjunction of Cubist and Deco elements can be found in the rare still lifes of the expatriate American painter, Gerald Murphy (1888–1964). Murphy was a rich amateur: Scott Fitzgerald made him the model for his hero in *Tender is the Night*. Murphy's period of activity as a painter was brief, from 1921, when he first arrived in Paris, until 1933, when he returned to America. His teacher was Natalia Gontcharova, but his chief influences were Braque, Gris and Léger. Murphy worked slowly, and his paintings are very few in number, with only six surviving out of a possible twelve or fourteen. The best known is *Razor* (Pl.85), painted in 1924, and now in the Dallas Museum. Like his other paintings, this is a depiction of magnified everyday objects. The influence of Synthetic Cubism, and especially the work of Juan Gris, is obvious. But so too is that of Art Deco poster designers, most of all Cassandre. The conventions of this sort of poster-design – the sharp edges of the forms, flattened planes and preternatural clarity of depiction – are here transferred to a higher artistic level.

In the course of the nineteenth century landscape painting became one of the primary vehicles of expression for Romantic feeling. J.M.W. Turner raised it to a new

85 GERALD MURPHY. *Razor*. 1924. Dallas Museum of Art, Foundation for the Arts Collection, gift of the Artist

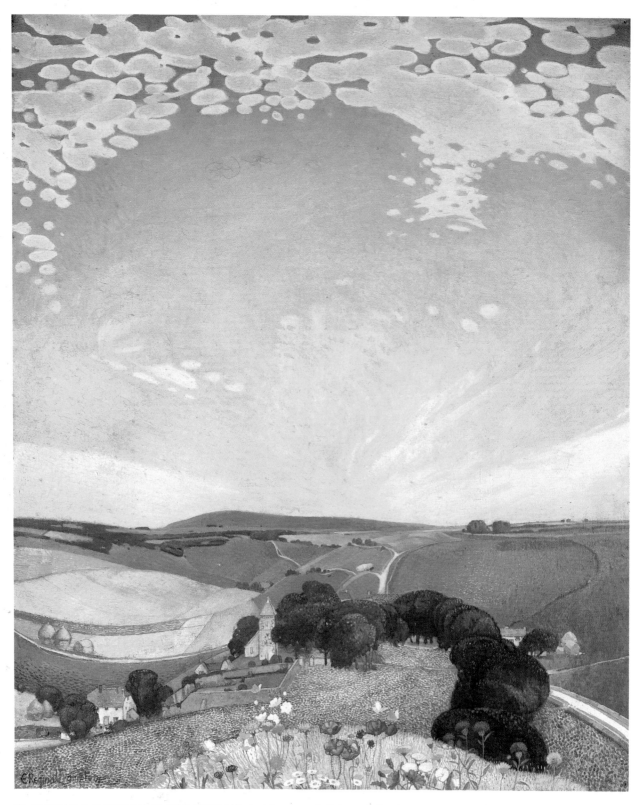

86 EDWARD REGINALD FRAMPTON. *Landscape*. n.d. Private Collection

level of commitment and seriousness. Turner has been regarded as a precursor of Impressionism, but in fact his work leads on more directly to the Expressionists: for example, to Van Gogh's late landscapes painted in Provence and at Auvers. Van Gogh used the depiction of landscape to mirror his own interior states, and this procedure was also followed by the German Expressionists of Die Brücke, and by Soutine, in the series of landscapes painted at Ceret. The landscape painting of the Art Deco style goes against this tradition in that it returns the picture to being a decorative artefact. Its roots are to be found in different places, in the work of the Nabis and the Fauves, because of the emphasis put by both on sharply defined areas of flat colour, and also in the English Arts and Crafts tradition and in Japanese art, especially *ukioy-e* landscape prints by Hokusai and Hiroshige, and in screen painting. Another powerful influence was photography.

Deco landscapes can be divided into two broad categories: traditional rural scenes and urban or industrial scenes. The latter now seem more typical but the rural landscapes emerged first. They appeared not in France but in England where, just before and during the First World War, a number of painters such as Edward Reginald Frampton and Joseph Southall (1861–1944) were producing delicate landscapes which, in their emphasis on absolute precision of touch and liking for crisply defined colour and pattern, already foreshadow the Art Deco taste. Southall's views of the Fowey estuary (Pl.87), some of the most beautiful landscapes of their time, date from 1917. In France, the Cubist adventure was just reaching its climax, but Southall belonged to a completely different artistic world. He was inspired to begin painting in tempera after seeing Carpaccio's St. Ursula series on a visit to Italy in 1883. In 1907 he was one of the founder-members of the Birmingham Group of Artist Craftsmen, which exhibited at the Fine Art Society in London for the first time that year.

Throughout the first four decades of the twentieth century American painters produced landscapes in which they tried to render the character of what surrounded them, and to distinguish it from what could be seen in Europe. Many of these paintings have more than a touch of Art Deco. Where the Deco landscape flourished most abundantly was in the American South West. There are several reasons for this, some purely artistic, some to do with the nature of the landscape itself. On the artistic side, the influence of Gauguin was particularly strong upon many of the painters who identified themselves with the area. Gauguin's paintings produced in the South Seas provided a model for dealing with the exoticism of desert scenery, and also hints for depicting the local Navajo Indian culture. Later on, after the Muralist Movement established itself in Mexico, the influence of Gauguin was reinforced by that of Diego Rivera.

The main sequence of South-western landscapes can be said to begin with Raymond Jonson's *Light* (Pl.88) of 1917, a highly abstracted landscape showing a mesa in silhouette which was inspired by a trip to Colorado. It has been suggested that Jonson (1891–1982) was influenced by knowledge of Robert Delaunay's Orphist paintings and by the Synchronism of the Americans, Morgan Russell and Stanton Macdonald-Wright, but there were other exemplars nearer to hand in posters and graphic work

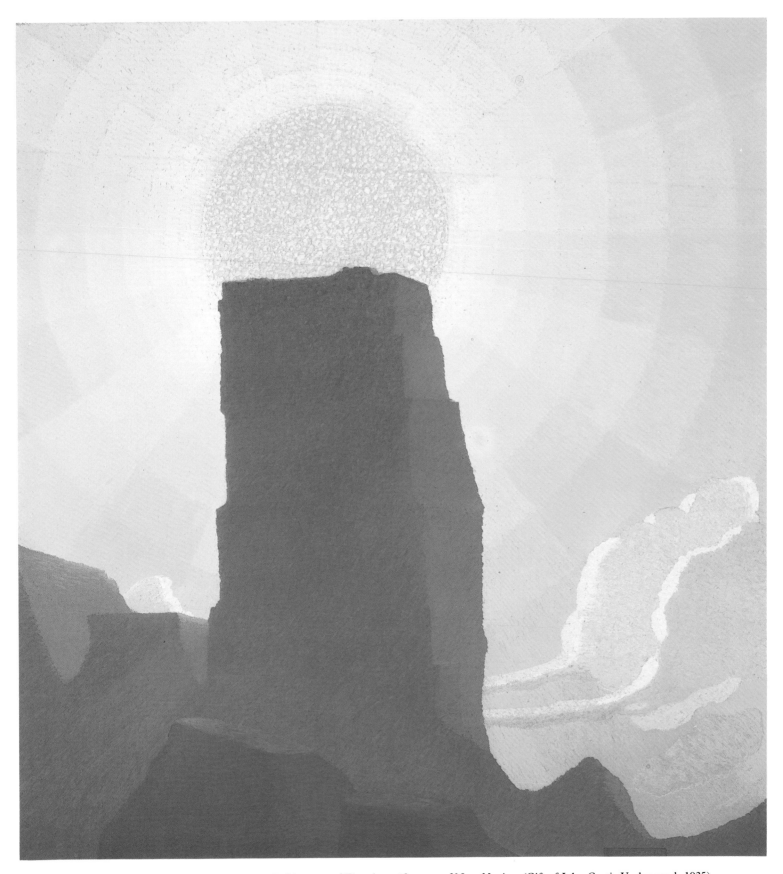

88 RAYMOND JOHNSON. *Light*. 1917. Museum of Fine Arts, Museum of New Mexico. (Gift of John Curtis Underwood, 1925)

126

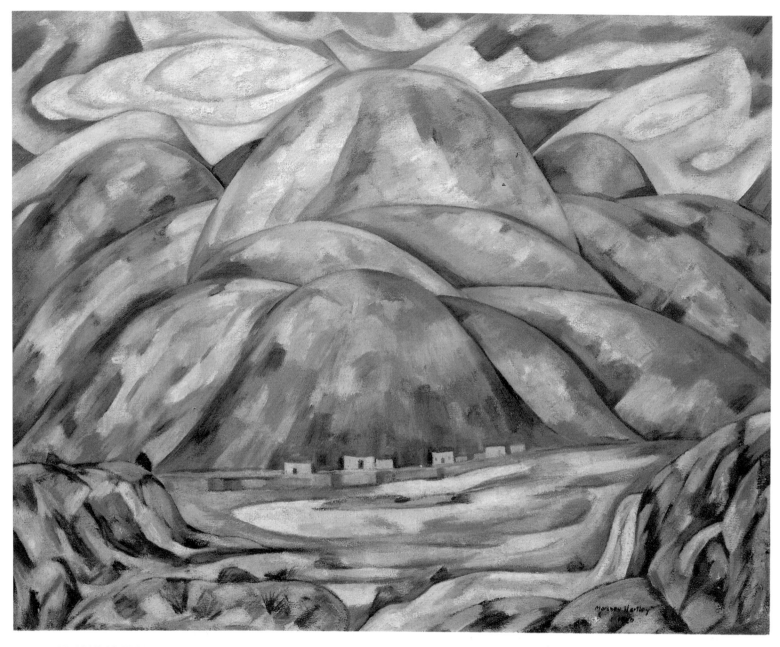

89 MARSDEN HARTLEY. *Landscape No 3, Cash Entry Mines, New Mexico.* 1920. The Art Institute of Chicago. (Alfred Stieglitz Collection)

employing similar conventions which were already being produced at that time. These would have been available to the artist, who was then based in Chicago. Most southwestern landscapes stem from the experience of New Mexico, where Santa Fe and Taos became artists' colonies. Two important painters who worked in the area were Marsden Hartley (1877–1943) and Andrew Dasburg (1887–1979). Hartley's *Landscape No 3, Cash Entry Mines, New Mexico* (Pl.89), painted in 1920, attempts a kind of compromise between the Expressionist style, which he had already absorbed during two periods of residence in Berlin, and a new kind of stylization suggested by the forms of the landscape itself. Dasburg developed a more permanent connection with New Mexico than Hartley, and his *New Mexican Village* (Pl.17) of 1926 is typical of the new manner of landscape painting which developed there.

Since the particularity of this style, and its local roots, have so often been stressed by American commentators, it is fair to point out that this supposedly local manifestation shows striking correspondences with things which were being done at the same time in Europe. *Upward Steps* (Pl.90) by Peter Foerster (1887–1948) was painted in Southern Italy in the same year as the painting by Dasburg just cited, and the two men were exact contemporaries. Foerster was a friend of the architect Mies van der Rohe, and showed with the Novembergruppe between 1920 and 1925. In later years he was acceptable to the Nazis: he was awarded the Dürer Prize of Nuremberg in 1935 and the Rome Prize in the following year.

The most important painter of the New Mexico landscape was Georgia O'Keeffe (1887–1986) who was born in Wisconsin and studied in Chicago and New York. It was nevertheless the American South West which exercised a decisive influence on her work, especially two periods (1912–14 and 1916–18) spent teaching in Texas. In 1916 some of her paintings were shown to the photographer Alfred Stieglitz, who ran the 291 Gallery, then almost the only avant-garde gallery in New York. Stieglitz exhibited them, without the artist's knowledge, and a personal relationship developed as a result. O'Keeffe moved to New York in 1918 and married Stieglitz in 1924. From 1929 onwards, she began spending the summer in New Mexico, living in an isolated adobe house near the village of Abiquiu, some 112 kilometres (70 miles) west of Taos. She did not settle permanently in New Mexico until Stieglitz's death in 1946. For many years before that, however, she had been making New Mexico images which are now accepted as classics of their type. A particularly powerful example is *Black Cross, New Mexico* (Pl.12), painted in 1929, which shows one of the large crosses which symbolize the historic Catholic presence in the region, seen against a typical New Mexican mountain landscape. It is obvious from this and many similar compositions that O'Keeffe learned a great deal from photography. The cross itself is seen the way the camera might see it – very close to the eye, blocking a clear view of the landscape, which stretches almost to infinity. It was essentially photography which taught artists about disorientating contrasts of scale of this type.

During the 1920s O'Keeffe also painted a very different series of pictures, devoted to the urban landscape of New York: *Radiator Building, Night – New York* (Pl.91),

90 PETER
FOERSTER.
Upward Steps. 1926.
Private Collection.
(Courtesy Barry
Friedman)

91 GEORGIA
O'KEEFFE.
Radiator Building,
Night – New York.
1927. The Alfred
Stieglitz Collection,
The Carl Van Vechten
Gallery of Fine Arts,
Fisk Museum of Art,
Nashville, Tennessee

92 RAMON SHIVA. *Untitled Cityscape – Chicago*. 1928. Private Collection. (Courtesy Barry Friedman)

93 RALSTON CRAWFORD. *Vertical Building*. 1934. San Francisco Museum of Modern Art. Arthur W. Barney Bequest Fund Purchase

132

94 BERNARD
BOUTET DE
MONVEL. *Usine*.
c. 1928. Private
Collection. (Courtesy
Barry Friedman)

95 *Right* CHARLES
DEMUTH. *My
Egypt*. 1929. New
York, Whitney
Museum of American
Art, Gift of Gertrude
Vanderbilt Whitney

painted in 1927, is a typical specimen. The Radiator Building was one of the new skyscrapers with Art Deco detailing which were transforming the appearance of the city at that time, and her treatment of the subject also has a strong Deco flavour, with its bold use of silhouettes and flat patterning. Her cityscapes form a part of a large group of paintings by herself and others which celebrate the modern urban environment. Some of these are by American artists with whom O'Keeffe and Stieglitz were personally associated. Members of this group – the Precisionists – include Charles Sheeler (1883–1965), Charles Demuth (1883–1935) and Ralston Crawford (1906–78). They are all closely linked to one another, and to O'Keeffe herself. It would, for instance, be easy to mistake Sheeler's *Church Street El* (Pl.11) of 1920 for one of O'Keeffe's cityscapes painted a few years later. Crawford, the youngest of the group, maintained the style well into the 1930s (Pl.93). Another practitioner of the style, who was less known because he did not work in New York, was the Spanish-born Ramon Shiva (1893–1963), who trained at the Chicago Art Institute and produced striking Chicago cityscapes during the 1920s. The example illustrated (Pl.92) dates from 1928. Shiva later moved to Santa Fe.

Urban architecture also inspired a number of European artists. One of these was the Dane Franciska Clausen (b. 1899), who began her career as a pupil of Hans Hofmann, at a time when the future Abstract Expressionist was still teaching in Munich, and who later worked with Moholy Nagy in Berlin and became a member of the Novembergruppe. Later still, she was a student of Léger, and it is his influence which appears most obviously in her small gouache of *Building Façades*, painted in 1930. The closest European rival to the American Precisionists was Boutet de Monvel. From 1926 onwards he spent a good deal of time in New York, and some of his most typical paintings are inspired by its architecture. His paintings of skyscrapers can only be distinguished from those of his American contemporaries by their greater refinement of handling and intricacy of detail. In some of them, he seems to anticipate the work of the present-day American Super Realist, Richard Estes. Boutet de Monvel shared Charles Demuth's interest in industrial installations, but felt less defensive about admiring them. His *Usine* (Pl.94), painted around 1928, at a time when the artist was at the height of his reputation (he had been asked to show his work in the Sue et Mare Pavillion at the Exposition des Arts Decoratifs in 1925, and in the mid and late 1920s was a member of the committee of both the Salon d'Automne and the Society des Beaux-Arts), is close in spirit to Demuth's celebrated *My Egypt* (Pl.95). One difference, however, is that Boutet de Monvel saw no need to give his painting a defensively ironic title.

The Art Deco landscape style found final symbolic use in the hands of the Texas Regionalist Alexandre Hogue (b. 1898). In the late 1930s Hogue was painting bitter commentaries on the effects of the Depression and of the agricultural policies which produced the Dustbowl. His *Erosion No 2 – Mother Earth Laid Bare* (Pl.96), painted in 1936, is one of the most extraordinary images of its decade. The Texas fields, their fertile top-soil stripped off, take the form of a nude giantess, sprawled exhausted on the ground.

96 ALEXANDRE HOGUE. *Erosion No 2 – Mother Earth Laid Bare*. 1936. The Philbrook Museum of Art, Tulsa, Oklahoma

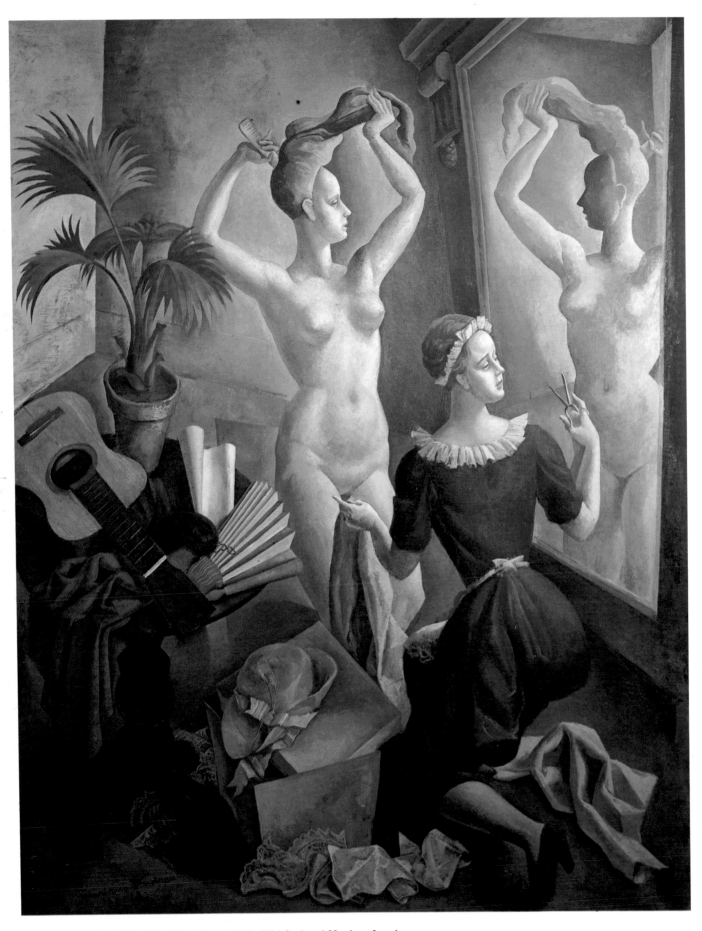

97 MARIANO ANDREU. *The Mirror*. 1928. Whitford and Hughes, London

98 FELICE CASORATI. *Le Signorine*. n.d. Galleria d'Arte Moderna, Venice

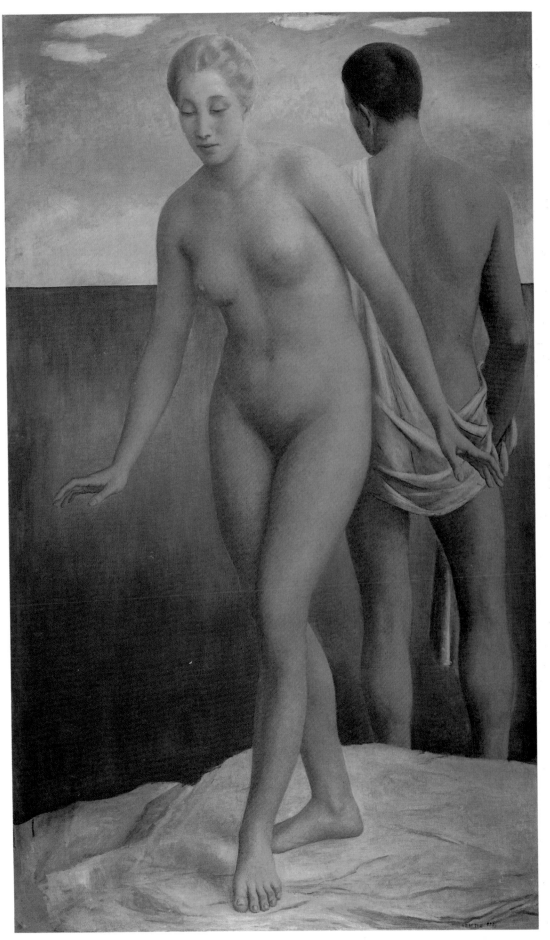

99 *Previous page:*
BUCKLEY MAC-
GURRIN. *Spanish
Fantasy. c.* 1930.
Private Collection.
(Courtesy Fine Art
Associates, London)

100 UBALDO
OPPI. *Two Nudes.*
1928–9. Private
Collection. (Courtesy
Galleria Gian Ferrari,
Milan)

101 *Right:*
CAGNACCIO DI
SAN PIETRO. *The
Spring.* 1935. Private
Collection. (Courtesy
Galleria Gian Ferrari,
Milan)

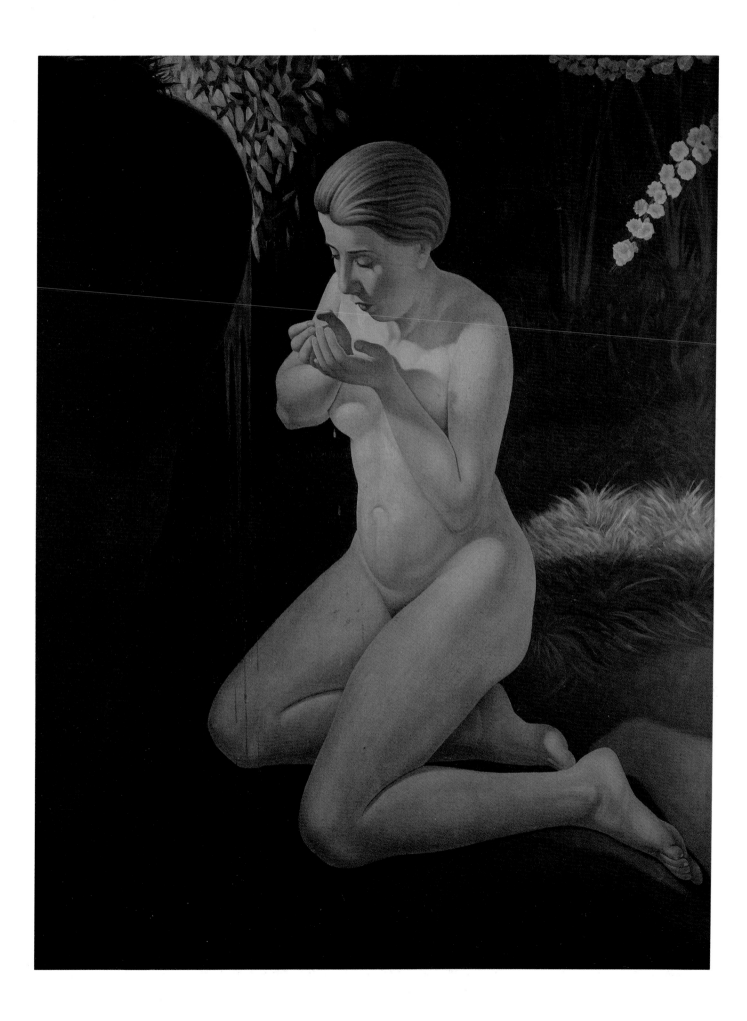

More conventional depictions of the nude were on the whole left to European painters, but these too formed part of the Deco repertoire. Sometimes the results could be stylistically a little confusing. *The Mirror* (Pl.97), by the Catalan, Mariano Andreu (b. 1889 or 1901), shows a conflict between a Cubist-influenced still life and the two figures which are the real subject. These do not quite match one another, with the dressmaker a good deal more mannered than her client, who is another product of Deco Classicism. The classical influence in this second figure is expected, because the woman is virtually nude. Deco artists always veered towards classical models whenever nudes formed a prominent part of the composition, whatever the ostensible subject. This can also be seen from the work of the American expatriate artist Buckley Mac-Gurrin, who lived and worked for a long time in Paris, before moving to California. His *Spanish Fantasy* (Pl.99) is basically a paraphrase of Ingres, but the background uses elements borrowed from Italian Futurism and the brooding Indian in the lower left corner is an obvious tribute to the Santa Fe style of the 1920s and 1930s. Lempicka's *Les Deux Amies* (Pl.14) is still more obviously indebted to Ingres – the specific source, here, is *Le Bain Turc*. The figures fill the whole surface of the canvas with an obsessive fleshliness which hints at Lempicka's predilection for lesbian adventures.

Just because they were so much in thrall to the classical heritage, it was probably the Italian artists of the time who painted the nude most convincingly. The actual subject of these Italian pictures is often left carefully vague. *Two Nudes* (Pl.100) by Ubaldo Oppi (1889–1942), one of the founder-members of the Novecento Group, is an elegant version of an age-old theme: 'male and female made he them'. *The Spring* (Pl.101), by Cagnaccio di San Pietro, painted in 1935, seems to demonstrate the continuing influence of Félix Vallotton. The subject itself was used, though in much more openly allegorical guise, by the great neo-classicist, Ingres. In this case the painting can be regarded either as being classical in both subject and style (a nymph by a fountain) or as being a purely 'realistic' subject (this is the way in which Courbet treated rather similar material). The choice of interpretation is left to the spectator. Art Deco artists often believed in having their cake and eating it.

A more complex painting incorporating a female nude is Casorati's *Le Signorine* (Pl.98) – the title is difficult to render exactly in English: it can mean *The Spinsters*, or else *The Misses* or *The Young Ladies*. Here the entirely nude figure second from the right seems to be in a state of some perplexity, while her companions regard her with a mixture of pleasure, puzzlement and perhaps disapproval. The labels which form part of the foreground still life give their names – Dolores F. (the figure to the left who resembles Bea Lillie), Violante, Bianca (the nude) and finally Gioconda. The precise meaning of the allegory remains obscure, though the still life objects include many borrowed from the traditional *vanitas* – a mirror, flowers, fruit, jewellery, a set of dice, a watch and, to the far left, what seems to be a breviary. What is not in doubt is the decorative quality of the work.

═ART DECO AND CUBISM═ 7

Cubism was one of the chief sources of inspiration for Deco pattern designers, and a somewhat bastardized form of it became common currency among artists whose own aims were primarily decorative. They used the characteristic forms of Cubism and virtually ignored its essence, which was the analysis of appearances. The artists who acted in this way seldom enjoyed close relationships with the inventors of the Cubist formal language, Braque and Picasso. Historically, Cubism splits into two phases – Analytic and Synthetic, the one engaged in a meticulous analysis of visual reality, the other in creating a parallel universe in which abstract shapes 'stand for' what is observed. Deco artists preferred to plunder Synthetic Cubism, with its flat cut-out shapes, rather than wrestling with its Analytic predecessor.

The transformation of Analytic Cubism in the hands of an artist who did not truly understand its aims, but saw in it something which he could exploit for decorative purposes, can however be seen in the work of the Belgian painter August Mambour (1896–1968). Mambour was fifteen years younger than either Picasso or Braque, and Cubism had become a living force when he was still in his teens. His *The Negress* (Pl.103) was not painted until 1928, two decades later than the work of Picasso's own so-called Negro Period, but close in

date to the high-style Deco furniture imitating African stools, and so on, which was made by craftsmen like Pierre Legrain. The painting is both a tribute to the cult of the negro, more or less at its height at the time when it was created, and a rather distant nod to an artistic experiment which was already long over. Cubist influence is more clearly visible in the treatment of the background than of the figure, which owes more to Gauguin than it does to Picasso. Though in no sense radical, the painting is amusing and in its own way elegant. Some of the artist's other work in the same style is distinctly bizarre, for example the *Charge of the Hippos*, showing a squadron of riders, who appear to be Europeans in some kind of military uniform. The hippos themselves are perched on wheels, and the riders have machine-guns tucked under their arms. The painting is presumably intended as an anti-war allegory.

One strong tendency was to mix Cubist influence with ideas borrowed from other Modernist styles. Delaunay's Orphism, itself derived from Cubism, was a favourite source, because of its emphasis on colour and dynamism. Pierre-Louis Flouquet (1900–67), who was born in Paris but made his career in Belgium, offers a good example of the impact made by Orphism. His *Abstract Composition* (Pl.102) of around 1925 has segmented areas of colour in the

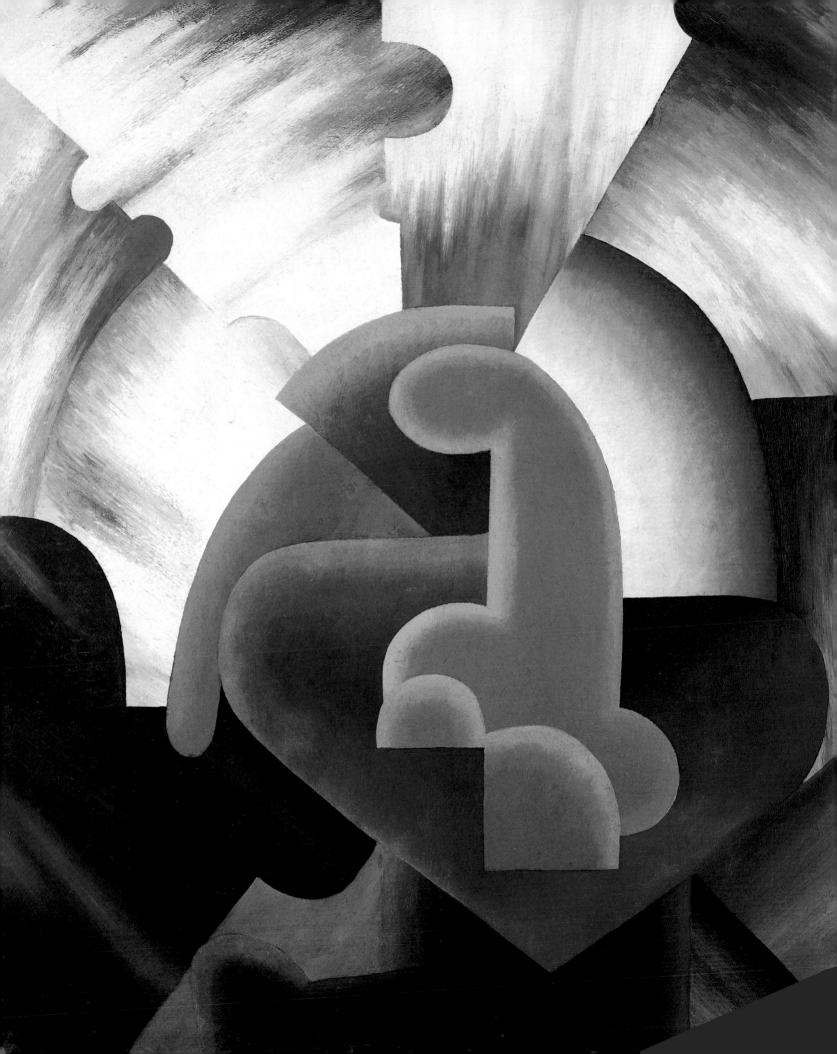

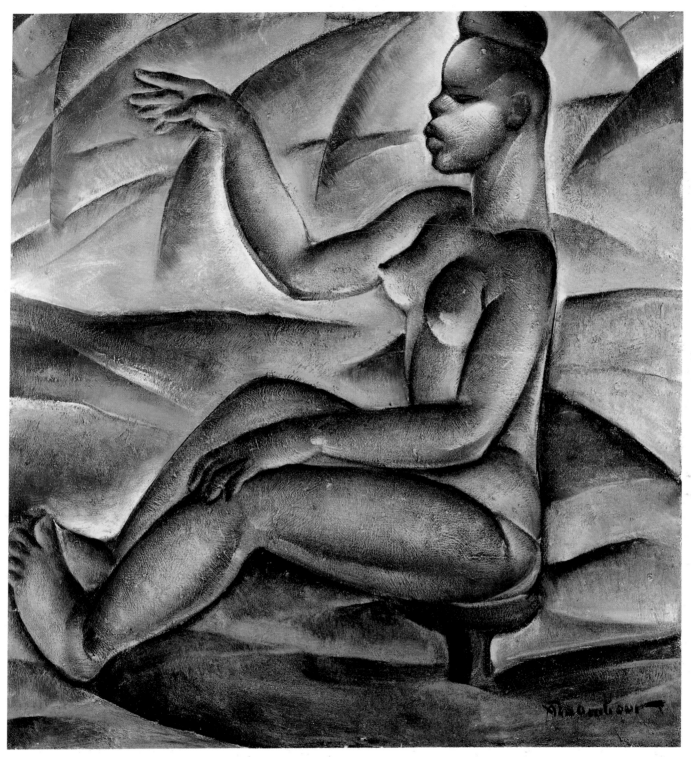

103 AUGUST MAMBOUR. *The Negress.* 1928. Private Collection. (Courtesy Barry Friedman)

102 PIERRE-LOUIS
FLOUQUET.
Abstract Composition.
c. 1925. Private
Collection. (Courtesy
Barry Friedman)

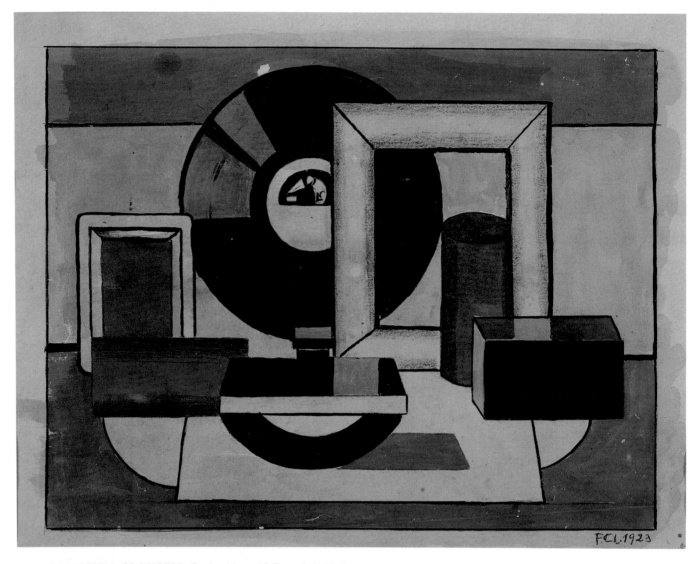

104 FRANCISKA CLAUSEN. *Composition with Record*. 1923. Private Collection. (Courtesy Barry Friedman)

105 MARCELLE
CAHN. *Abstract
Composition*. 1926.
Private Collection.
(Courtesy Barry
Friedman)

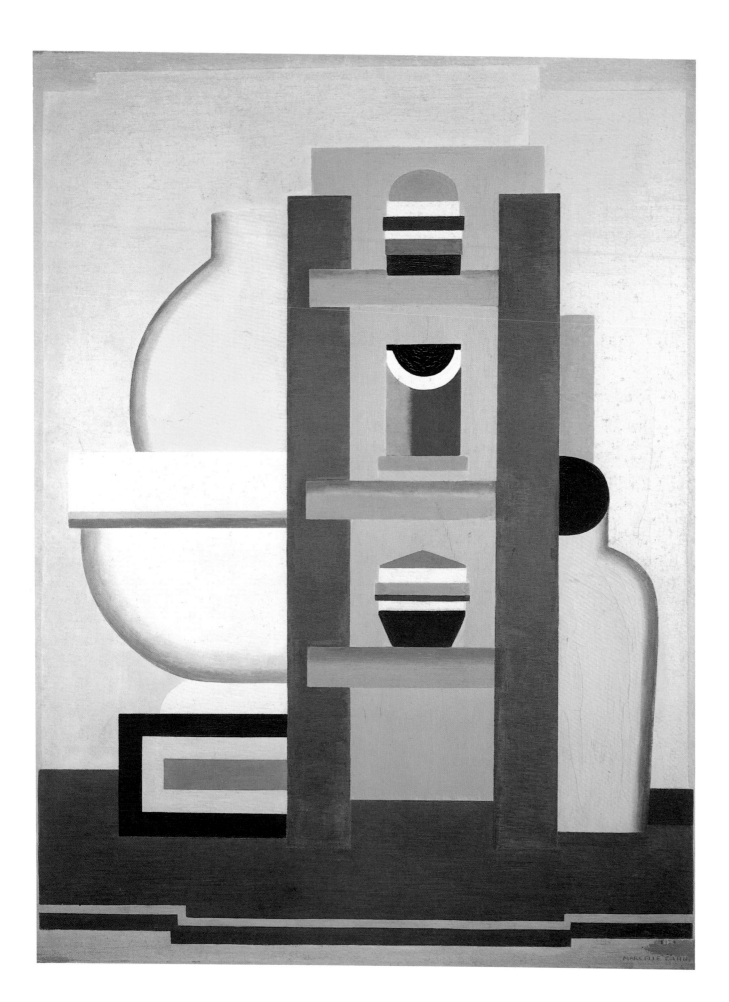

background which are redolent of Delaunay. The curious phallic form in the centre may be reminiscent of Brancusi's sculpture *The Princess*, which dates from 1916.

Many of the hybrid Deco/Synthetic Cubist paintings done in the 1920s were the work of foreign artists who worked for a while in Paris. The majority owed their contact with Cubism to Léger, who had now replaced Matisse as the chief guru for such foreign aspirants. Matisse himself, who had been surrounded by flocks of young Germans and Scandinavians in the years immediately preceding the First World War, had now retired to the South of France. The compositions produced under Léger's influence usually retained elements of figuration. Franciska Clausen's *Composition with Record* (Pl.104) was painted in 1923, when she was still working in Berlin. It nevertheless clearly reveals her awareness of what Léger was doing and especially his transformation of common objects – she moved to Paris and joined his circle a couple of years after producing it. The painting is not a city scene but an extremely simplified still life, featuring a blotter and a couple of photograph frames, as well as the gramophone record which gives the painting its title. This last object can perhaps be thought of as emblematic of the spirit of the time. The gramophone, though not a new invention, had come into its own and was changing social life.

In 1924 Léger, in partnership with Ozenfant, opened a school at 86 rue Notre-Dame-des-Champs in Paris. One of his most devoted pupils was the Swiss artist Marcelle Cahn (1895–1981). Her *Abstract Composition* (Pl.105) of 1926 figured in the exhibition 'Léger and Purist Paris', held at the Tate Gallery in London in 1970–1. The painting is clearly another simplified still life, rather like Clausen's, but carried out on a more ambitious scale. It is possible to make out two vases, a bowl, and what look like some small pottery objects on a set of shelves. Cahn, like nearly all of Léger's disciples, would almost certainly have been shocked and angered to find herself numbered among the artists typical of Art Deco. The Purism to which both Léger and Ozenfant subscribed was in theory a retort to the hedonism of designers such as Ruhlmann, and to the academicism of artists such as Jean Dupas. In fact, a painting such as this combines an undoubted decorativeness with a certain degree of intellectual inertia. Decoration has become an end in itself. This comment applies with equal force to a painting by yet another pupil of Léger – *Non-Objective Composition* (Pl.106) by the American, Florence Henri (1895–1982). Henri was already a pupil by 1922, before the school was opened. She visited the Bauhaus at its Weimar location in the following year, and again in 1926, the year in which *Non-Objective Composition* was painted. She thus formed a link between the group around Léger and the experiments being made under the influence of Dutch and Russian Constructivism in Germany. It must be noted that this particular painting, in flat contradiction of its title, stubbornly preserves recognizably figurative elements. The most conspicuous is the guitar shape at the centre left, pointing to the influence of Synthetic Cubism.

More sympathetic than the many still lifes and quasi-still lifes produced under Léger's influence are the energetic paintings of dancers which were also a staple of the decorative art of the time. Thorvald

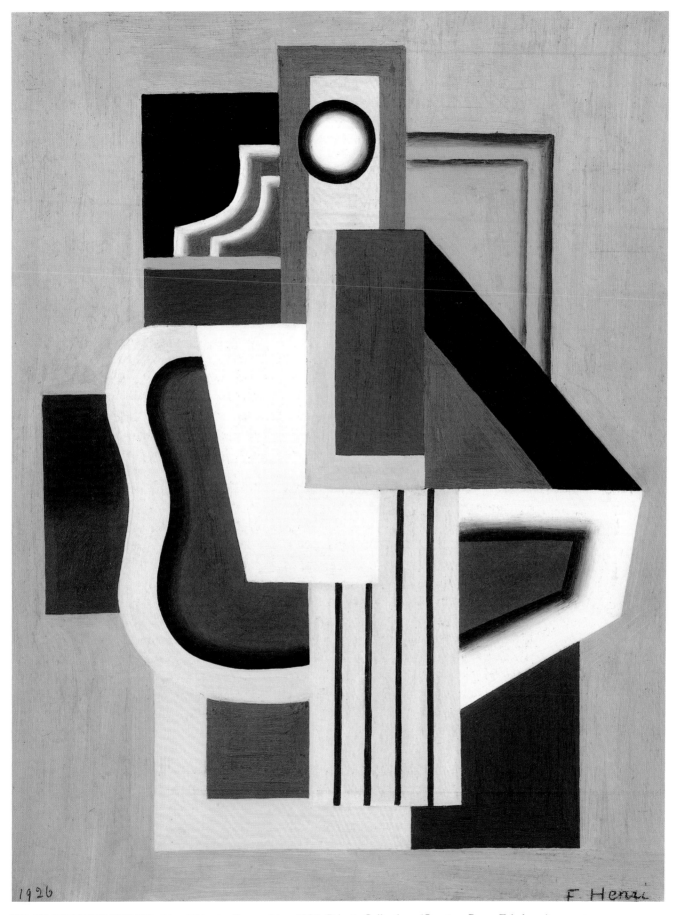

1926

F Henri

106 FLORENCE HENRI. *Non-Objective Composition*. 1926. Private Collection. (Courtesy Barry Friedman)

150

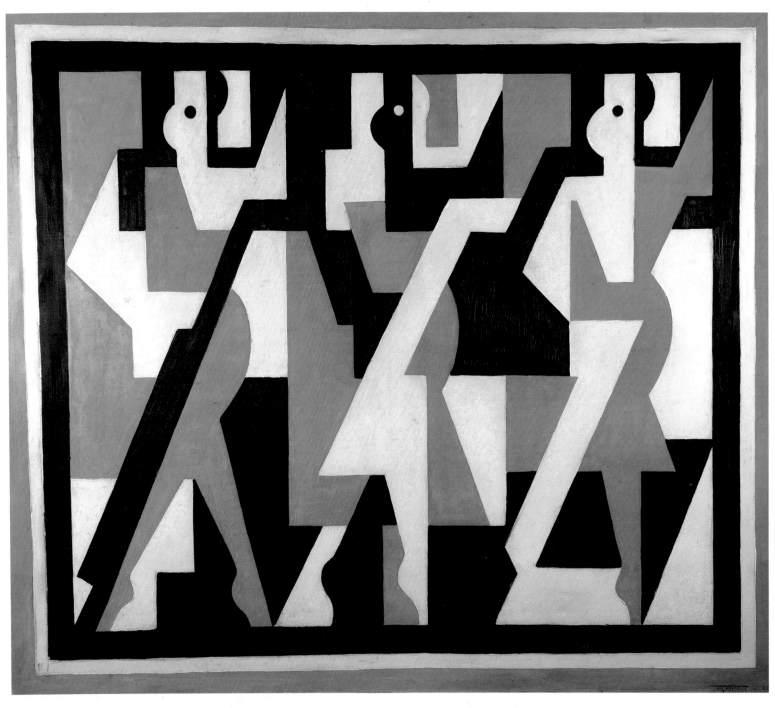

107 THORVALD HELLESEN. *The Dancers*. 1925. Private Collection. (Courtesy Barry Friedman)

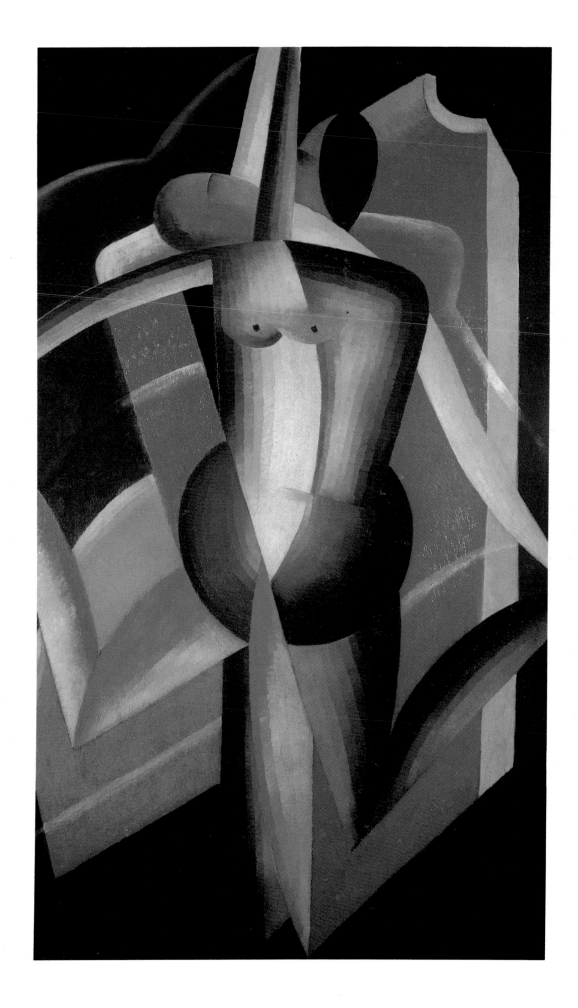

108 EMILE VAN
DER CAMMEN.
The Dancers c. 1924.
Whitford and
Hughes, London

Hellesen (1888–1937), a Norwegian who settled in Paris, regarded Léger as a mentor, and formed part of the group of Cubist painters who showed their work at Leon Rosenberg's gallery, L'Effort Moderne. His ambitious canvas of *Dancers* (Pl.107) – more than 1½ metres (5 feet) long – breaks away from Léger in a way which seems to have been impossible for many of his other disciples. The painting is an apotheosis of jazz, an intricate pattern in pink, black and white. Its connection with some of the most typical posters of the time, such as that designed by Paul Colin three years later for the Bal Tabarin in Paris, is immediately recognizable.

Other artists also used Cubist conventions to try and convey the same *joie de vivre*, for example the painting of a dancing couple (Pl.108) by the Dutch artist Van der Cammen. The followers of Cubism might try to insist on a fundamental distinction between themselves and the last products of academic classicism, such as Dupas and Poughéon, but essentially their aims, their tastes and their audience were the same. Art Deco painting marked itself off from the Modernist styles which it absorbed by its hedonistic insistence that the reaction of the audience was still all-important. Unlike the pioneer Modernists who were their contemporaries, the painters who can seriously be classified as being part of the Art Deco ethos had little ambition to change the world they lived in – they were content to accept and reflect it as it was.

≡ARTISTS' BIOGRAPHIES≡

Numbers at the end of each entry refer to page numbers (roman) and plate numbers (*italic*)

MARIANO ANDREUX
Barcelona 1901–77

Exhibitions in Barcelona then in London, Munich, New York.
1920 Exhibition of Catalan artists, Paris.
1924, 1925, 1931 Salon des Tuileries, Paris.
1936 Contemporary Spanish Art exhibition, Paris.
1945 Portrait of Jean Giraudoux at the Salon d'Automne, Paris.
Illustrations for *Amphitryon 38* by Giraudoux.
Stage designs for operas and comic operas. 142; *Frontisp.*, *97*

MAXWELL ARMFIELD
Ringwood 1882–1972

Studies at the Birmingham College of Fine Art, then in Paris.
In 1905 and 1906 Paris, Musée du Luxembourg and in London.
Stands out among his generation of English painters by his realism. 93, 110

BALTHUS (Balthasar Klossowski de Rola)
Paris 1908–81

Member of an artistic family, he meets Bonnard, Roussel, Derain.
Starts painting at the age of 16; R. M. Rilke publishes and writes a preface to his early drawings (1921).
1934 First exhibition in Paris.

1961–76 Director of the Villa Medici, Rome.
Retrospective exhibitions in 1966, Paris, Musée des Arts Décoratifs; 1968, London, Tate Gallery; 1971 Paris, Galerie Claude Bernard; 1973 Marseilles, Musée Cantini; 1984 Paris, Centre Georges Pompidou and New York, Metropolitan Museum of Art. 69; *46*, *47*

BERNARD BOUTET DE MONVEL
Paris 1884–the Azores 1949

Starts his artistic education with his father then with the painter L. D. Merson and the sculptor J. Dampt.
Starts exhibiting in 1903 in Paris; and from 1907 at the Carnegie Institute of Pittsburgh.
Exhibitions of engravings, illustrations and paintings in Brussels, Copenhagen, Paris.
1926 Exhibits in New York. Works in the USA and in France.
1951 Retrospective exhibition, Paris, Musée Galliera. 7, 17, 64, 134; *9*, *41*, *94*

FERNAND BOUTON
Fleurus (Hainaut)

Belgian painter.
1938 Exhibits in Paris, at the Salon de la Société Nationale des Beaux-Arts. 110; *77*

RENÉ BUTHAUD
Saintes 1886–Bordeaux 1986

Studies at the École des Beaux-Arts in Bordeaux then in Paris, studies

painting and engraving before specializing in 1918 in ceramics.
Exhibits in Paris at the Salon des Artistes Décorateurs and the Salon d'Automne.
1925–6 Manages the Primavera works for the Printemps department store.
Develops a crackled enamel technique.
1925 Exposition Internationale des Arts Décoratifs. 37; *23*

PAUL CADMUS
New York 1904

American painter and illustrator.
Studies at the Art Students' League and at the National Academy of Design. 96; *67*, *68*

MARCELLE CAHN
Strasburg 1895–Neuilly-sur-Seine 1981

Educated in Strasburg, then in Berlin where she joins the 'Sturm' group.
1919 Meets Vuillard, M. Denis, C. Bérard in Paris.
1922 Meets Munch in Zurich.
1925 Paris, works in F. Léger's studio.
1926 Exhibits at the Brooklyn Museum.
1930 Joins the group Cercle et Carré, forms a friendship with Mondrian and Arp.
After the war forms the Salon des Réalités Nouvelles. One-man shows in Paris 1959, London 1960 and Milan 1964. 148; *105*

FELICE CASORATI
Novara 1883–Turin 1963

Early work strongly influenced by
Jugendstil and the Vienna Secession.
1913 One-man show, Ca'Pesaro,
Venice.
1924 Biennale, Milan.
1925 Casa Gualino, furniture design,
sandstone sculpture.
1928 Chair of Painting at the
Albertina Academy.
1936 6th Triennale, Milan.
1937 One-man show, Salon de la
Stampa, Turin. Grand Prix at the
Exposition Internationale, Paris.
1938 Biennale, Venice. Painting prize.
64, 83, 142; *98*

FRANCISKA CLAUSEN
Aabenraa 1899

Studies in Denmark. 1912, meets
Moholy-Nagy and Archipenko in
Berlin. Creates abstract geometric
collages under the influence of the
Russian Constructivists.
1924–33 Works in Paris, F. Léger's
studio.
1926 K. Dreier exhibition, Brooklyn.
1927–8 Salon des Indépendants, Paris.
1929 Participates in the activities of
the group Cercle et Carré. Retires to
Denmark. 134, 148; *104*

RALSTON CRAWFORD
St Catharines 1906–78

1920–6 Sailor.
1926–30 Studies at the Otis Art
Institute, the Pennsylvania Academy,
Philadelphia and the Barnes
Foundation.
1932–3 Paris, Académie Colarossi and
the Académie Scandinave.
1937 Philadelphia, Boyer Galleries.
First experiments with photography.
1938 Philadelphia Art Alliance.
1940–1 Teaches at the Academy of
Cincinnati.
1948–9 Exhibitions in Buffalo and
Brooklyn. 134; *93*

ANDREW DASBURG
Paris 1887–1979

Studies with Cox, Harrison and
Henri.
1925 Second prize at the Panamerican
Exhibition in Los Angeles.
1915–16 Becomes one of the
precursors of abstract expressionism in
the US with Thomas Benton and
Marsden, Hartley. 127; *17*

ALEXANDER DEINEKA
Kurst 1899–1969

School of Fine Arts, Kharskov, then
the Vkhutemos Institute, Moscow.
Many exhibitions in the USSR, East
Germany, Hungary, Austria,
Czechoslovakia and Yugoslavia. His
painting of 1928 depicting the
heroism of the inhabitants of St
Petersburg during the Revolution
exhibited in 1958 in Brussels then in
1968 in Paris, Exhibition 'Art from
the Scythian to today'. 104–6; *74*.

RAPHAEL DELORME
Bordeaux 1885–1962

1920 and 1923 Member of the Salon
de la Société Nationale des Beaux-
Arts and of the Salon d'Automne, in
Paris. Invited to participate in the
Tuileries. 37, 43, 54, 104; *5, 26, 27*

CHARLES DEMUTH
Lancaster 1883–1935

Studies at the Pennsylvania Academy.
1907 Discovers Fauvism in Paris.
Meets the Steins and discovers
Cubism.
1915 First one-man show, New York.
1925 '7 Americans', New York.
1929 '19 Living Americans', Museum
of Modern Art, New York.
1933 First Biennale of American Art,
Whitney Museum.
1937–8 Commemorative Exhibition,
Whitney Museum. 134; *95*

ANDRÉ DERAIN
Chatou 1880–Chambourcy 1954

Studies at the Académie Carrière at
the age of 19. Shares a studio with
Vlaminck at Chatou.
1905–6 Visits London.
1907 In Montmartre, frequents the
'Bateau-Lavoir'. Meets Picasso.
Designs stage sets and costumes.
1919 *La Boutique Fantasque* for
Diaghilev at the Alhambra, London.
1926 *Jack in the Box* by Erik Satie.
1947 *Mam'zelle Angot*.
1953 *Le Barbier de Séville* for the
Festival d'Aix-en-Provence. 12, 54,
64, 69; *42*

JEAN DUPAS
Bordeaux 1882–1964

Student of Carolus-Duran and
A. Besnard.
1909 Honourable mention.
1910 3rd Class medal; Grand Prix de
Rome.
1941 Member of l'Institut, Paris. 37,
40–3, 54, 92, 104, 148, 152; *1, 24,
25, 61*

WILLIAM RUSSELL FLINT
Edinburgh 1880–1969

Studies with a lithographer. Practises
as an illustrator in London.
1905 and 1906 Exhibits in Paris.
1906–7 London, Royal Academy.
1909 and 1914 Venice.
1914 Berlin.
1924 ARA.
1933 RA, RE.
1936 PRWS.
1947 Knight Bachelor.
1962 Retrospective, Royal Academy,
London. 54; *37*

PIERRE-LOUIS FLOUQUET
Paris 1900–Brussels 1967

Works with Magritte. Member of
many avant-garde groups in Brussels
and Paris. Influenced by Cubism.
1925 Exhibits with 'Der Sturm' in
Berlin, then in the USA. Ceases to
paint after this. 143; *102*

EDWARD REGINALD
FRAMPTON
London 1870–1923

Exhibits at the Royal Academy.
From 1877, exhibits in Paris and is
awarded a medal in 1910 and
another in 1920. 46, 73, 124; *29, 86*

ERNEST FRITSCH
Berlin 1892–1962

1918 Joins the Novembergruppe.
1928, 1929 Lives in Paris and Rome.
Returns to Germany where he is
subject to the rise of Nazism and is
declared a 'degenerate artist'. After
the war teaches at the Academy of
Fine Arts in Berlin. 110; *79*

BORIS GRIGORIEV
Moscow 1886–Cannes 1939

1903 Stroganoff Institute, Moscow and
the St Petersburg Academy.
1912–14 Lives in Paris. Returns to St
Petersburg. P83–7. 1918 Escapes to
Berlin.
1909 Impressionist Exhibition.
1912–13 Société des Indépendants.
1913 Member of the Association du
Monde d'Art.
1929 Moves to Paris. 83–7; *59*

WILLIAM GROPPER
New York 1897

Early career as an illustrator. Travels
the world recording his impressions
in water-colour. Paints murals.
Received many awards including a
Scholarship in 1937. 96; *69*

MARSDEN HARTLEY
Lewiston 1877–Ellsworth 1943

Studies in New York. Visit to Paris
in 1912 where he meets the Cubists.
1913 Exhibits in Munich with the
'Blaue Reiter', and in New York at
the Armoury Show.
1916 Returns to the US where he
becomes an exponent of abstract
expressionism before returning to
representational painting in 1918. 127;
89

FLORENCE HENRI
New York 1895–Compiègne 1982

Studies art in Berlin and Munich,
then in 1924 at the Académie
Moderne, Paris, under F. Léger and
A. Ozenfant.
1925 Exhibits at 'L'Art d'Aujourd'hui'.
1927 Attends Moholy-Nagy's and
Albers's course at Dessau.
Experiments with various photographic
techniques.
1929 Returns to Paris. Exhibition
'Film und Foto', Stuttgart.
1930 One-man show, Paris.
1931 Exhibits at 'Foreign advertising
photography', New York.
1932 'Modern European Photography',
New York.
1970–2 Exhibits at MOMA, New
York. Starts painting again in 1960.
148; *106*

ALEXANDRE HOGUE
Memphis 1898
134; *96*

SIR GERALD KELLY
London 1879–1972

Long stay in Paris where he meets
Whistler.
1904 Exhibits at the Salon
d'Automne. Travels to Spain, South
Africa and America. Exhibits in
London from 1910.
1930 RA. 79; *50*

MARIE LAURENCIN
Paris 1883–1956

Friend of Guillaume Apollinaire.
Frequents the 'Bateau-Lavoir'.
1912 Salon d'Automne: participates in
the designing of 'La Maison Cubiste'.
1913 and 1940 Exhibits at the
Léonce Rosenberg Gallery.
1924 Works on the scenery of *Les
Biches* by Francis Poulenc, for
Diaghilev's Ballets Russes.
1925 Exhibits at the Exposition
Internationale de Paris. 7, 64–9; *43*

FERNAND LÉGER
Argentan 1881–Gif-sur-Yvette 1955

1900 Architectural draughtsman in
Paris.
1903 Académie Julian.
1908 At la Ruche, becomes friend of
Archipenko, Chagall, Laurens and
Soutine.
1911 Salon des Indépendants, Salle
Cubiste.
1920 Meets Le Corbusier.
1921 Has contacts with 'De Stijl'.
1924 Founds a studio with Ozenfant.
Directs the film *Ballet Mécanique*.
1925 Paints murals for the Pavillon
de l'Esprit Nouveau, Exposition
Internationale, Paris.
1940–5 Lives in the USA.
1949 Returns to France. Experiments
with ceramics, mosaics and stained
glass. 15, 17, 18, 120, 134, 148,
152; *8*

TAMARA DE LEMPICKA
Warsaw 1898–Cuernavaca 1980

St Petersburg Academy. Student of
Maurice Denis and André Lhote in
Paris. From 1923, exhibits at
numerous private and joint shows.
1927 Prix d'honneur at the Exposition
Internationale in Bordeaux. Portraitist
influenced by Cubism and Léger's
'Tubism'. 23, 32, 43–6, 61–4, 69,
79, 89, 96, 142; *14, 28, 38, 39, 40,
62*

ANDRÉ LHOTE
Bordeaux 1885–Paris 1962

1892 Apprenticed to a sculptor in
Bordeaux.
1917 Adopts synthetic Cubism.
1919–39 Works for the *Nouvelle
Revue Française*.
1922 Founds the Académie Lhote. He
exercises a strong influence through
his reading and writings.
1955 Paintings for the Medical
Faculty in Bordeaux. 29, 43, 61, 96,
120; *18, 83*

MARIETTE LYDIS
Vienna 1890–Buenos Aires 1970

1927 Settles in Paris where she is immediately noticed by A. Salmin. She owes her fame mainly to her prints and illustrations. 89; *60*

BUCKLEY MAC-GURRIN
1929–37 Exhibits at the Salon d'Automne. 142; *99*

AUGUSTE MAMBOUR
Liège 1896–1968

Wins the Prix de Rome, and travels to the Congo. From 1926 to 1928 is attracted by the surrealism of Tanguy, Ernst and Dali, then reverts to an expressionism centred on the theme of man.
1931 Becomes Professor at the Liège Academy. 143; *103*

PIERO MARUSSIG
Trieste 1879–Pavia 1937

Visits Vienna, Munich, Rome and Paris. Returns to Trieste.
1919 One-man show, Milan. Meets Carrà.
1922 Joins the Novecento Group, of which he becomes one of the leaders.
Group exhibitions: 1927 Amsterdam; 1929 Geneva; 1930 Buenos Aires; 1931 Stockholm and Helsinki.
1930 Founds a studio in the *quatrocento* tradition in Milan. 106; *73*

GERALD MURPHY
USA 1888–1964

Settled in Europe. Painted stylized still-lives. 120; *85*

GEORGIA O'KEEFFE
Sun Prairie 1887–1986

Student of William Chase and Arthur Dow. She revolts against academism and the imitation of European painters.
From 1916, exhibits in New York, Galerie 291, then at the Anderson Galleries.
1926 First paintings of New York skyscrapers.
1927 Retrospective exhibition at the Brooklyn Museum.
1931 First painting of bones.
1940 Settles in New Mexico.
1943 Important retrospective exhibition at the Art Institute of Chicago. 23, 127, 134; *12, 91*

UBALDO OPPI
Bologna 1889–1942

1907 Studies in Vienna with Klimt.
1911–15 Studies in Paris.
1913 Exhibits at the Ca'Pesaro and the P. Guillaume Gallery, Paris.
1920, 1921 Salon des Indépendants.
1923 Joins the Novecento Group.
1925 Starts painting religious subjects.
1928 Frescoes in Padua.
1930 One-man show, Milan. 142; *100*

AMÉDÉE OZENFANT
Saint-Quentin 1886–Cannes 1966

Studies at the Académie de la Palette. Student of J.E. Blanche and G. Desvallières with La Fresnaye and Ségonzac, 1918. Founds the *Purisme* magazine with the painter Charles-Édouard Jeanneret (the architect Le Corbusier).
1920–5 With Le Corbusier founds and edits the review *L'Esprit Nouveau.*
1925–8 Monumental painting.
1928 Publishes his writings *Art.*
1932 Founds the Académie Ozenfant in Paris, then in London. 15, 120, 148; *84.*

GUY PÈNE DU BOIS
USA 1884–1958

Studies at the Chase School. Student of Steinlen in Paris.
1906 First exhibition in Paris, at the Salon de la Nationale.
1933 Worcester Art Museum. 96, 104; *66*

GLYN PHILPOT
London 1884–1937

Student of Philip Conrad and J. P. Laurens.
1923 RA. 54, 92–6; *34, 35, 64, 65*

PABLO PICASSO
Malaga 1881–Mougins 1973

Painter, draughtsman, engraver, sculptor, ceramist and writer. After studying in Barcelona he settles in Paris in 1900. His work is divided into periods. The *Demoiselles d'Avignon* are the starting point of Cubism, created by Picasso and Braque.
1917–24 works for the Ballets Russes on *Parade, The Three-cornered hat* and *Pulcinella.*
1920s Neo-classical period.
1925 Exhibits at the Peinture Surréaliste exhibition at the Galerie Pierre.
1930 First prize at the International Exhibition, Pittsburgh.
1937 *Guernica,* International Exhibition, Paris.
1939 Retrospective exhibition at MOMA, New York.
1945–55 Returns to subjects from antiquity and searches for new means of expression, engraving, lithography, sculpture and ceramics from 1947 with the Madoura studio. 12, 15, 23, 96, 143; *4*

YURI IVANOVITCH PIMENOV
Moscow 1903–77

1920–25 Studies at the Vkhutemos.
1928 Visits Italy and Germany.
1925–8 Organizes the Association of Stankovists (OST). Member of the Academy of Arts of the USSR. 104; *71*

EUGÈNE ROBERT POUGHÉON
Paris 1886–1955

Student of J. P. Laurens and Besnard.
1914 Prix de Rome.

1927 and 1929 Awarded medals. 36, 37, 40, 58, 152; *22*

DOD PROCTER
London 1892–1972

Studies with Stanhope Forbes at Newlyn, then in Paris at the Academy Colarossi.
1912 Marries Ernest Procter.
1913 Exhibits with him at the Société des Beaux-Arts.
From 1922 Works with her husband on the decoration of the Kokine Palace in Rangoon (Burma).
1926–8 Carnegie Institute, Pittsburgh. 46, 54, 79; *33*

ERNEST PROCTER
Tynemouth 1886–North Shields 1935

Studies with Stanhope Forbes at Newlyn, then in Paris at the Academy Colarossi.
1913 Exhibits at the Société Nationale des Beaux-Arts, Paris.
1916 International Society.
1920 Decorates the Kokine Palace in Rangoon. Exhibits at the Royal Academy.
1929 Member of the New English Art Club.
1934–5 Teaches at the Glasgow School of Art. 23, 46–54, 79; *10, 31, 32*

WILLIAM ROBERTS
London 1895–1980

Studies at the Slade.
1913–14 A member of the vorticists with Wyndham Lewis. His style was inspired by Cubism and Futurism.

1958 ARA.
1966 RA. 79; *54, 55*

CAGNACCIO DI SAN PIETRO
Italy 1897–1946

Surrealist painter.
1948 Venice Biennale. 64, 83, 142; *101*

GINO SEVERINI
Cortona 1883–Paris 1966

Joins the Neo-impressionists in Rome.
1906 Settles in Paris.
1910 Signs the Futurist manifesto and is its proponent in France.
1912 *Les Peintres Futuristes*, Paris.
1916–19 One-man shows, Paris.
1921 Publishes *Du Cubisme au Classicisme*. Paints a number of frescoes in churches.
1935 First prize, Quadriennale de Rome.
1940–2 Stage design and costumes for Stravinsky's *Pulcinello* in Venice. 29, 115; *80*

CHARLES SHEELER
Philadelphia 1883–New York 1965

1903–5 Student of W. Chase at the Pennsylvania Academy.
Professional photographer. Visits London, the Netherlands and Spain.
1908–9 Visits Italy and France.
1913 Exhibits at the Armoury Show and meets Duchamp, Picabia.
From 1912 he pursues a parallel career as a photographer.
1939 Retrospective at MOMA, New York.
1954 University of California.
1963 University of Iowa. 17, 134; *11*

WILLIAM STRANG
Dumbarton 1859–Bournemouth 1921

Pupil of A. Legros. Member of the Royal Society of Painters Etchers. ARA. Exhibits in Paris. Awarded a silver medal at the Universal Exhibition in 1889. Exhibits at the Royal Academy. 73; *49*

FÉLIX VALLOTTON
Lausanne 1865–Paris 1925

Arrives in Paris at the age of 18. Frequents the Académie Julian.
1893 Salon des Indépendants, Paris. Exhibits with the Nabis and joins the group in 1897. His wood cuts are published in periodicals and meet with international acclaim. He sympathizes with the anarchist movement. His paintings are quasi-photographic in their realism. 12, 142; *3*

KEES VAN DONGEN
Delfshaven 1877–Monte Carlo 1968

Studies at the Academy of Fine Arts, Rotterdam.
1906 In Paris he is in touch with the Bateau-Lavoir Group. Works on illustrated publications including the *Revue Blanche*. Exhibits at the Fauve exhibition.
1908 Works with the ceramist Metthey. Exhibits in Düsseldorf, then with Die Brücke in Dresden.
1909–15 Galerie Bernheim-Jeune, Paris.
From 1916 Becomes a society artist which ensures his fame after the war. 69, 92, 96; *44, 45, 63*

≡BIBLIOGRAPHY≡

There are now a number of books devoted to various aspects of Art Deco, but very few which give any space to painting. There are also remarkably few specialist studies of individual Art Deco painters. What I list here are a few books and catalogues which I have found useful in my research of the subject. It is not intended as an exhaustive bibliography of the Art Deco style.

Victor Arwas. *Art Deco.* Academy Editions, London, 1980.

Martin Battersby, revised and edited by **Philippe Garner.** *The Decorative Twenties.* Whitney Library of Design. New York, 1988.

Martin Battersby, revised and enlarged by **Philippe Garner.** *The Decorative Thirties.* Whitney History of Design, New York, 1988.

Patricia Bayer. *Art Deco Source Book.* Phaidon, Oxford, 1988.

Felice Casorati, 1883–1963. Exhibition catalogue. Academia Albertina di Belli Arte di Torino, 19 Feb–31 March 1989. Fabbri Editori, Milan, 1989.

Alistair Duncan. *Art Deco.* Thames and Hudson, London, 1988.

Guiliano Ercoli. *Art Deco Prints.* Phaidon · Christie's, Oxford, 1989.

Claudia Gian Ferrari. *Ubaldo Oppi.* Electa, Milan, 1989.

Michael Hoog et al. *Catalogue de la Collection Jean Walter and Paul Guillaume: Musée de l'Orangerie.* Editions de la Réunion de Musée Nationaux, Paris, 1984.

Italian Art, 1900–45. Exhibition catalogue, Palazzo Grassi, Venice. Bompani, Milan, 1989.

Dan Klein, Nancy A. McClelland and **Malcolm Haslam.** *In the Deco Style.* Thames and Hudson, London, 1987.

Baroness Kizette de Lempicka-Foxhall. *Passion by Design: The Art and Times of Tamara de Lempicka.* Phaidon, Oxford, 1987.

Léger and Purist Paris. Exhibition catalogue, Tate Gallery, London, 18 Nov. 1970–24 Jan 1971.

Léger et l'Esprit Moderne. Exhibition catalogue, Musee d'Art Moderne de la Ville de Paris, 17 Mar–6 June 1982 (and later at the Museum of Fine Arts, Houston and Musée Rath, Geneva).

Charles Meere, 1890–1961. Exhibition catalogue, S. H. Ervin Gallery, Sydney, 9 Oct–15 Nov 1987.

Sabine Rewald. *Balthus.* The Metropolitan Museum of Art, New York, and Harry N. Abrams, New York, 1984.

Diana Souhani. *Gluck: Her Biography.* Pandora Press, London, 1988.

≡INDEX≡